Giovanna Calvenzi

ITALIA

Portrait of a Country throughout 60 years of Photography

contrasto

Edited by
Giovanna Calvenzi
Editorial project
Roberto Koch
Design
Francesco Camagna
Coordination
Alessandra Mauro
Editorial staff
Suleima Autore
Production
Barbara Barattolo
Printing
EBS, Verona
Translation from Italian
Dorigen Caldwell

First published in Italy in 2003 by
Contrasto Due Srl,
via degli Scialoia, 3
00196 Rome
Italy

Original edition © 2003 Contrasto Due Srl, Rome
All photographs © 2003 the photographers,
as better indicated at page 350

ISBN 88-89032-00-6

Printed and bound in Italy

Contents

Photographs by Abbas, Michael Ackermann, Giampietro A
Barbieri, Gabriele Basilico, John Batho, Walter Battistessa
Aldo Bonasia, Giovanna Borgese, Gianni Borghesan, Luca E
Campagnano, Luca Campigotto, Robert Capa, Mario Carrieri
Giuseppe Cavalli, Alain Ceccaroli, Carla Cerati, Giovanni C
Daniele Dainelli, Bruce Davidson, John Davies, Mario De
Demarchelier, Raymond Depardon, Paola De Pietri, Paola
Giorgia Fiorio, Franco Fontana, Vittore Fossati, Mauro Gal
Ghirri, Mario Giacomelli, Giancolombo, Gianni Giansanti, F
Guidi, Andreas Gursky, Ernst Haas, Arno Hammacher, Thor
Richard Kalvar, William Klein, Roberto Koch, Josef Koudel
Lotti, Uliano Lucas, Martino Marangoni, Nino Migliori, Ric
Nicolini, Walter Niedermayr, Claude Nori, Occhiomagico,
Patellani, Marco Pesaresi, Tino Petrelli, Franco Pinna, Fran
Marialba Russo, Claudio Sabatino, Roberto Salbitani, Seb
Secchiaroli, Philippe Séclier, Enzo Sellerio, Shobha, Massin
Struth, Toni Thorimbert, Angelo Turetta, Massimo Vitali,

stini, Marco Anelli, Eve Arnold, Marina Ballo Charmet, Olivo
Gianni Berengo Gardin, Antonio Biasiucci, Werner Bischof,
no, René Burri, Romano Cagnoni, Alfredo Camisa, Marcella
Henri Cartier-Bresson, Vincenzo Castella, Mario Cattaneo,
aramonte, Francesco Cito, Cesare Colombo, Mario Cresci,
asi, Toni Del Tin, Stefano De Luigi, Carl De Keyzer, Patrick
i Bello, Pietro Donzelli, Elliott Erwitt, Ernesto Fantozzi,
ani, Federico Garolla, Caio Garrubba, Moreno Gentili, Luigi
ncesco Giovannini, Claudio Gobbi, William Guerrieri, Guido
s Höpker, Frank Horvat, Francesco Jodice, Mimmo Jodice,
, Sergio Larrain, Herbert List, Silvestre Loconsolo, Giorgio
rdo Moncalvo, Paolo Monti, Ugo Mulas, Ikko Narahara, Toni
ristina Omenetto, Martin Parr, Enrico Pasquali, Federico
sco Radino, Piero Raffaelli, Roger Ressmeyer, Fulvio Roiter,
tião Salgado, Massimo Sciacca, Ferdinando Scianna, Tazio
 Siragusa, Mario Spada, Joel Sternfeld, Paul Strand, Thomas
istina Zamagni, Franco Zecchin.

Introduction

by **Giovanna Calvenzi**

When photography was born, Italy was not yet a nation but a collection of small independent states. For centuries it had been one of the main destinations on the Grand Tour, and the likes of Goethe and Stendhal had journeyed there and recorded their personal visions of the *Bel Paese* (beautiful country). Driven by the lure of the light and the sun, young aristocrats, poets, painters and writers made their way south and, from 1840 onwards, photographers began to join them.

The practitioners of this new narrative form came from all over Europe to take in the country's archaeological sites, scenery, places of natural beauty, everyday life and folklore. In less than a century they not only built up a vast photographic archive, but they also effectively created a collection of stereotypes which would be revisited and re-presented over and over again: Italy would become and remain synonymous with Greco-Roman archaeology, religious processions, women dressed in black, sheep, cypresses and umbrella pines. It may well continue to be the most photographed country in the world, but it was only after the Second World War that alternative environments and events became the subject of more modern photographic treatment. Nowadays it is real life, in both the cities and the countryside, that is the primary goal of the photographers' quest, in all its many creative forms.

The idea of recounting the history of a country through sixty years of photography is a huge and exciting task. The incredible richness and variety of the images has made it necessary to give this work a narrative structure, although we have tried to be conscious of the pitfalls of autobiography, with its tendency to omit certain aspects and forget others. As a consequence, this volume makes no claims to completeness and is aware of being just one visual history among the many that might have been compiled.

The book is divided into three sections. Together these form a kind of journey, comprising three separate pathways which overlap in time, place and theme. The first of these sections follows a chronological sequence, recounting how the country has evolved over the last sixty years, alongside the thoughts of those who witnessed this evolution. Sixty years separate the first image in this section, which is by Robert Capa and depicts the arrival of the American army in Sicily in 1943, from the last, in which Gabriele Basilico shows the Calabrian coast, where the bridge over the Strait of Messina may soon be built. The choice of images runs through recent history, encompassing all possible genres: from the work of photo-journalists to diligent amateurs, from the earliest pioneers to contemporary professionals from the worlds of fashion, architecture, landscape and experimental art.

The second section tackles themes specific to Italy. It comprises six essays which reflect upon moments and movements that have defined the evolution of Italian visual culture, both from the point of view of creativity and the way in which the images were used. The third section engages directly with ways of seeing: twenty artists – ten from Italy and ten from elsewhere – have been paired to present a portfolio of images on ten different themes, with the explicit intention of recounting the history of photography and photographic language, in all their vast expressive possibilities.

Italy through the Eyes of Photographers

From the end of the Second World War to European unification. An anthology of images recounting sixty years of Italian history, and portraying the evolution of the language of photography.

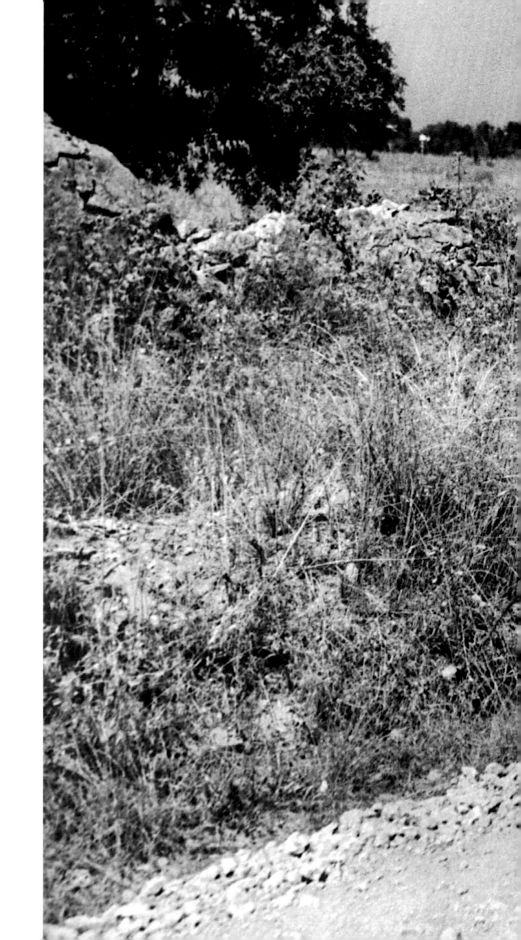

Robert Capa Near Nicosia, 1943

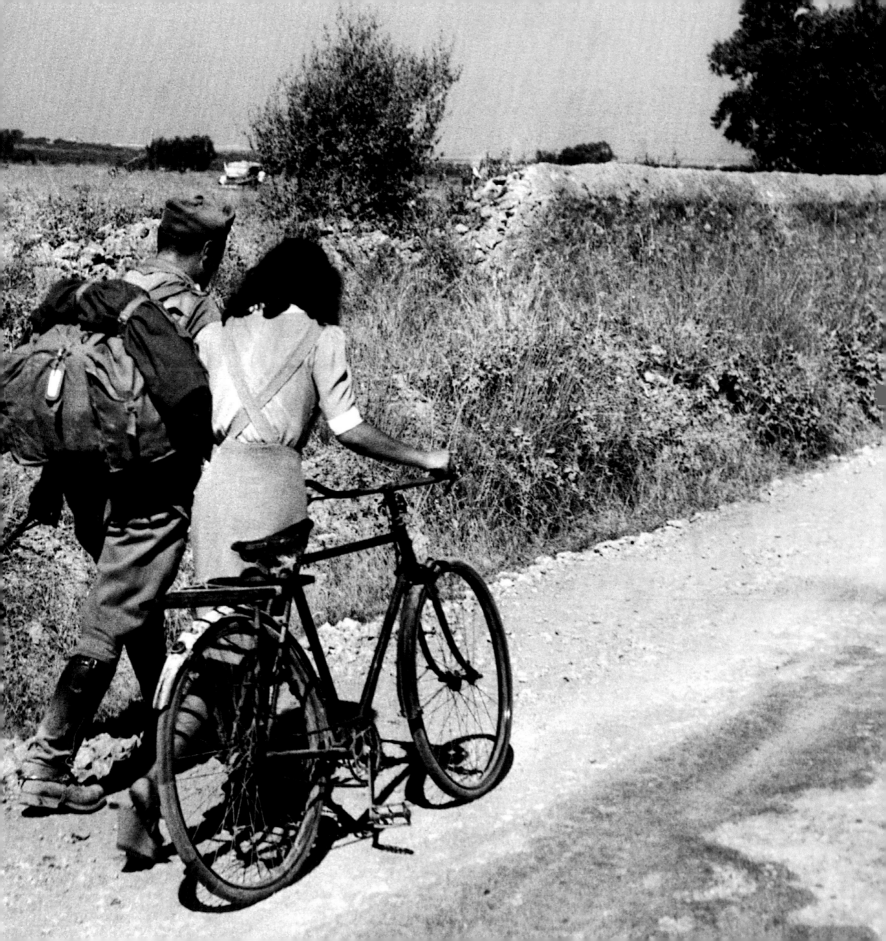

Federico Patellani The Crowd in Piazza Castello During the Rally for Achille Grande, Milan, 1946

Portrait of a Country on its Knees

The turning point came in the turbulent summer of 1943. On 10 July, the Allies landed in Sicily and began their journey north through the peninsula. On 25 July, the King of Italy appointed Marshal Pietro Badoglio as the new head of the Government and ordered the arrest of Benito Mussolini. On the evening of 8 September, Badoglio informed the nation in a radio transmission that Italy had asked General Eisenhower for an armistice, and that the request had been accepted.

The people of Italy were ecstatic at the news, but the elation was short-lived. One war was over, but another was just beginning: a battle on home ground to liberate Italy from the German invaders. This was to be a bloody battle, lasting until 25 April 1945 when the fighting finally stopped. Now the nightmare was over and freedom had won out in the end, but the country was already on its knees. The cities were smoking ruins and the manufacturing infrastructure had almost ceased to exist. The mechanical and steel industries had sustained the most serious damage, along with the communications and transport networks. Only one sixth of the merchant navy survived the war, 40 per cent of bridges and railway lines had been destroyed and the roads were no longer navigable.

This physical damage was compounded by inflation and high unemployment, which reached 20 per cent of the workforce in 1948. The population was also physically worn out. The average daily intake of calories was dramatically reduced and consumption in all areas was seriously down on pre-war figures. Unrest grew: in the South the peasants occupied uncultivated land, while in the North the industrial workers took to the streets in protest.

Yet, amid the debris and poverty, Italy was slowly getting back on its feet. Reconstruction began with a determined social and economic resurgence, which was also evident in the popular vote, including the referendum on the monarchy, the elections of a constituent assembly on 2 June 1946 and the general elections of 18 April 1948.

The country was split by political divisions, however, and the privations suffered across the board could not but affect the cultural climate. The themes of ethics and social responsibility dominated over those of aesthetics, leading to the emergence of neo-realism. Film directors, writers, artists and photographers abandoned the route of artistic experimentation *tout court* in order to record post-war Italy in a cold, disillusioned manner. As the critic Salvatore Guglielmino wrote, there was a hunger for reality, 'that pressing reality which is there for all to see'.

With the return of freedom, the press began to flourish once more. New weekly magazines emerged, including *L'Europeo* and *Oggi* in 1945, *Il Mondo*, founded by Mario Pannunzio, in 1949 and *Epoca* in 1950. *Tempo* was printed again from 1946. In a country where illiteracy was still high (in 1951 it ran to 13 per cent of those over six years old), there was a particular hunger for images. And it was the photographers who responded most specifically to this need. Professionals and amateurs, Italians and foreigners travelled the length and breadth of Italy, recording the joy of new-found liberty alongside the struggles to build a new life, the ruins and the return to work, the martyred landscapes and the surviving wonders. This was a great people's project, one which set out to recount what was happening in the country through the pages of newspapers, the earliest photography books and the work of the new photographic groups. **G.F.**

Federico Patellani The Lazio Countryside, 1945

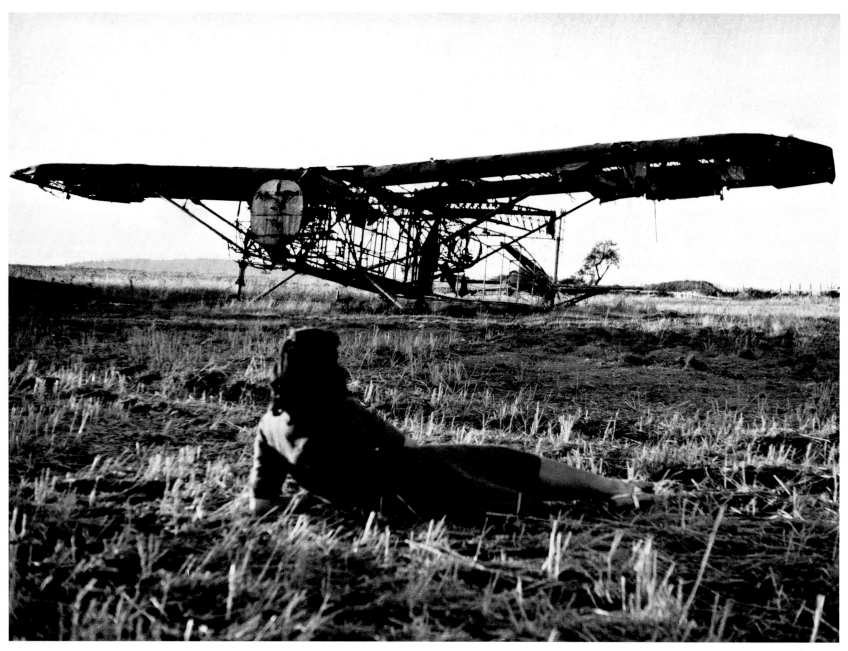

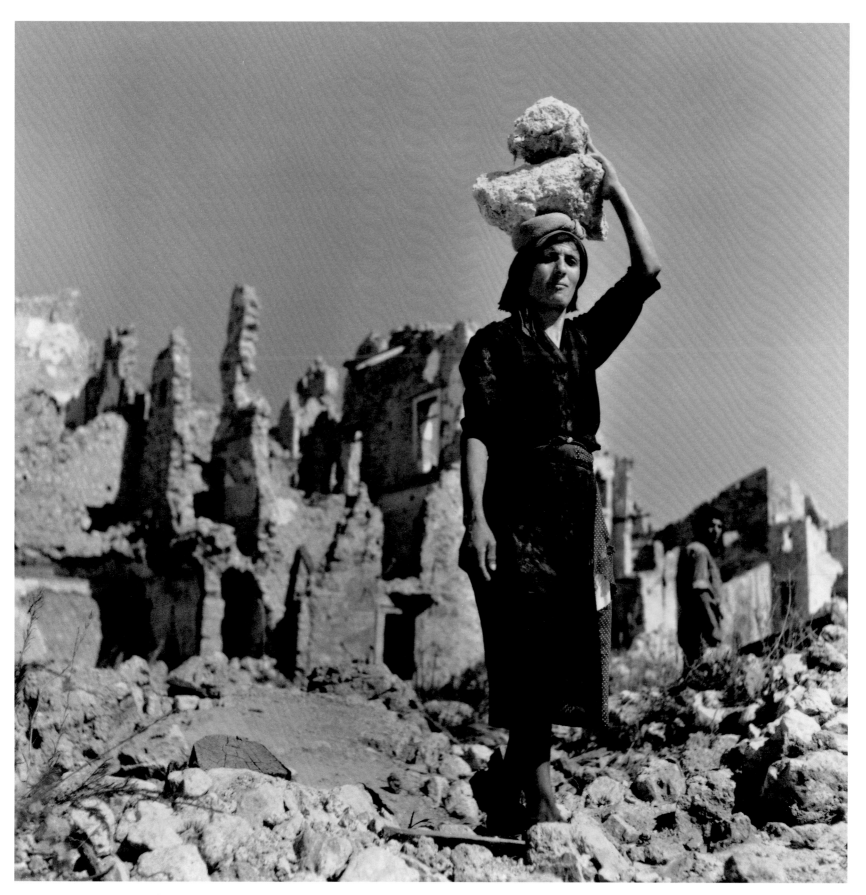

Giuseppe Cavalli A Girl Alone, 1940s

Francesco Giovannini The Date, 1948

Herbert List Trastevere, Rome, 1953

Tino Petrelli Elections, Milan, 1948

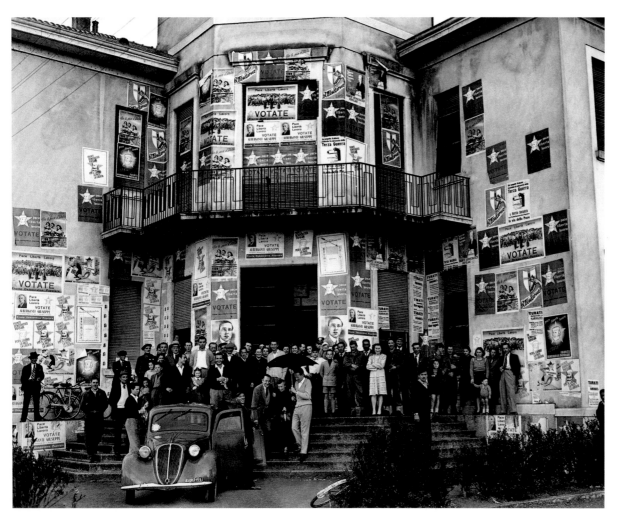

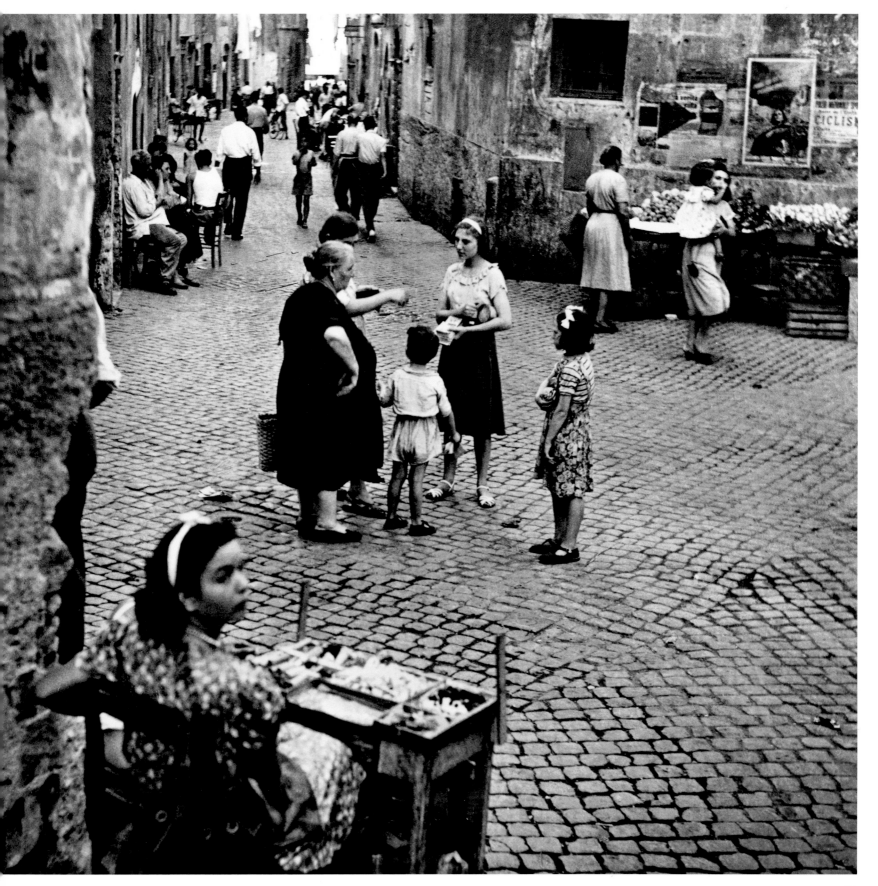

Mario Cattaneo Naples, 1950s

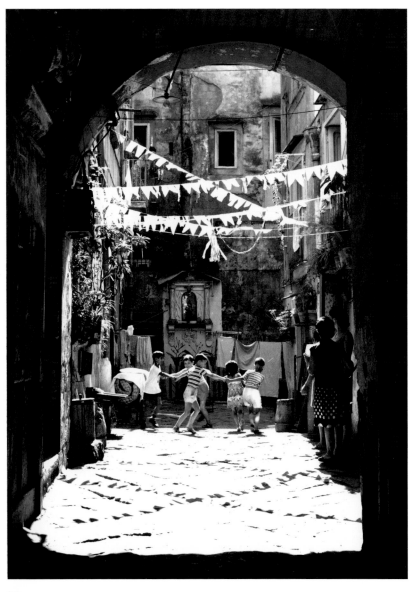

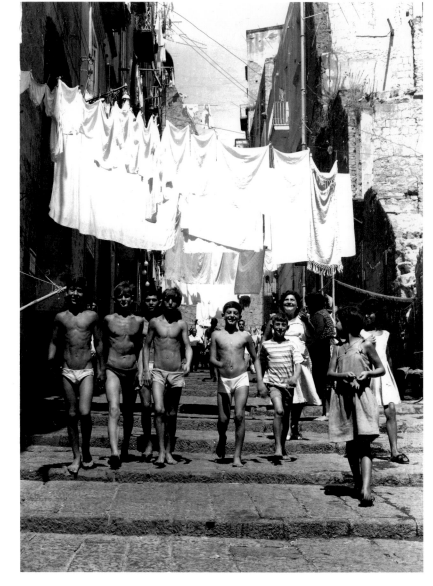

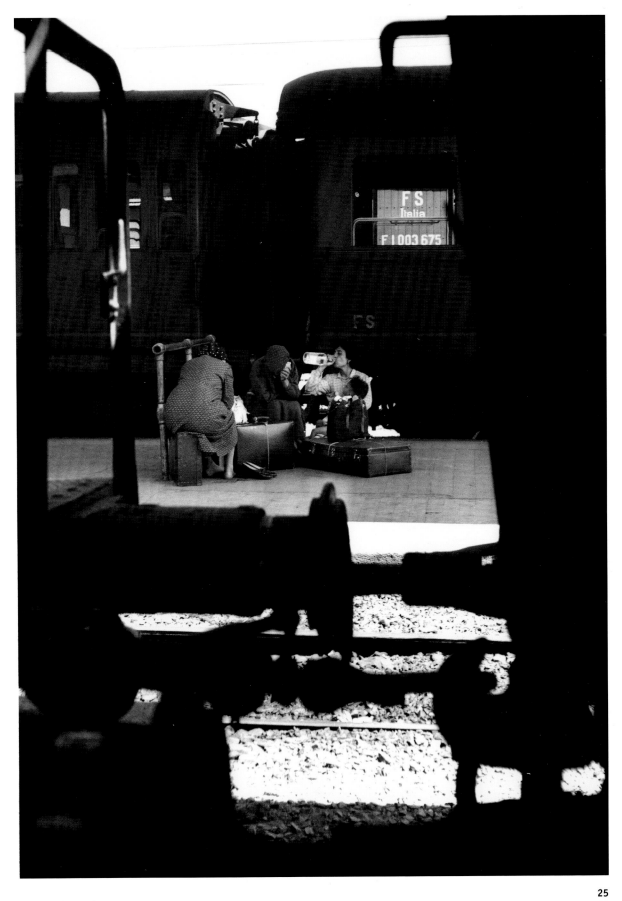

Pietro Donzelli Emigrants at Rovigo Station, 1953

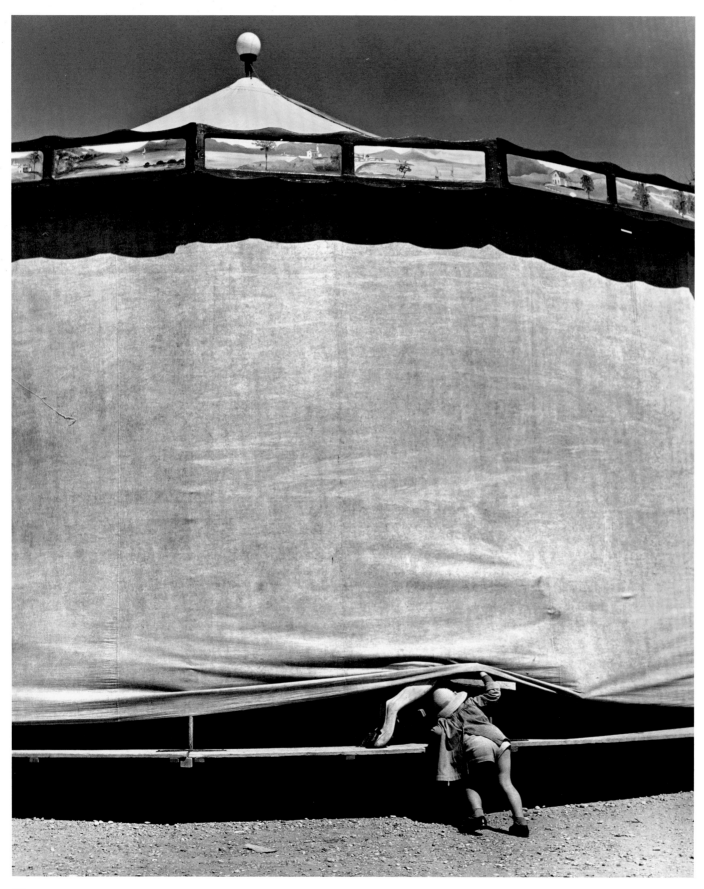

Fulvio Roiter Meolo, 1950

Toni Del Tin Sad Carnival, Venice, 1954

Tino Petrelli Polesine, 1959

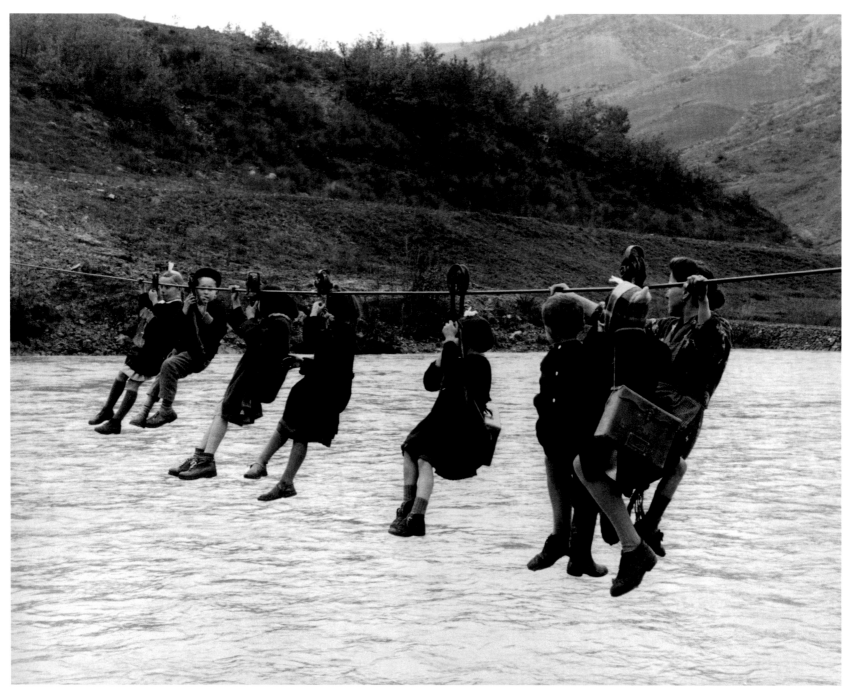

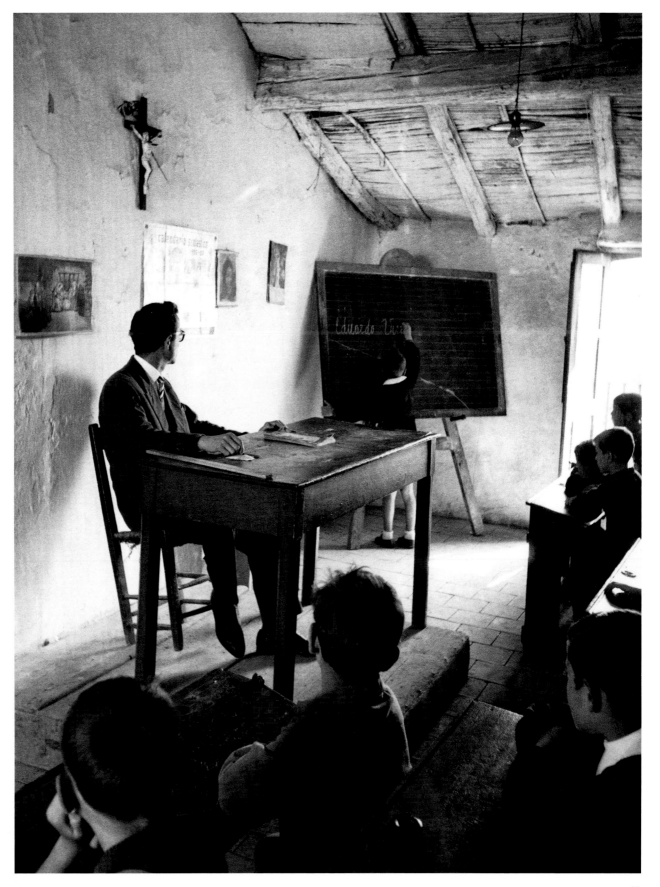

Mario **De Biasi** School in Rocca Imperiale, Calabria, 1954

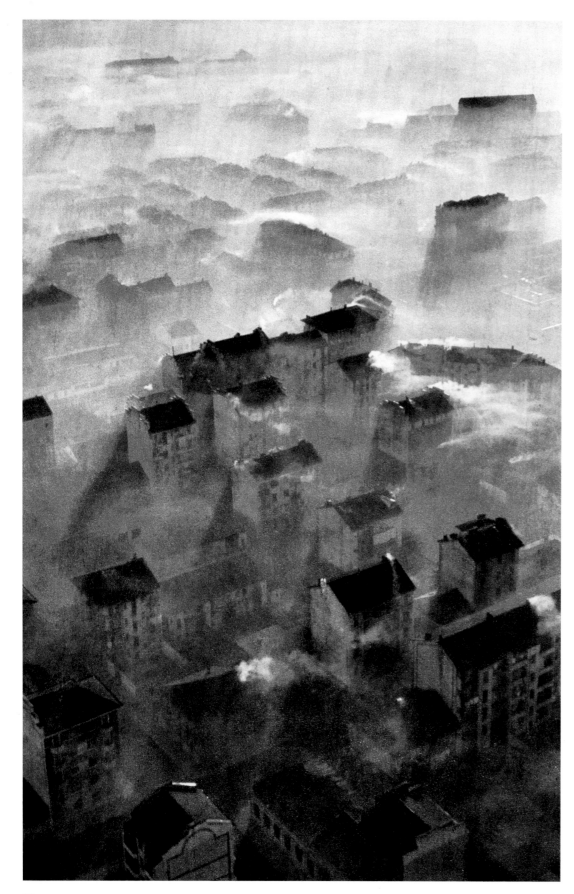

Riccardo Moncalvo Cold Morning, Turin, 1955

Enrico Pasquali Transporting Wood, Spinello, Forlì, 1955

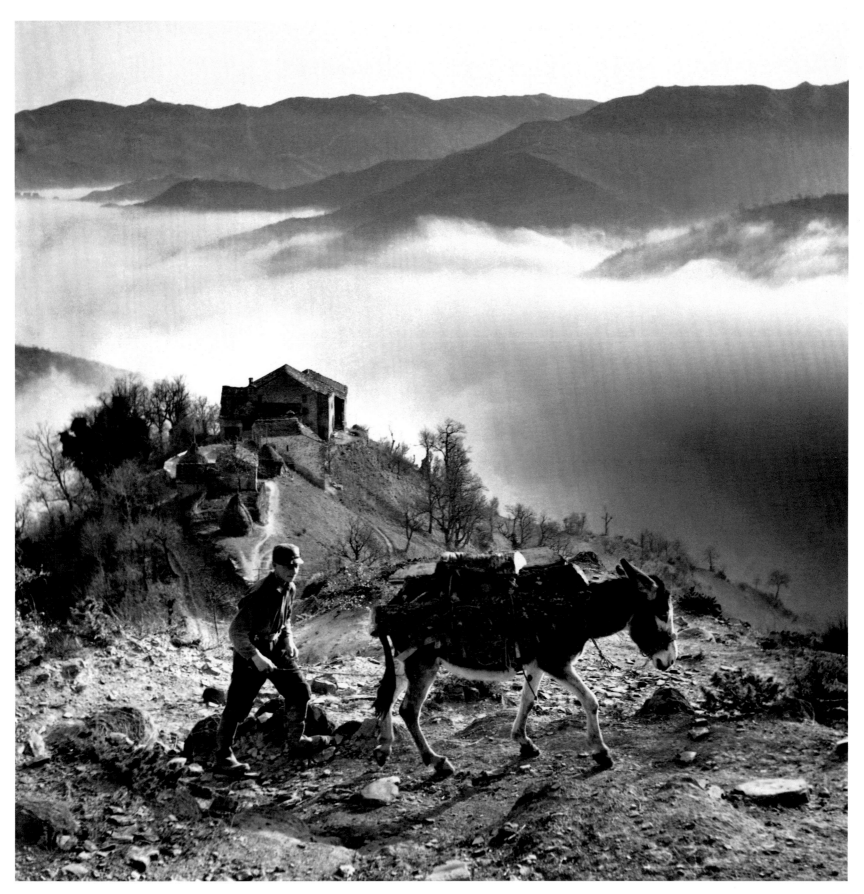

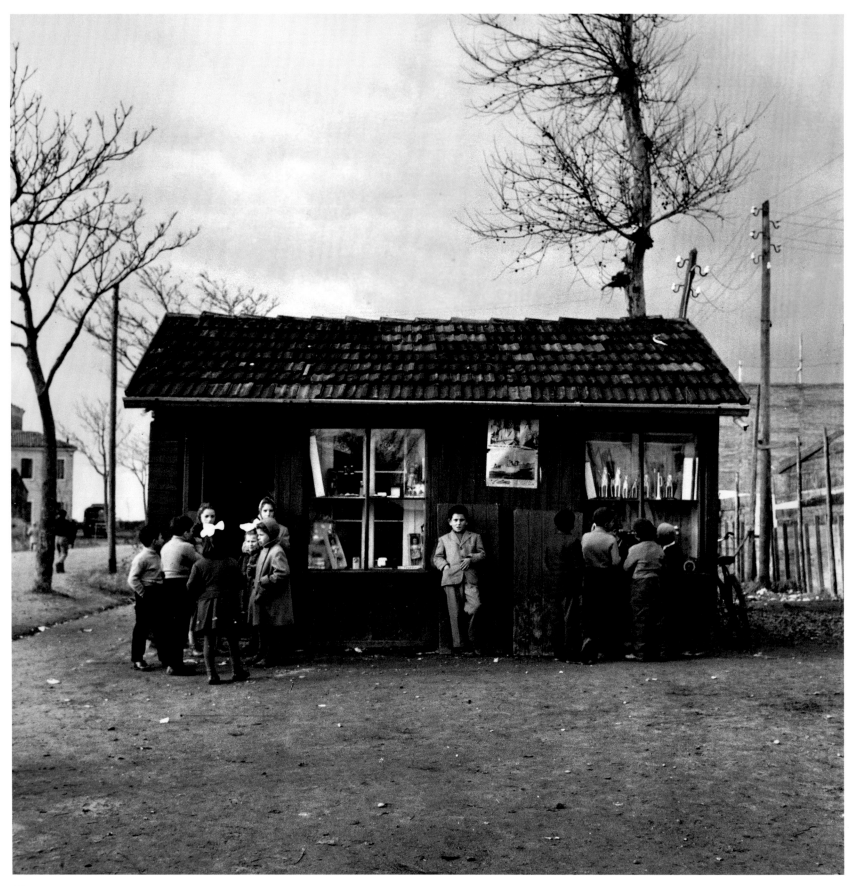

Nino Migliori The Po Delta, 1956

Gianni Borghesan Casamatta, 1954

Paolo Monti The Naviglio Grande past San Cristoforo, Milan, 1953–56

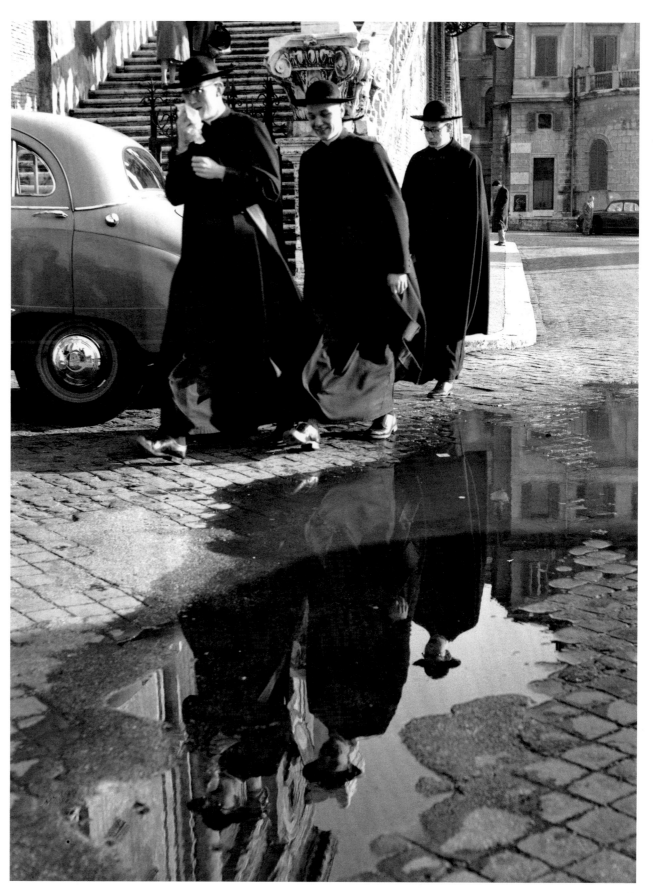

Tazio Secchiaroli Trinità dei Monti, Rome, 1956

Depicting the Miracle

The ghosts of the Second World War began to fade and, by the second half of the 1950s, an unprecedented economic expansion was changing the face of Italy. During the period of the 'economic miracle', the gross national product was growing by an average of 6 per cent, per capita income almost doubled and unemployment reached a record low. The economic balance had been reversed and by 1961 industry became the chief sector of employment (37.4 per cent of the total working population), followed by the tertiary sector and public administration (32.2 per cent) and agriculture (30.4 per cent).

The 'boom', however, exacerbated the gap between the North, which enjoyed extraordinary expansion, and the disadvantaged areas of the South, still tied to a peasant economy. Driven by both need and the lure of the city, hundreds of thousands of people emigrated towards the industrial centres of Northern Italy, which were unable to absorb such a high volume of immigrants and began to grow out of control.

The outskirts of the cities were transformed into dormitory suburbs, lacking in services and green spaces, grey backdrops for stories of degradation and marginalization. During the course of the decade, the population of Milan grew by 25 per cent, while that of Turin increased by 43 per cent. It was not simply a matter of numbers: while the South held onto its own traditions, culture and old social structures, everyday life in the big cities appeared to be radically transformed by the wave of modernity and the trappings of consumerism.

Electrical goods, cars and television were the shining symbols of the 'Italian miracle'. The population took to the roads en masse: in 1955 Fiat came out with its new car, the 600, while the following year Piaggio produced the millionth Vespa scooter and 1957 saw the debut of another legendary automobile, the Fiat 500.

As the cities began to experience the problems of traffic congestion, a motorway network was planned to guarantee swifter links between the different regions. More importantly, however, the unification of the country was achieved through television, which bypassed the many cultural and linguistic barriers that still divided Italians, and became an increasingly central part of their lives and collective imagination. The public television company, RAI, began broadcasting on 3 January 1954. It became phenomenally successful, and a second channel was introduced in 1961. Cinemas and other public venues were filled with people eager to watch the most popular programmes: the quiz show *Lascia o Raddoppia?* (Double or Quits?), the promotional cartoons of *Carosello* (Carousel) and the Festival of Sanremo, which was the showcase for Italian popular music from Nilla Pizzi and Domenico Modugno to Adriano Celentano and Luigi Tenco (who killed himself during the festival of 1967).

Television was not everything, however. Cinema was establishing itself, its stars becoming the preferred 'victims' of a new generation of forceful photographers: the 'paparazzi'. Important magazines and newspapers came onto the scene, including *L'Espresso* in 1955, which employed a group of animated freelance photographers driven both by passion and a striking civic commitment. In 1956, *Il Giorno* became the first daily newspaper to employ a permanent photographic staff, and in 1962 *Panorama* became Italy's first news magazine.

In the same year, a law was introduced making it obligatory to stay in school until the age of fourteen. People daydreamed while reading *The Leopard* by Giuseppe Tomasi di Lampedusa or watching Federico Fellini's *La dolce vita*. Italy was richer, but it was also more cultured. **G.F.**

Arno Hammacher Building the Pirelli Building, Milan, 1958

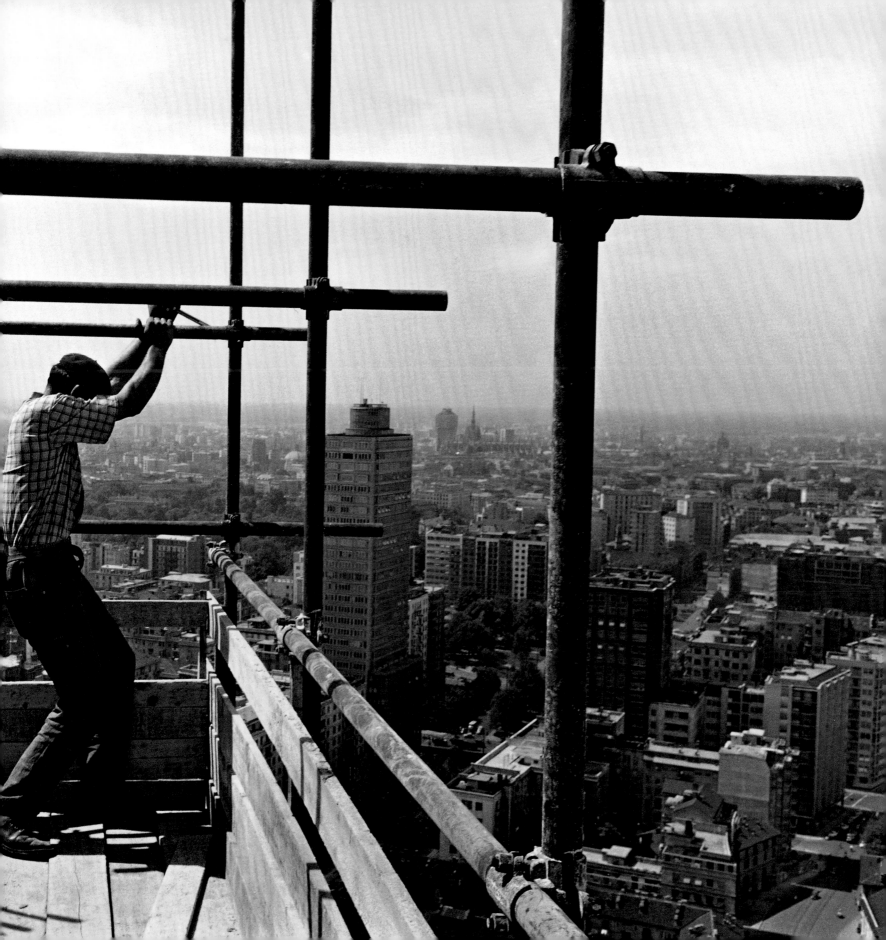

Caio Garrubba Naples, 1956

Giancolombo Carpi, 1956

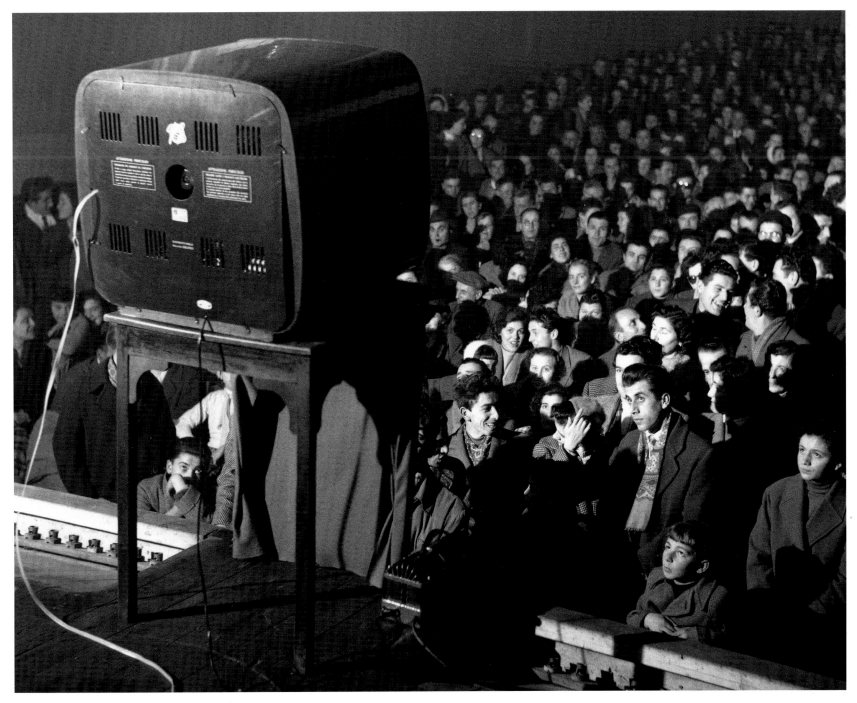

Mario De Biasi Milan, 1954

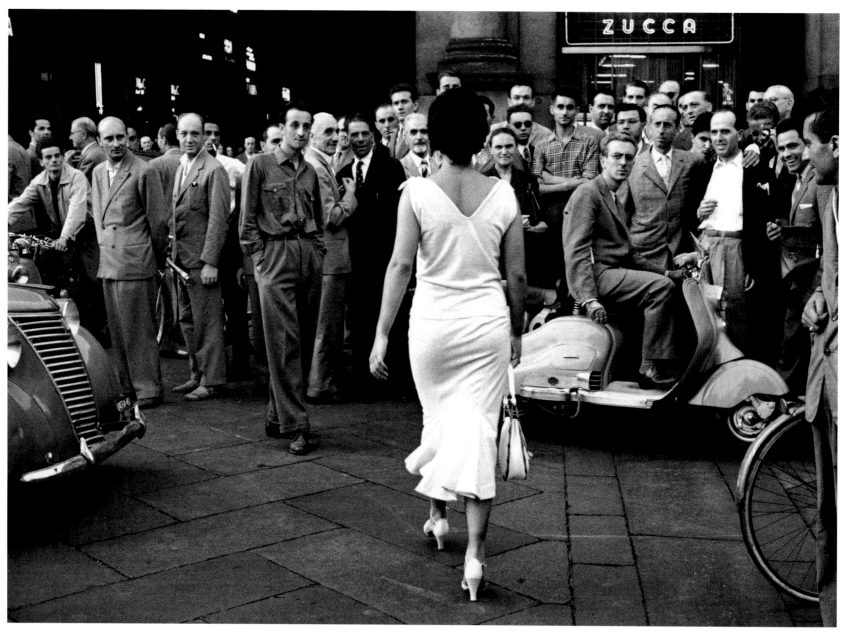

Federico Garolla Sorelle Fontana Fashion House, Rome, 1955

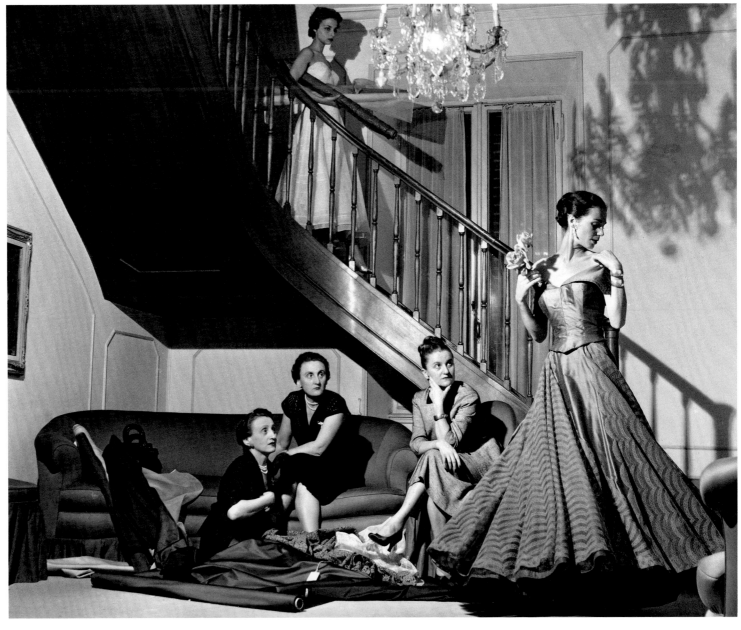

René **Burri** Street Theatre, Naples, 1956

René **Burri** Street Theatre, Naples, 1956

René **Burri** Street Theatre, Naples, 1956

René Burri Pompeii, Naples, 1956

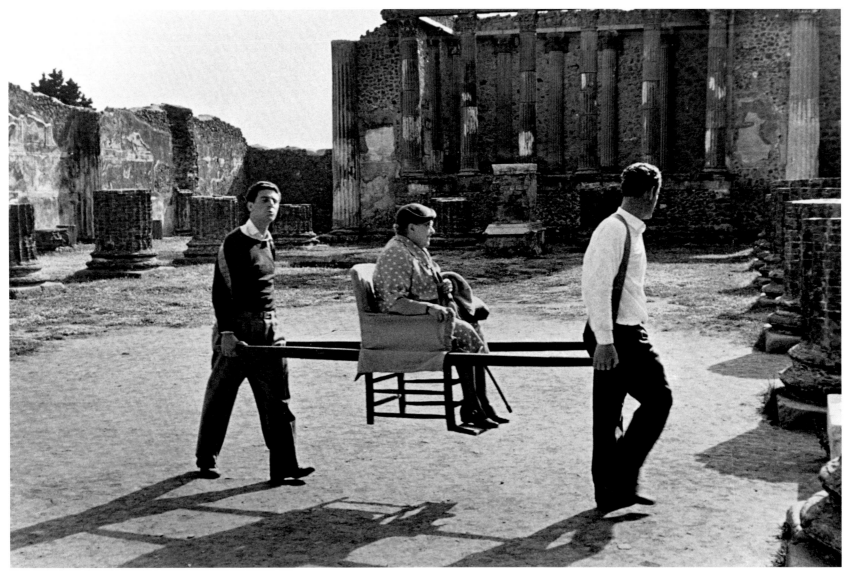

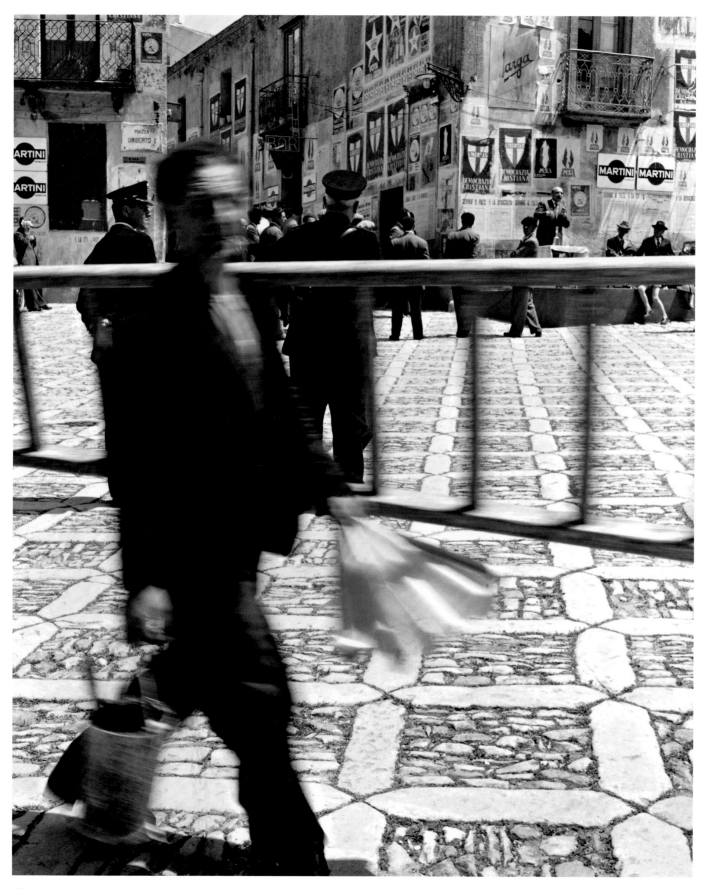

Alfredo **Camisa** Elections in Erice, 1955

46

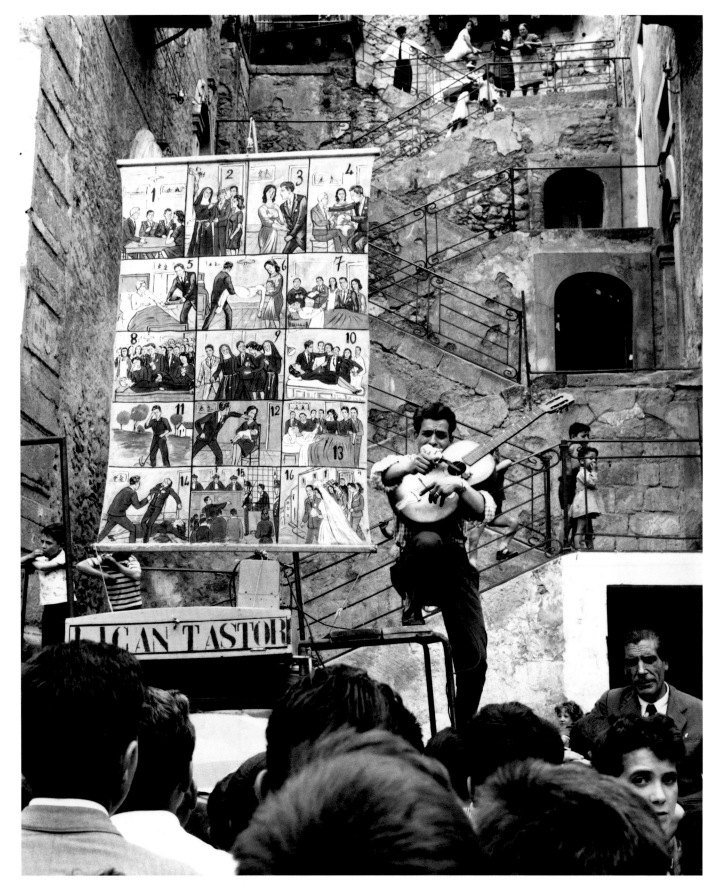

47

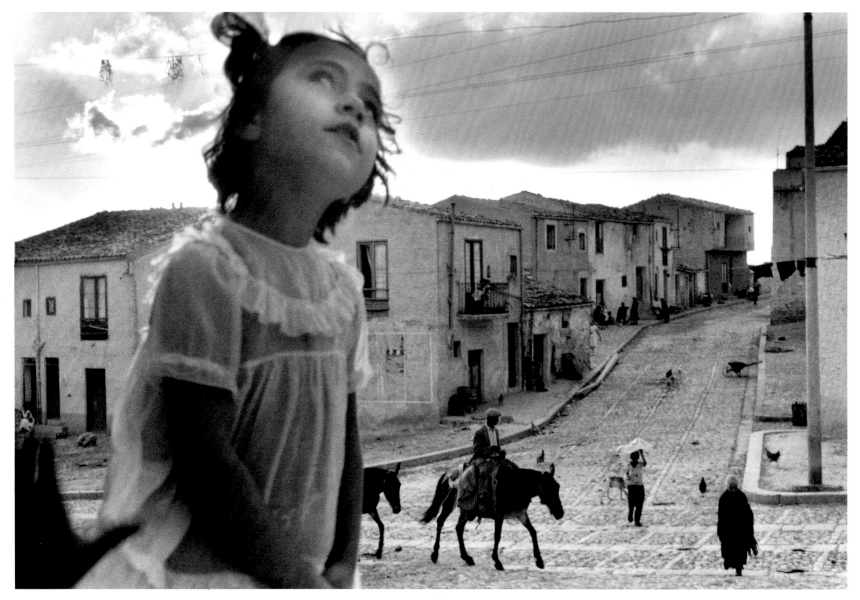

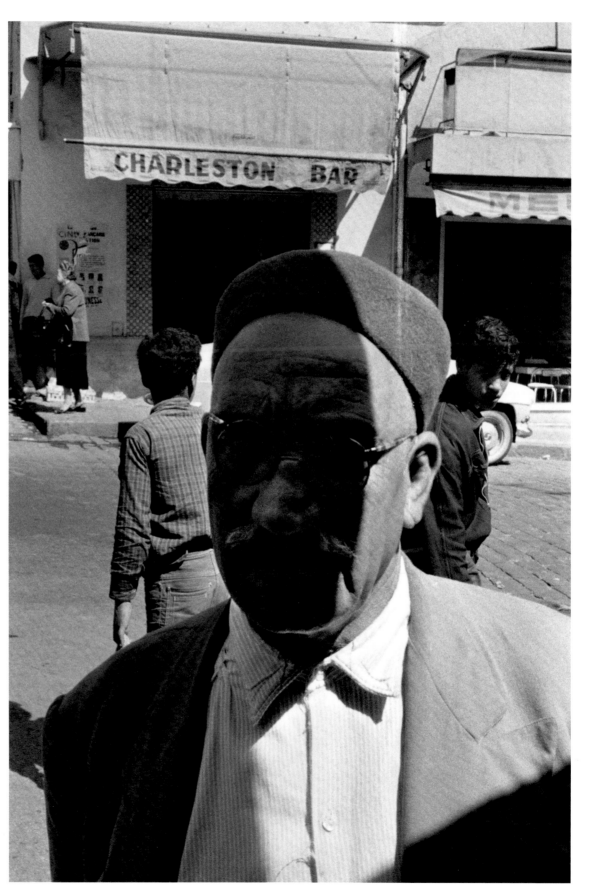

Enzo Sellerio Palermo, 1962

Franco Pinna Lula, Nuoro, 1961

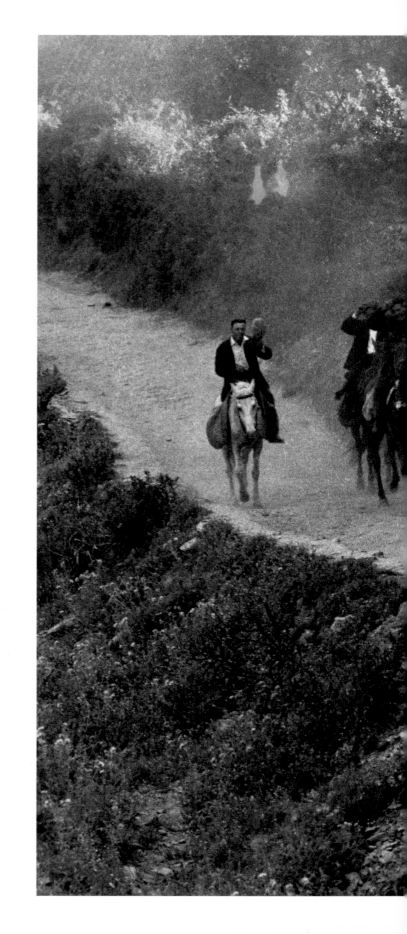

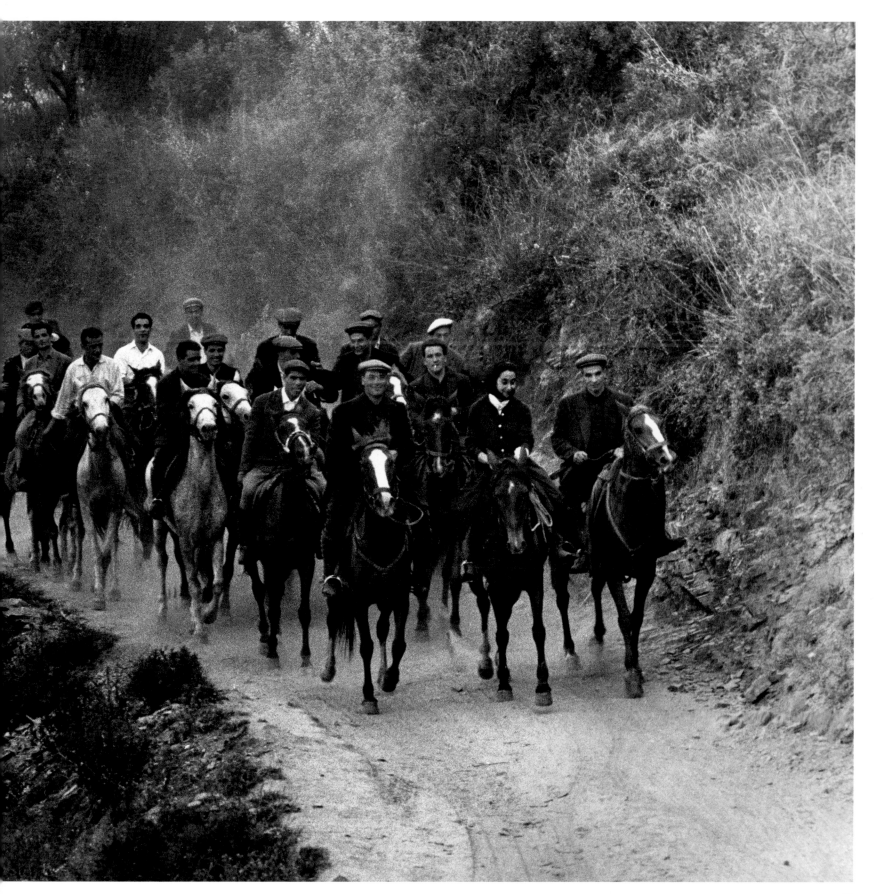

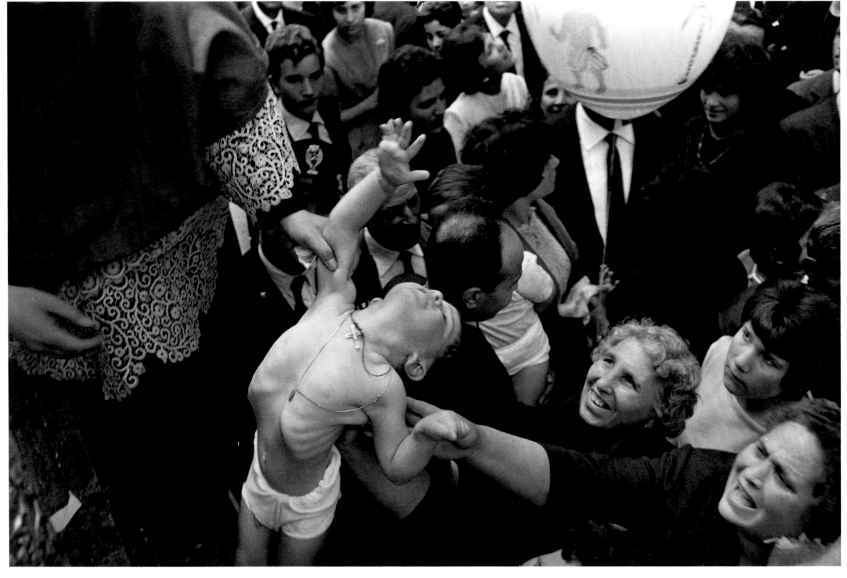

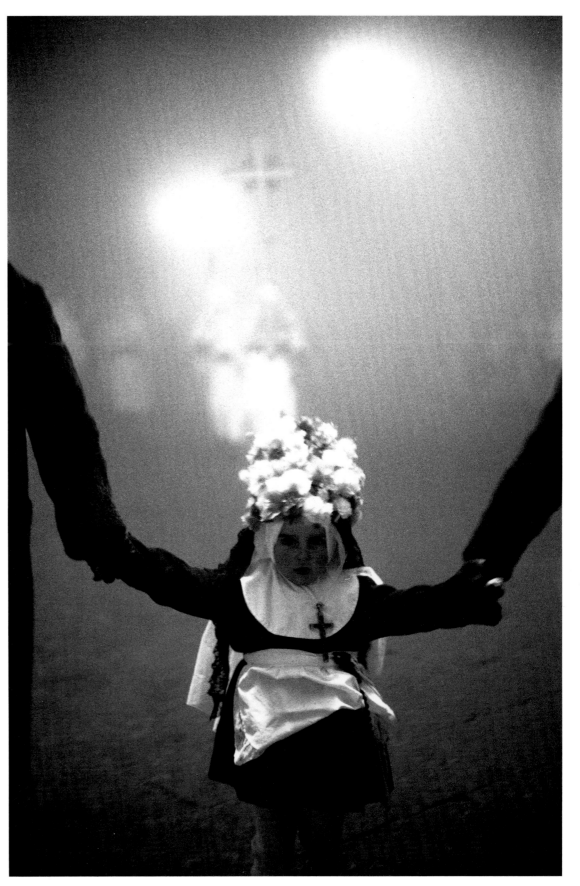

Gianni Berengo Gardin Venice, 1960

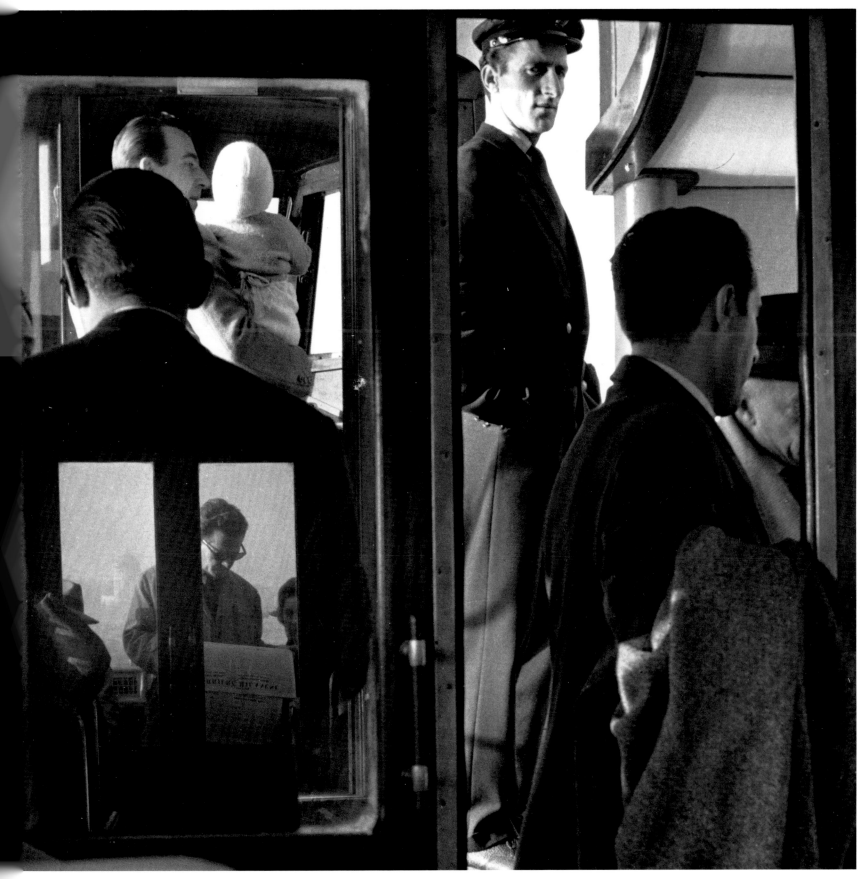

Bruce Davidson Sicily, 1961

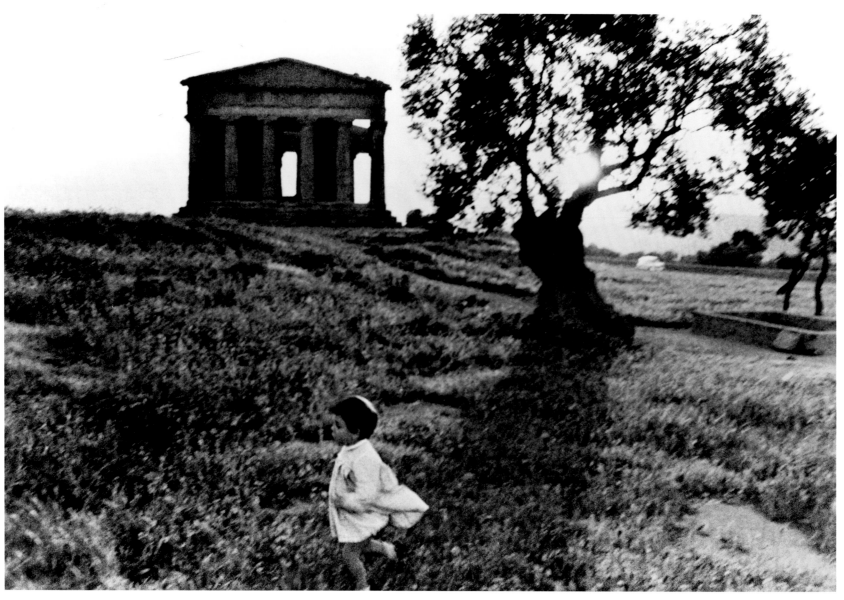

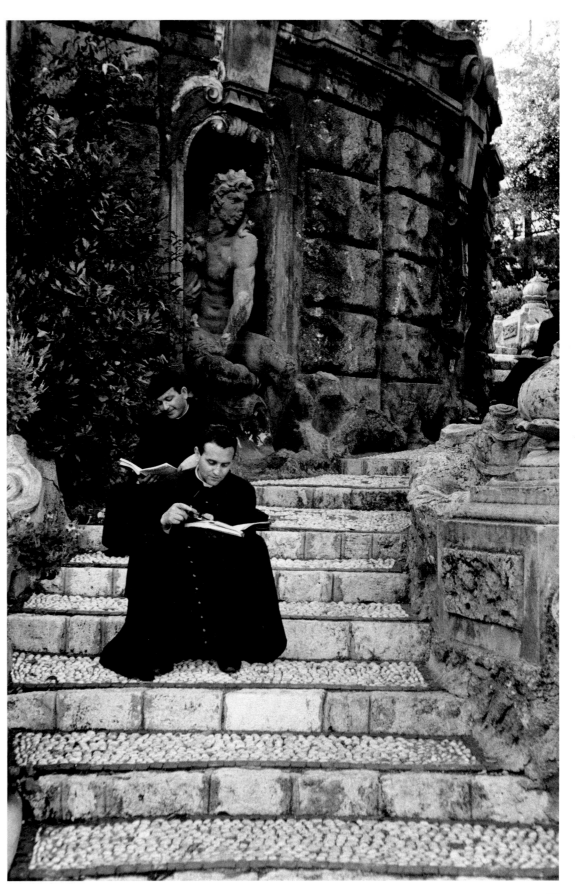

Eve Arnold Vatican, Rome, 1967

Enzo Sellerio Palermo, 1960

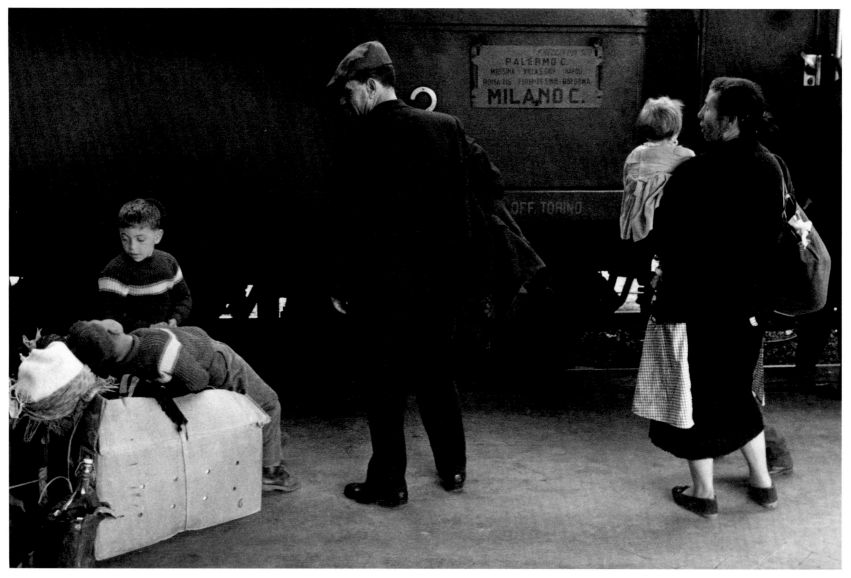

Walter Battistessa Immigrants in Milan, 1969

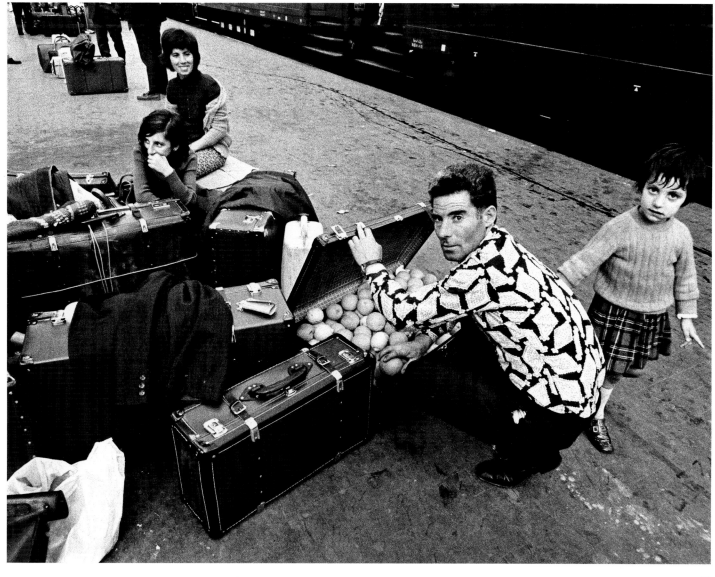

Toni Nicolini Fashion Show in Via della Spiga, Milan, 1969

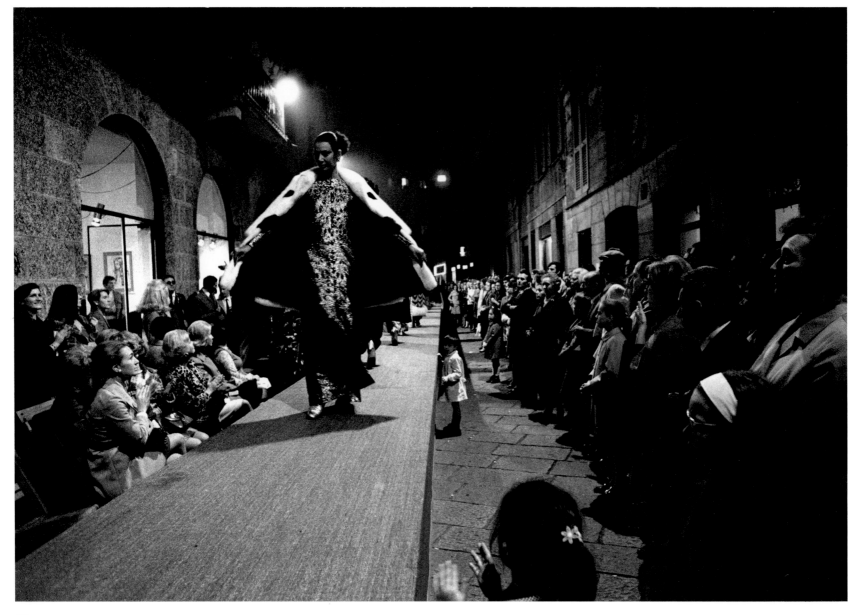

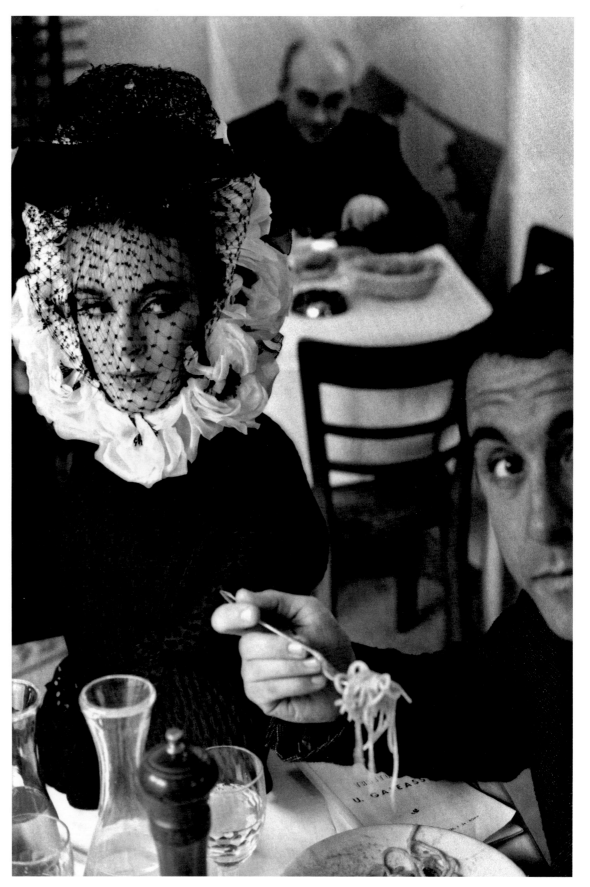

Frank Horvat Fashion Shoot for *Harper's Bazaar*, Rome, 1962

63

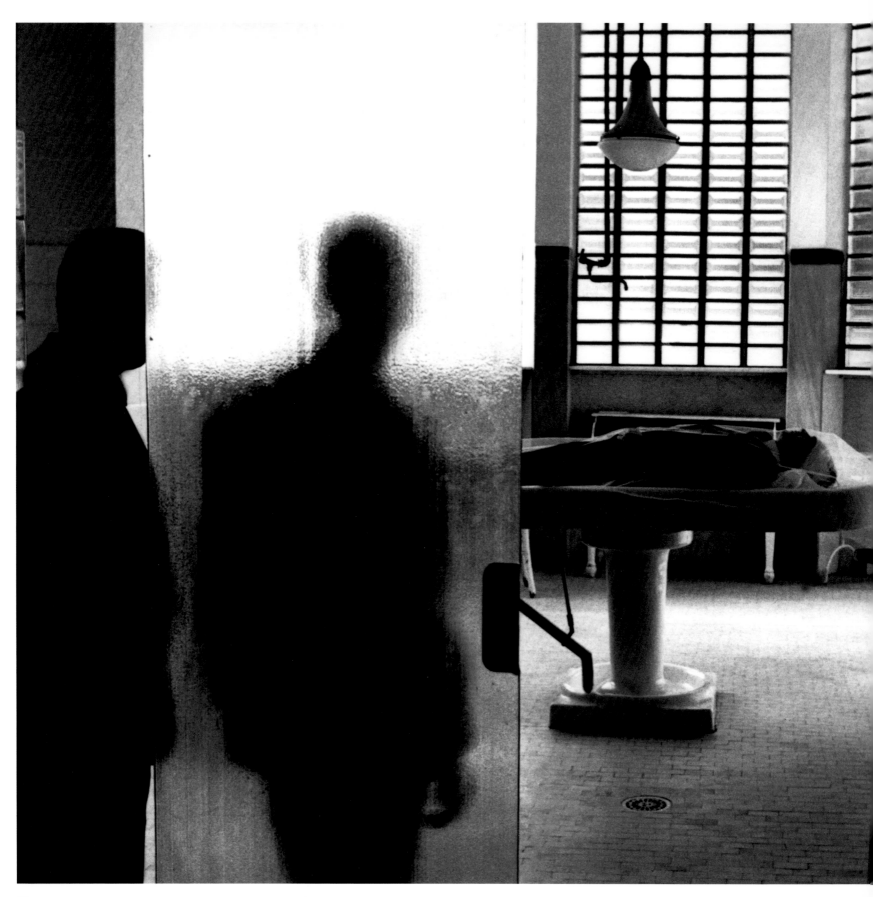

The Years of Experiment and Commitment

The economic boom, which had reached its peak in the first years of the 1960s, gradually receded and Italy began to show signs of depression in all aspects of society. The tide of revolt that started in the United States, which was at war in Vietnam, soon took Europe by storm. There was a strong desire for change, and in Italy the universities of Turin, Trent, Pisa and Milan became the focus of youth protests. On 1 March 1968, in the gardens of Valle Giulia in Rome, there were violent clashes between students and police, and schools and universities were occupied in every big city. The disaffection spread to the workers, and the ensuing union struggles culminated in the mass strikes of the so-called 'Hot Autumn' of 1969.

Along with the marches and protests, suddenly there was bloodshed. At 4.37 p.m. on Friday 12 December, a bomb exploded inside the National Agricultural Bank in Piazza Fontana, at the very heart of Milan. Sixteen people died and eighty-seven were injured. Suspicion initially fell on the anarchists, but soon the focus of the investigation shifted to reveal alarming scenarios, which are not entirely clear to this day.

The massacre of Piazza Fontana was the dramatic prologue to a long season of violence, which racked the country and reached its climax in the kidnap and murder of the Christian Democrat prime minister, Aldo Moro, by the Red Brigades. On the streets, meanwhile, youth protests became increasingly bitter and radical, overshadowing the creative energy that had characterized the second half of the 1960s.

This was the decade in which politics seemed to pervade every aspect of life, both public and private. The nation discussed and was divided on the big issues of the day, such as divorce, women's liberation and abortion. At the same time, the economy was suffering from worrying stagnation, with inflation at more than 20 per cent and unemployment running high.

It was a time of crisis and social conflict. The dominant feeling of disquiet also underpinned the creative enquiries of photographers, artists and intellectuals, as they sought to capture a world in flux. The year 1968 was a defining moment of idealism and commitment, characterized by the rejection of the politics and culture of the past, a period which lasted longer in Italy than any other European country. Out of this unrest, a new generation of photographers emerged, speaking a language of aggression and innovation. A new type of criticism developed alongside this, which prompted artists such as Ugo Mulas and Franco Vaccari to explore the meaning of the medium itself. Marcella Campagnano used images as a means to reflect on the condition of women, while Roberto Salbitani created an urban landscape invaded by advertising. The range of issues increased and the foundations were laid for what would follow, as photography gradually defined itself as an instrument of artistic expression. **G.F.**

Cesare Colombo The Galfa Building, Milan, 1968

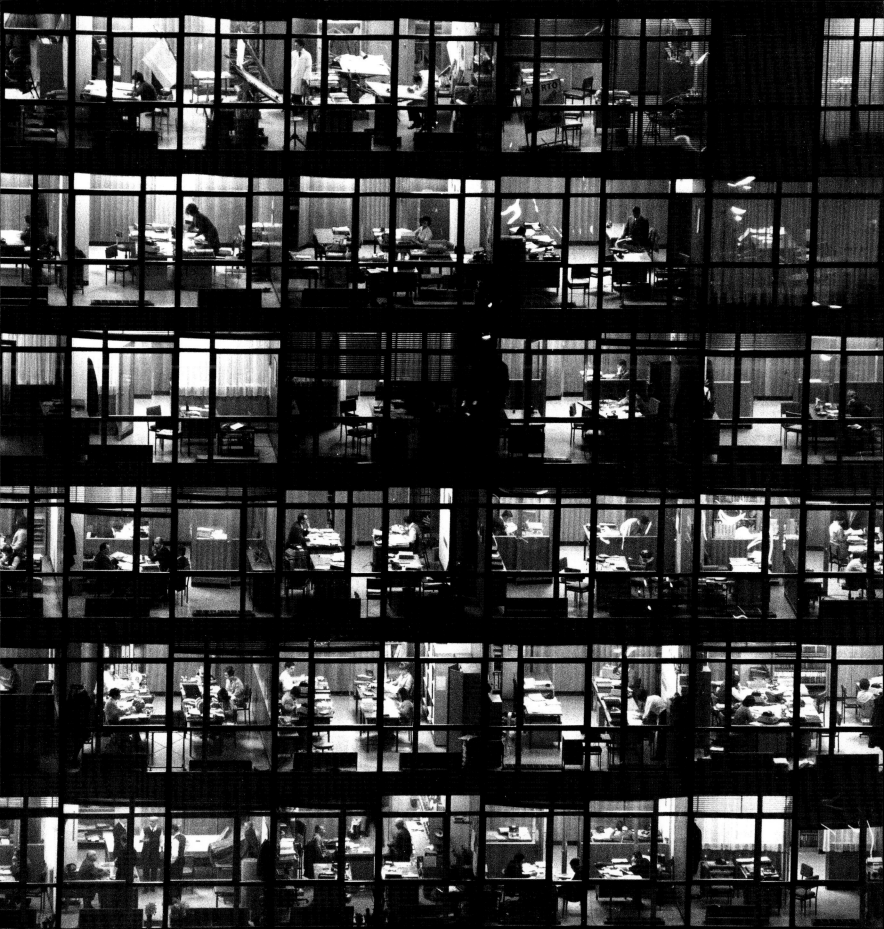

Giovanna Borgese Lunch Break for Workers at Falck Steelworks, Sesto San Giovanni, 1975

Uliano Lucas Gratosoglio District, Milan, 1973

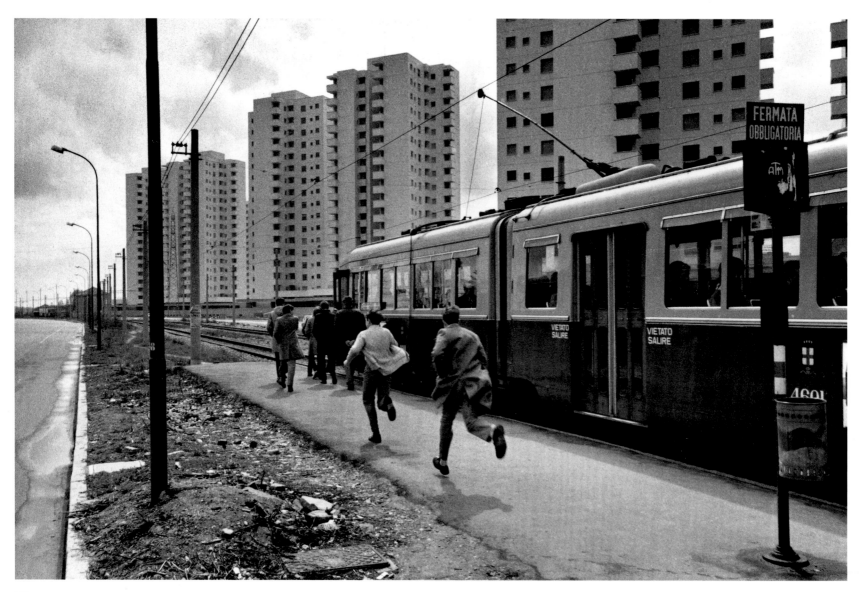

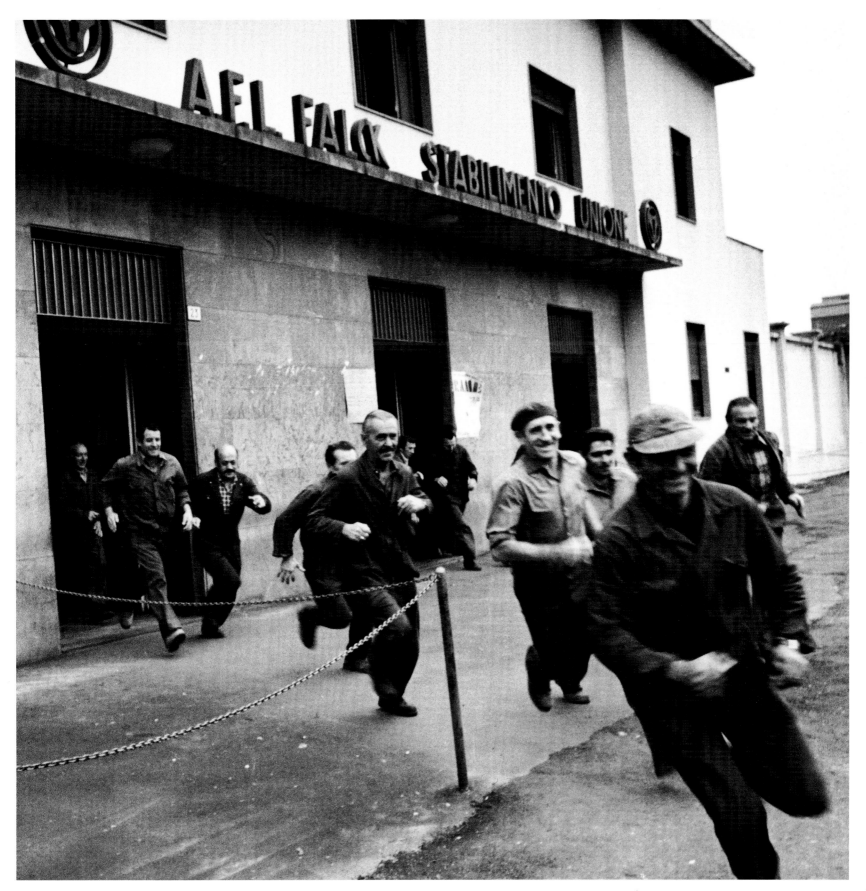

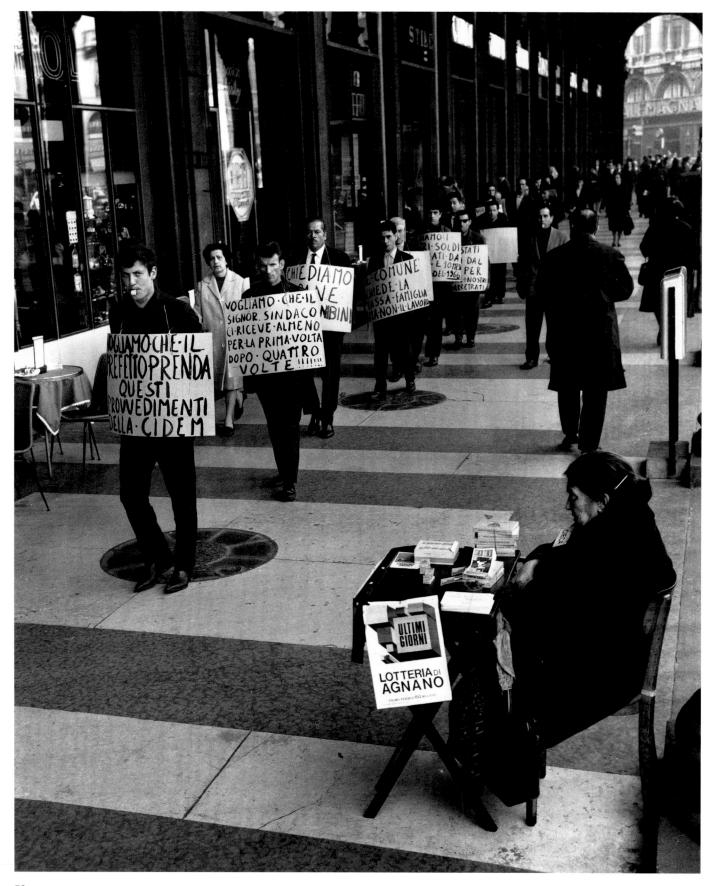

Silvestre Loconsolo Protest by Workers at a Metallurgical Firm, Milan, 1968

Piero Raffaelli Demonstration outside the Triennale, Milan, 1968

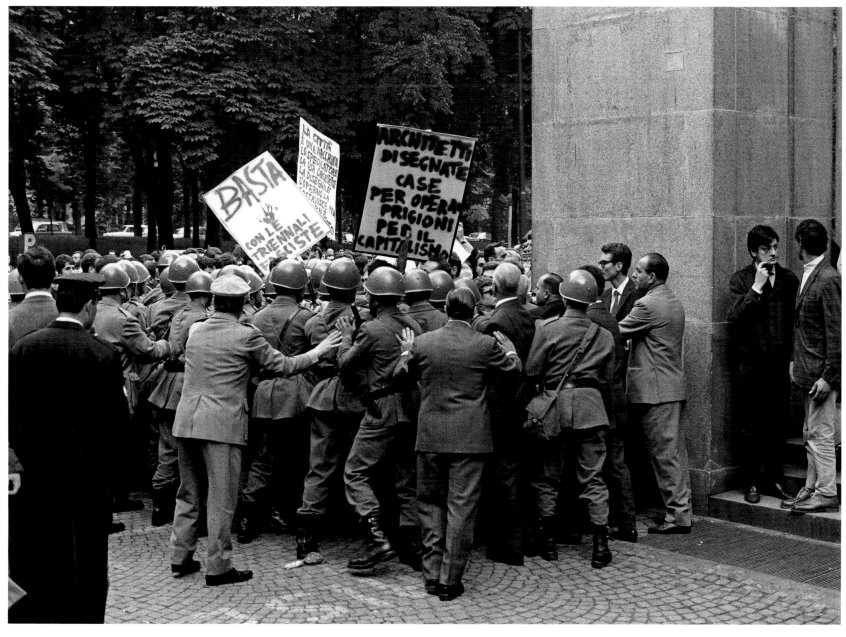

Roberto Salbitani Corso del Popolo, Padua, 1972

Ugo Mulas Verification no. 4, *The Uses of Photography*, for the Alinari brothers, 1971–72

Lamberto Vitali showed me some photos taken by the Alinari brothers, depicting King Victor Emanuel II. One in particular really struck me. Two images of the King appear on the same plate; they are practically identical, except that in one of them the King is shown more in profile. In actual fact, one of them has been touched up, the other not. The photographer has used a large plate for images which are actually quite small, measuring just a few centimetres, almost the size of a calling card. For convenience sake, and so as not to waste the plate, he has taken two photographs, in different poses, using two different apertures. The result is this double photo: on one side, the King appears proud and heroic; on the other, without the retouching, the King is old and has bags under his eyes, as if mummified with age. The presence on a single plate not only of two photos, but of two realities, is surprising, not least because the person depicted is a king, a symbol of power.

We are presented with two images which appear similar but are in reality opposites, as if they represent truth and the falsification of that truth. This is the true purpose of photography. On the one hand, there is the true story, which stays in the archives; on the other, there is the embellished one, captivating, pleasant, which is the one that is made public.

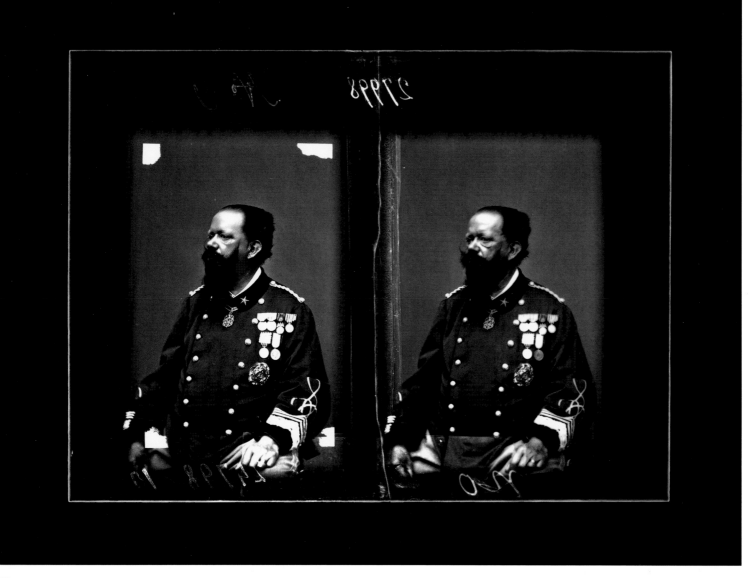

Ugo Mulas Verification no. 8, *Lenses*. For Davide Mosconi, photographer, 1971–72

Photographic manuals often include a sequence of photographs of the same view taken with different lenses: from the whole picture, one arrives at a small detail, through a series of successive transitions. What is given is a mechanical explanation, namely the ability of the lens to bring things closer or make them look further away, to reduce or enlarge the field. And yet the explanation should be understood above all in a linguistic sense: using a wide-angle or telescopic lens to reproduce the same image means giving two different interpretations. Using the first, the face is deformed in such a way as to create a caricature, because the parts in the foreground appear larger than they would through a normal lens, while the parts furthest away seem blurred or even eliminated. Using the second, all elements are represented on the same plane, and the protruding parts are aligned with the background, with the result that they are emphasized, or favoured. The face, the person, the pose, are the same in both images, but the two photos are profoundly different.

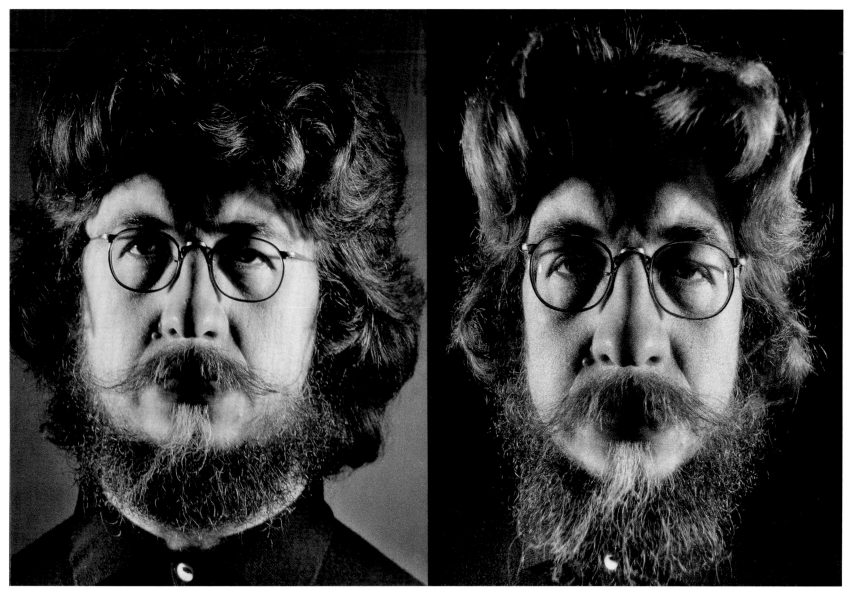

Marcella Campagnano Inventing Femininity: Roles, 1975

Aldo Bonasia Milan, 11 March 1972

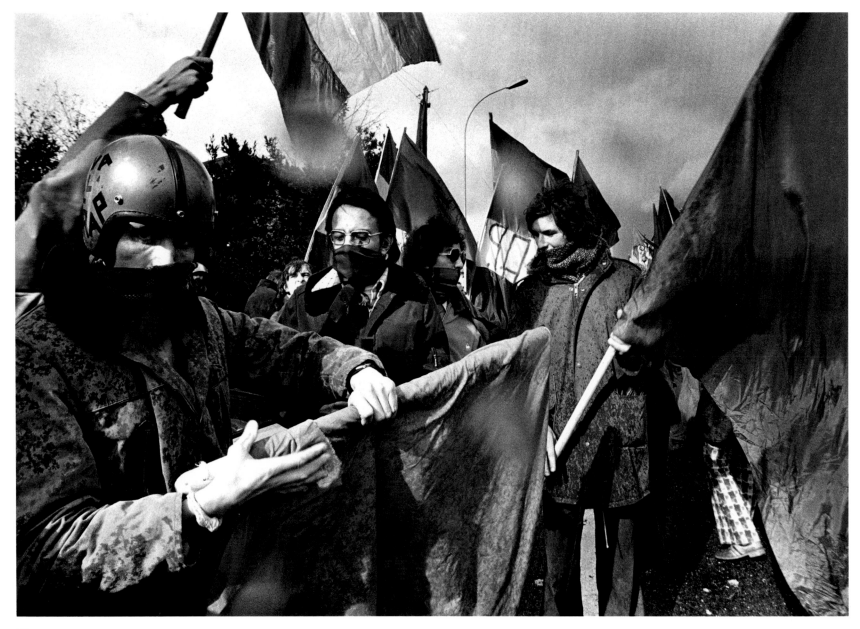

Aldo Bonasia Milan, 11 March 1972

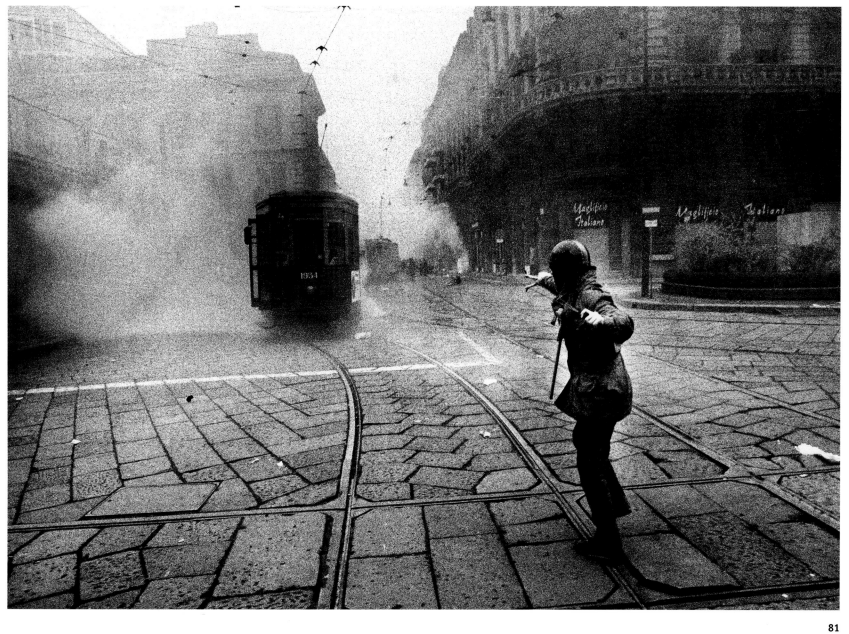

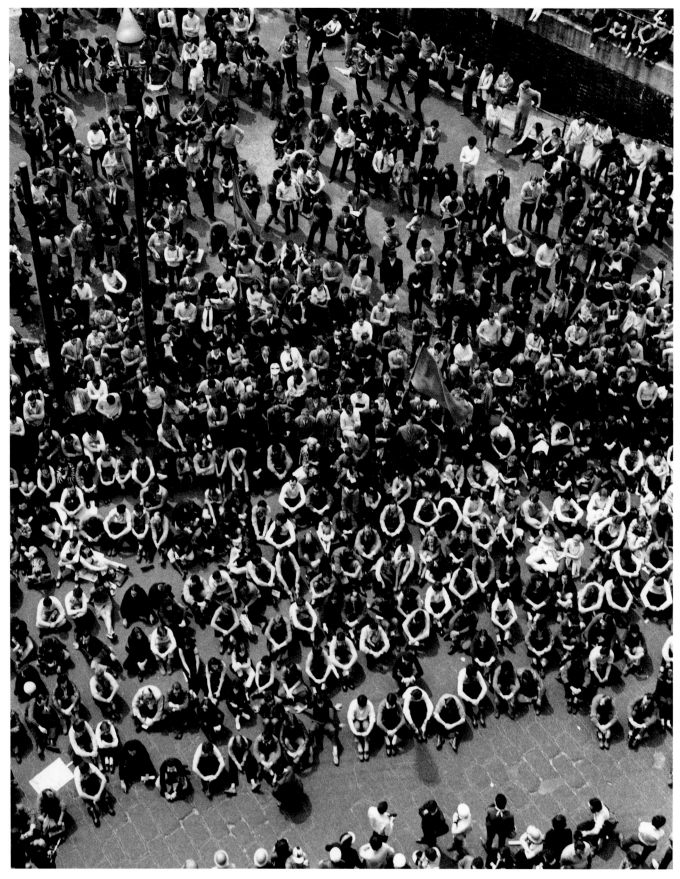

Uliano Lucas Student Strike, Milan, 1974

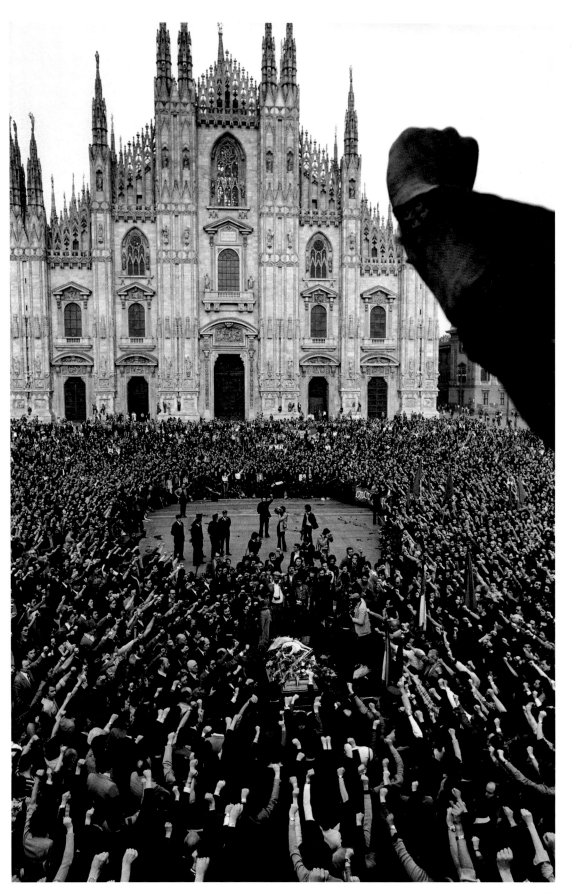

Francesco Radino *Funeral of Giannino Zibecchi, Milan, 1975*

Mauro Galligani Seveso, 1976

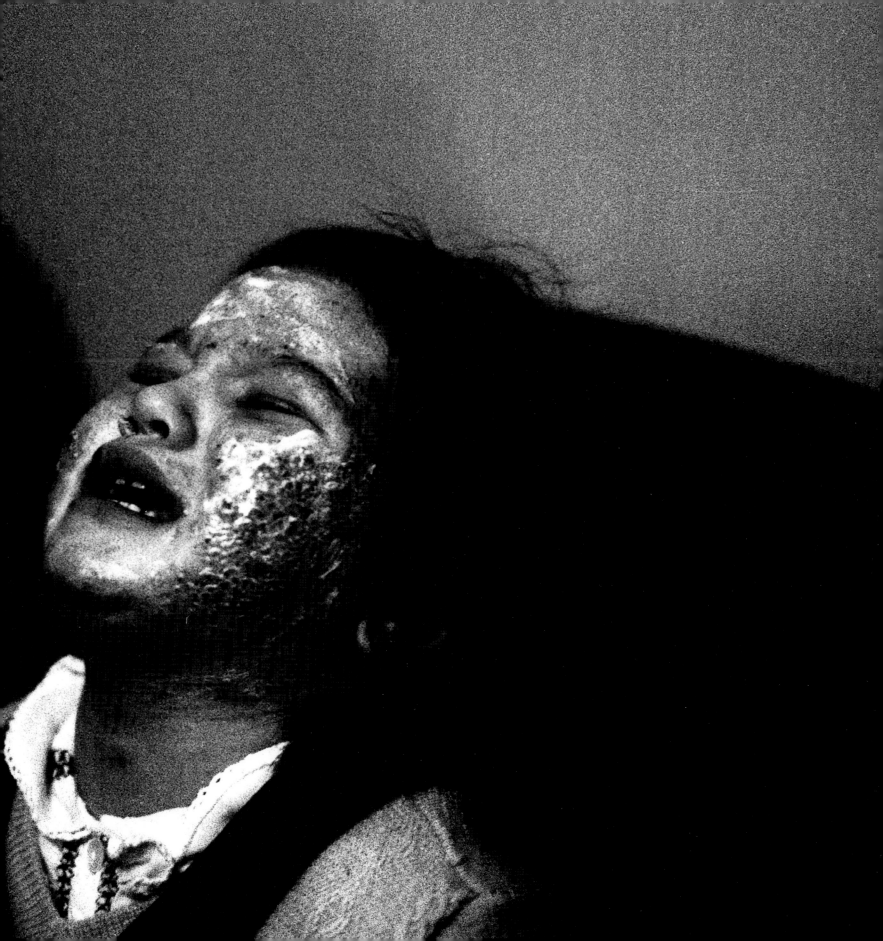

Toni Nicolini Non-Authoritarian Nursery, Milan, 1976

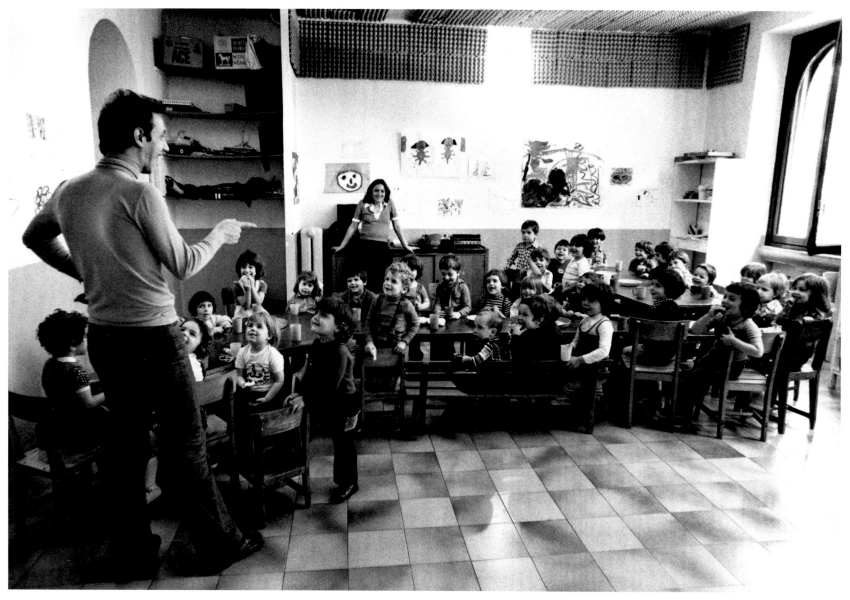

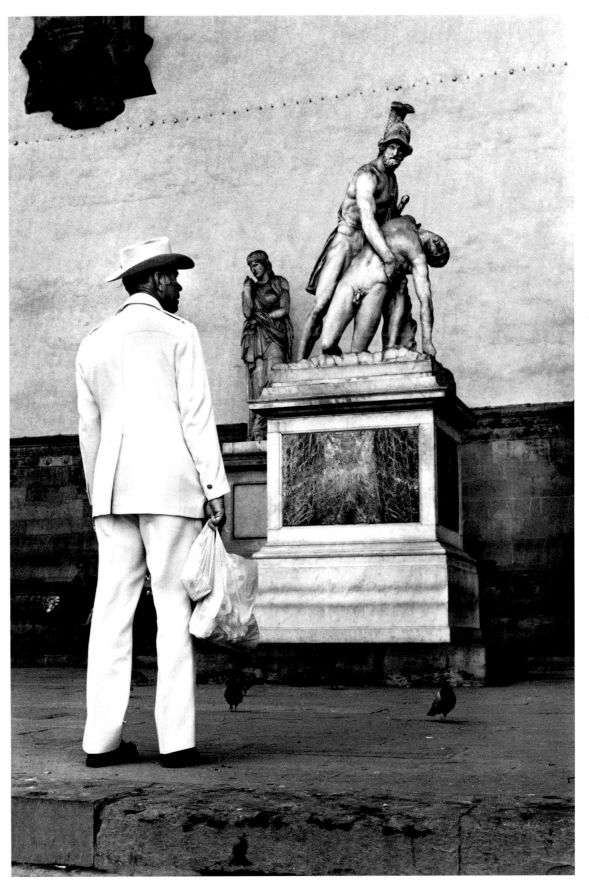

Roberto Koch After the Earthquake in Irpinia, Balvano, 1980

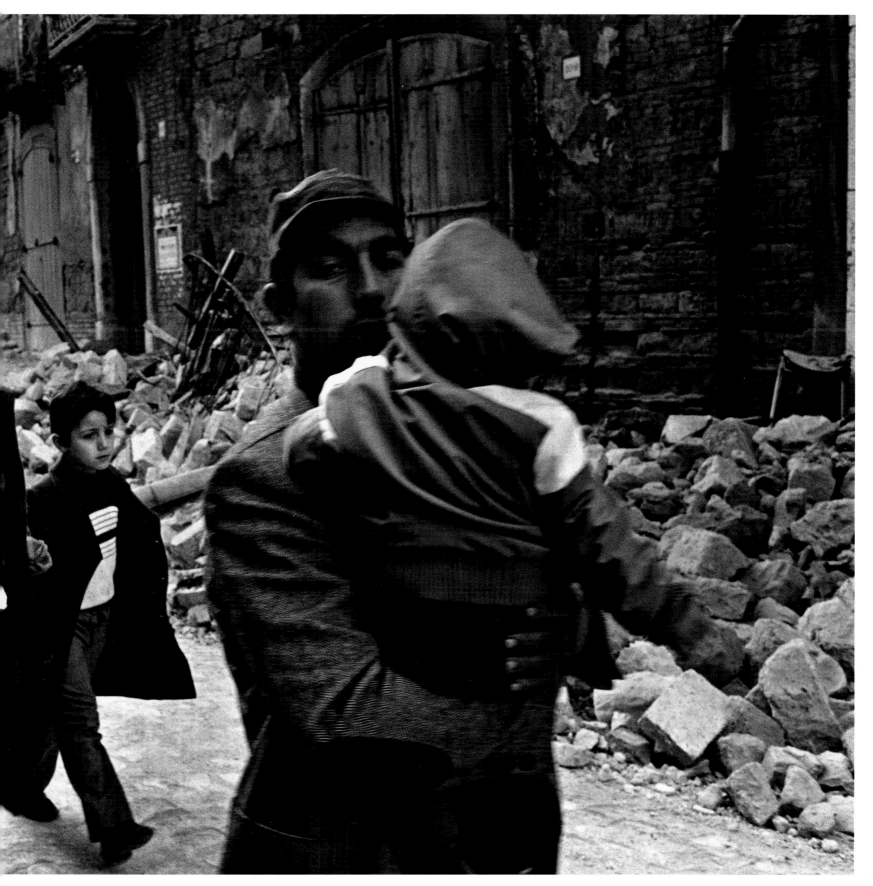

The 1980s

The 1980s represented a new era for Italy, in which the country would enjoy economic growth and widespread prosperity. At the beginning of the decade, however, it seemed as if nothing had changed. Fiat was in crisis and the resulting wave of redundancies provoked strong reactions from the unions. On 27 June 1980, an Itavia DC9 exploded in mid-flight over the sea of Ustica, off the coast of Palermo, killing eighty-one people. On 2 August, a powerful bomb ripped through the waiting rooms of Bologna railway station, leaving eighty dead and over two hundred injured. This latest episode in the dark 'strategy of tension' was the worst act of terrorism Italy had ever seen.

Still more rivers of blood flowed: the 'Years of Lead' might have been on the wane, and yet now, more than ever, the violence appeared desperate and unstoppable. The guns of the brigadists continued firing, along with those of the neo-fascist extremists, hitting journalists, lawyers and policemen. But this did prove to be the end of the line. Terrorism was quashed and the climate of fear did at last disappear – even though, almost at the same time, the Mafia reared its head once more and perpetrated a series of high-profile killings.

Economic conditions improved. While unemployment remained high, inflation, which had reached 21 per cent in 1980, began to come down. Growth was sustained, gross national product rose. In 1987, Italy was ranked fifth among the world's industrial powers. These were the years of the Government led by Bettino Craxi, the first socialist prime minister. Italians were busy investing in government bonds and the stock exchange, where the total value of shares quadrupled in the space of five years – and with the dividends people changed the way they lived. Meanwhile, a small cultural revolution had taken place within the home through the small screen. On 30 September 1980, *Canale 5* officially began broadcasting, the nucleus of the private television company set up by businessman Silvio Berlusconi, which was to change the Italian media forever.

It was a time of hedonism and aspiration. The new values were careerism, wealth and individualism. Yuppies and managers came to the fore, and Milan gained a reputation for working hard and playing hard. Giorgio Armani, Gianni Versace and Gianfranco Ferré, the future kings of 'Made in Italy', burst onto the international scene. Fashion moved into publishing as well. Magazines such as *Amica* and particularly *Max*, with its slogan 'I exist', put forward an aggressive international image. Daily newspapers began to issue supplements (*Sette*, published by the *Corriere della Sera*, and *Il Venerdì di Repubblica*), and photo-journalism gained an impetus, which resulted in the emergence of new agencies and artists.

In 1984, an exhibition called 'Viaggio in Italia' (Journey through Italy) was held in Bari. Curated by Luigi Ghirri, it marked a radical shift in Italian photography, as artists of different ages, experiences and provenances explored the evolution of the landscape, with the common aim of reflecting on what was happening in the country, from a critical and self-critical viewpoint. This was the birth of what would later become known as the 'Italian School of Landscape'. It was a fertile, creative period, which would last until the end of the millennium and saw Italian photography accepted into international museums and galleries. **G.F.**

Franco Zecchin Palermo, 1983

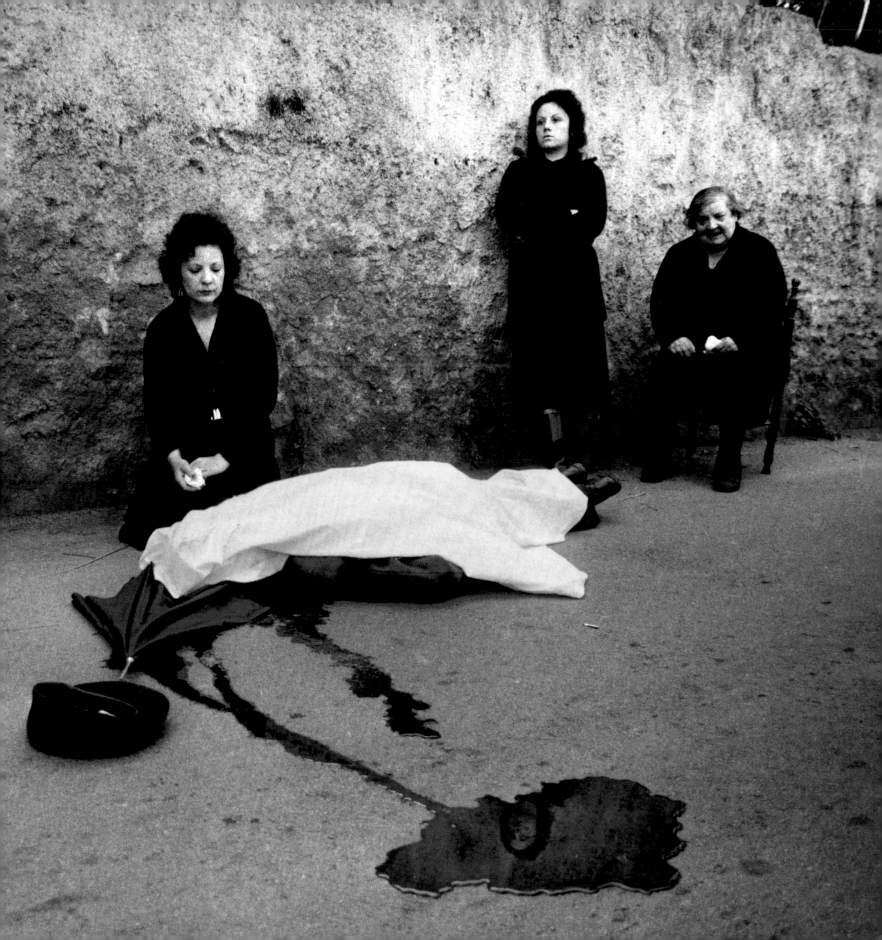

Richard Kalvar Rome, 1981

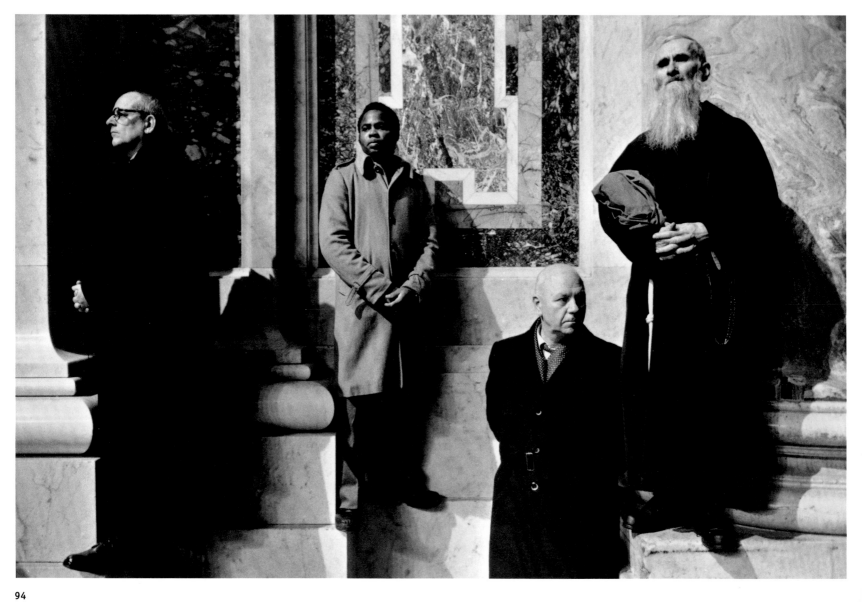

Angelo Turetta Society Party, Rome, 1980s

Cesare Colombo Shopping Centre, 1980

Patrick Demarchelier Fashion Shoot for *Amica*, Venice, 1984

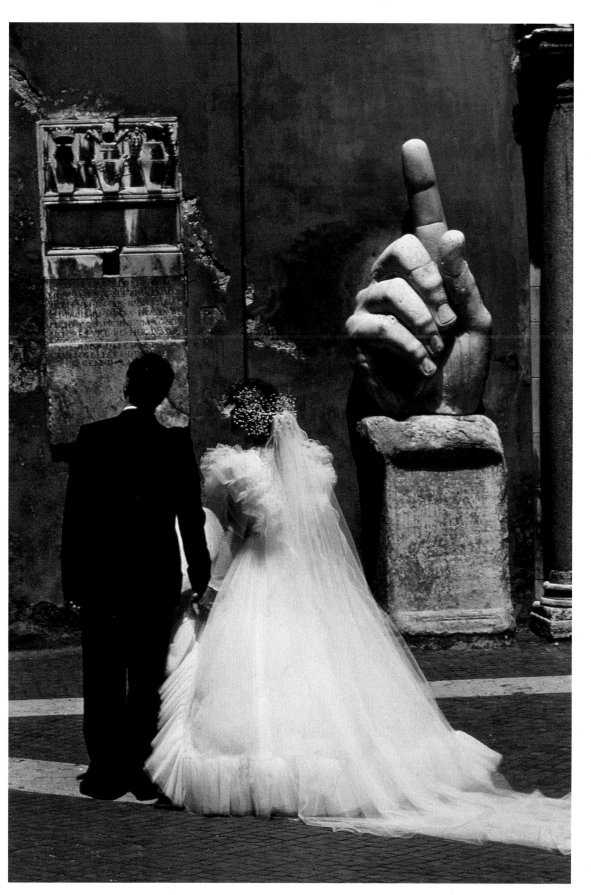

Thomas **Höpker** Wedding at the Campidoglio, Rome, 1984

99

Luigi Ghirri Capri, 1981

Luigi Ghirri Naples, 1980

Franco Fontana Modena, 1982

Mario Cresci From the series *Immagini di un paesaggio imprevisto*, Basilicata, 1982

Vittore Fossati Santo Stefano Belbo, Cuneo, 1983

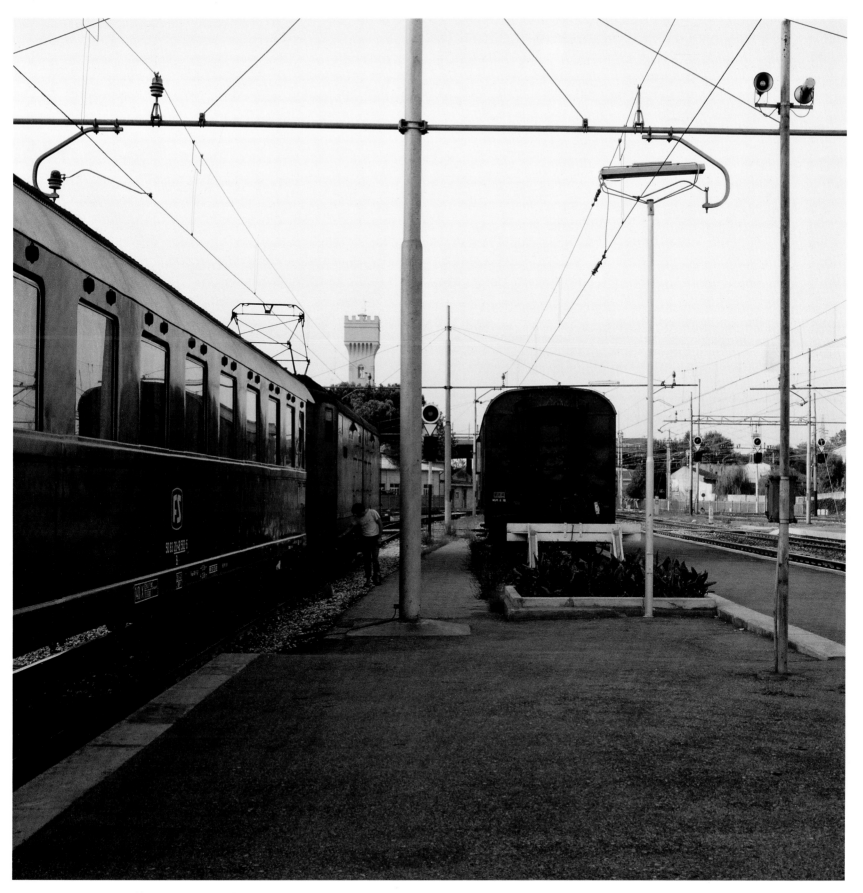

Antonio Biasiucci Dragoni, Caserta, 1987

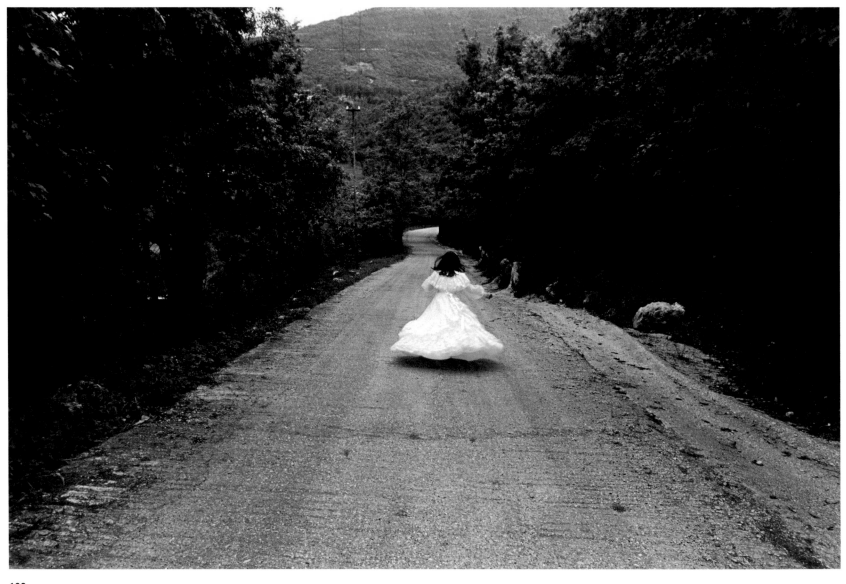

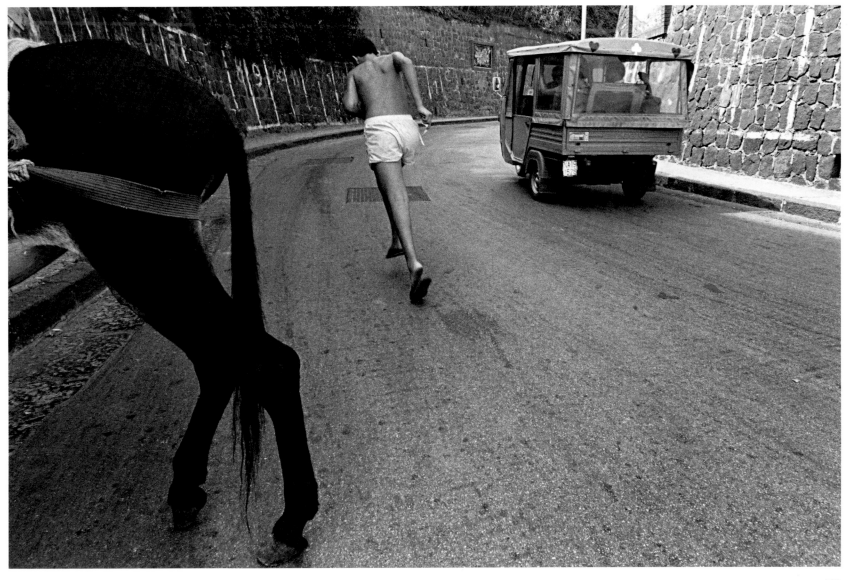

Martino Marangoni Florence, 1990

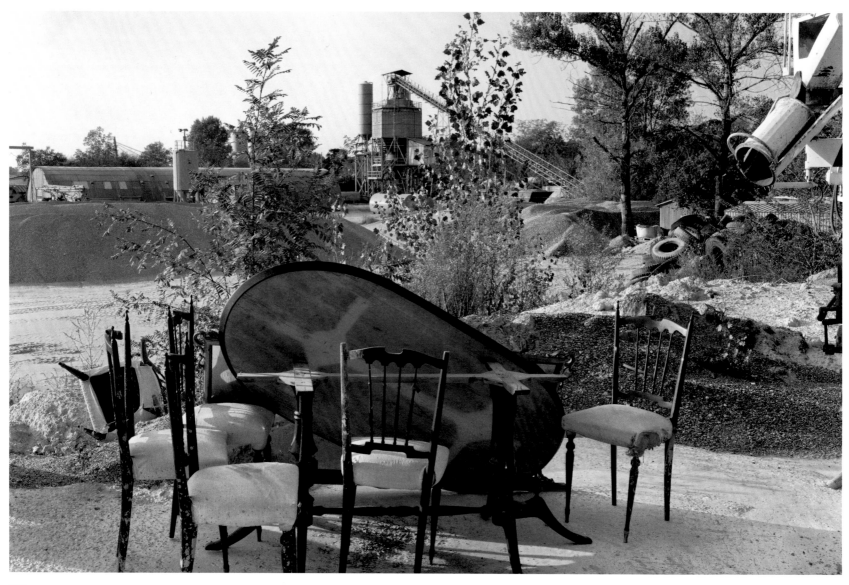

Ikko Narahara Venice, 1985

Francesco Cito The Palio, Siena, 1993

John **Batho** Venice, 1984

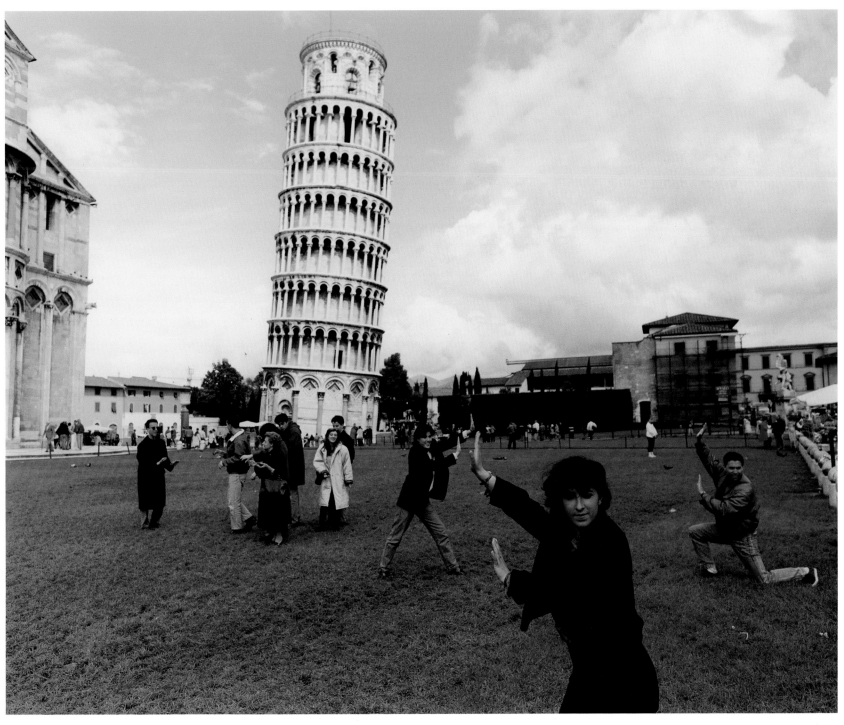

Beyond the Boundaries

The euphoria of the previous decade vanished as Italy experienced a new economic slump. The recession was global, but it hit harder in Italy than elsewhere, thanks to high inflation, high unemployment and a public deficit that continued to spiral out of control (in 1995 it represented 125 per cent of the gross national product).

This was a time of economic hardship, but also of dreams. Albanian immigrants began landing on the Puglian coast, hoping for a better life despite their desperate circumstances. Meanwhile, the opening match of the World Cup, between Argentina and Cameroon, was held on 8 June 1990 and, with it, millions began to dream of glory. Edoardo Bennato and Gianna Nannini sang of 'magical nights', filled with the feats of Totò Schillaci, whom everyone saw as the new Paolo Rossi. But it was not to be: the goals of the Palermo phenomenon were not enough and the title went to the German team. From football passion to news, the Mafia returned with devastating violence: in 1992 two Sicilian judges in the front line in the fight against organized crime, Giovanni Falcone and Paolo Borsellino, were blown up by car bombs. On the political front, the fall of the Berlin Wall and the collapse of the Soviet Union had ramifications for Italy as well. Under the stewardship of Achille Occhetto, the Italian Communist Party abandoned the hammer and sickle for the more colourful oak tree, and changed its name to the Democratic Party of the Left. This was an historic occasion and yet it was eclipsed by the arrest of Mario Chiesa, the socialist leader of the Pio Albergo Trivulzio of Milan.

This was the beginning of what came to be known as the *Mani Pulite* (Clean Hands) campaign: the huge judicial investigation which exposed the network of bribes underlying the country's power structures. The smear of corruption hit politicians at both a local and national level, and ultimately led to the collapse of the parties at the heart of the Government. This was the end of an era. The scandal of *Tangentopoli* (Bribe City) brought the so-called first republic to a close. The centre-left and centre-right parties now began to take turns in power: in 1994, Silvio Berlusconi gained control, leading a coalition which included the Lega Nord of Umberto Bossi; in 1996, it was the turn of the centre-left Ulivo party led by Romano Prodi; while 2001 saw Berlusconi elected prime minister for a second time. Meanwhile, Europe became more and more integrated, resulting in the introduction of the Euro in 2002 and the phasing out of the lira.

It was during the 1990s that photography in Italy was recognized as an art form, accepted on the same level as its big 'sisters', by the market and institutions alike. Reportage journalism suffered, but there was a growth in the publication of books of photographs. There was also an increase in public and private funding for photographic campaigns that chronicled the Italian way of life. New technology opened up new possibilities of language, and a fresh era of communication began. Boundaries were constantly being broken down between different media, cultures and countries. **G.F.**

Thomas Struth Galleria dell'Accademia, Venice, 1992

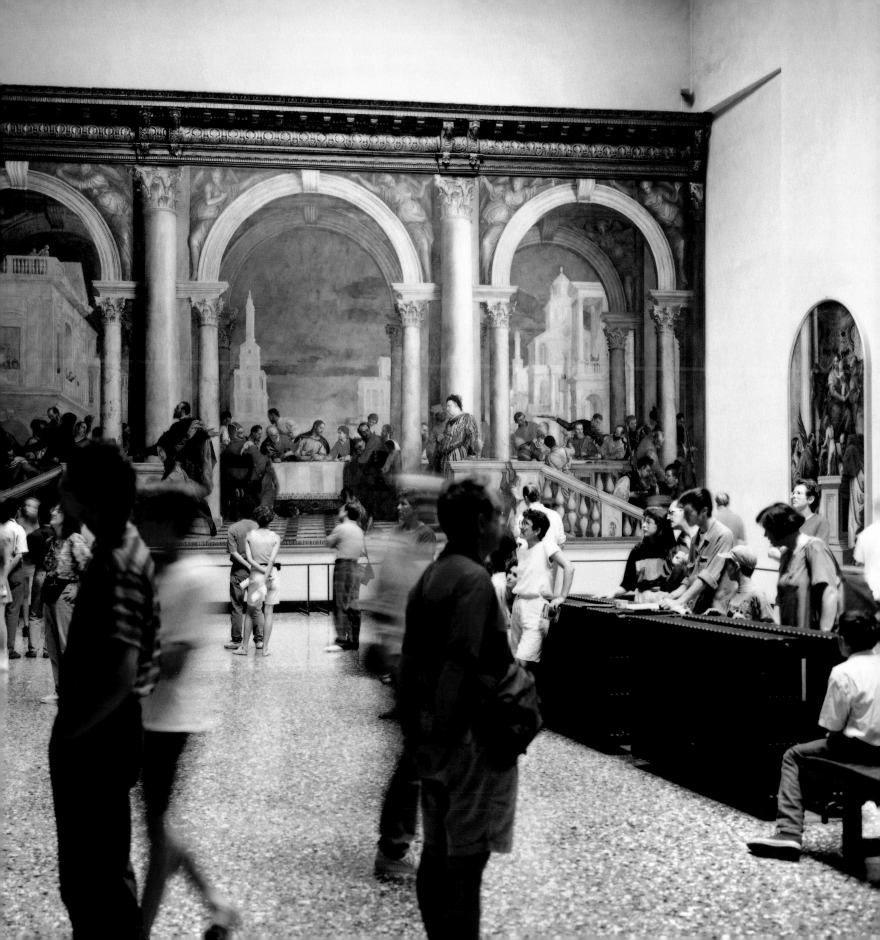

Gianni Giansanti Lesson with Marcus Aurelius, Rome, 1982

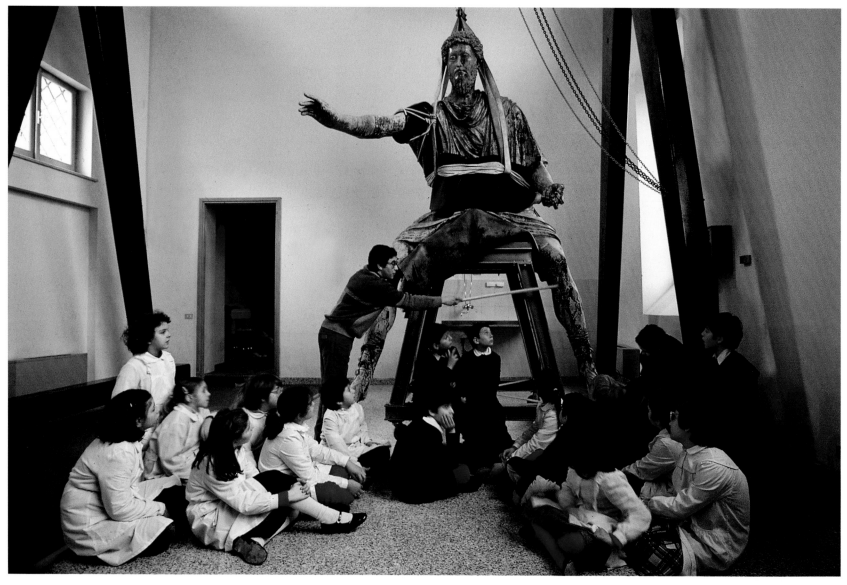

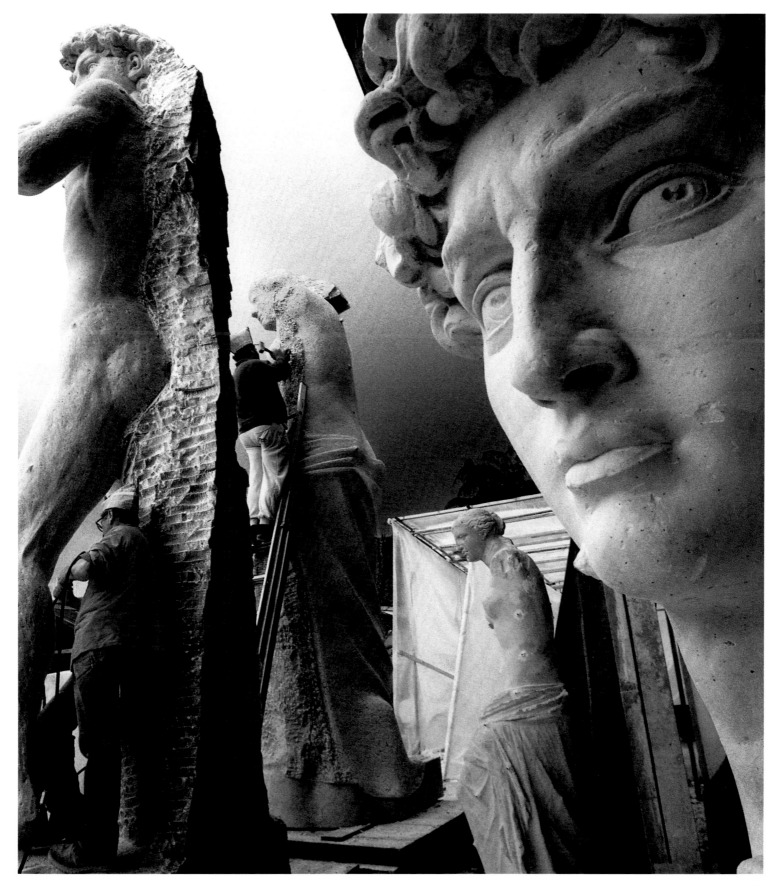

Romano Cagnoni Pietrasanta, 1990

121

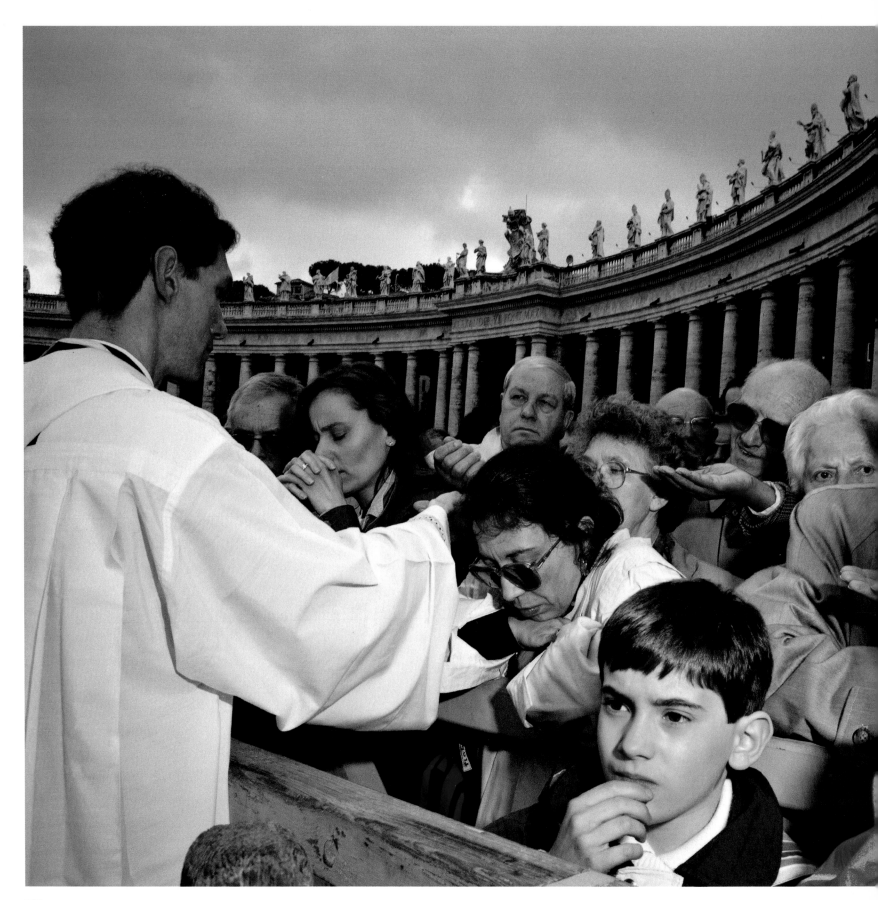

Carl De Keyzer Easter at the Vatican, Rome, 1993

Massimo Siragusa Villarosa, Enna, 1999

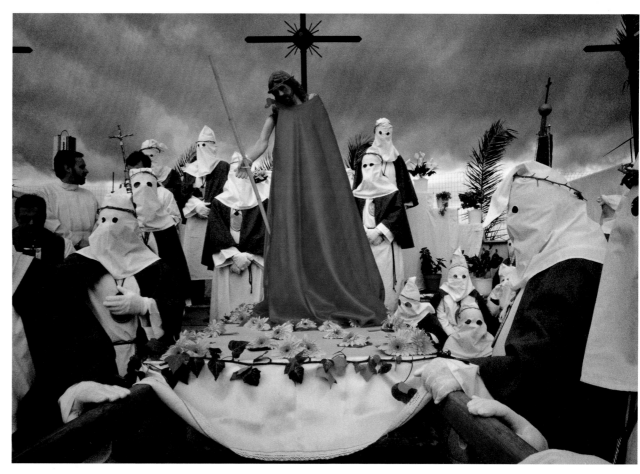

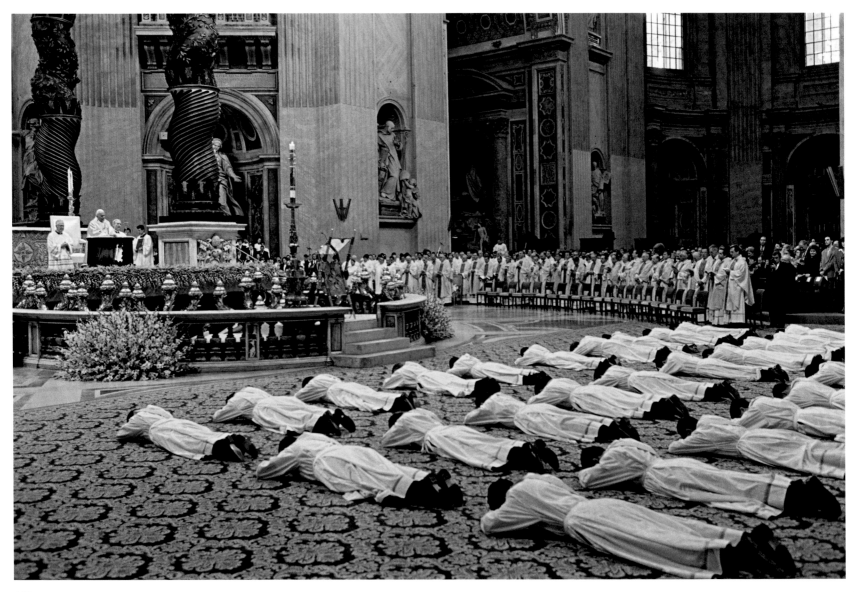

Marco Pesaresi Rimini, 1996

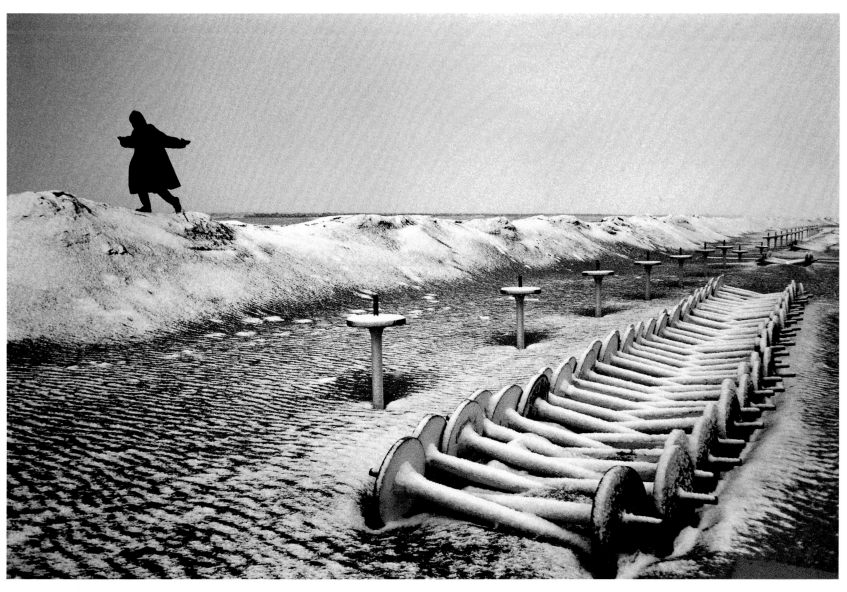

Alain Ceccaroli Eur, Rome, 1996

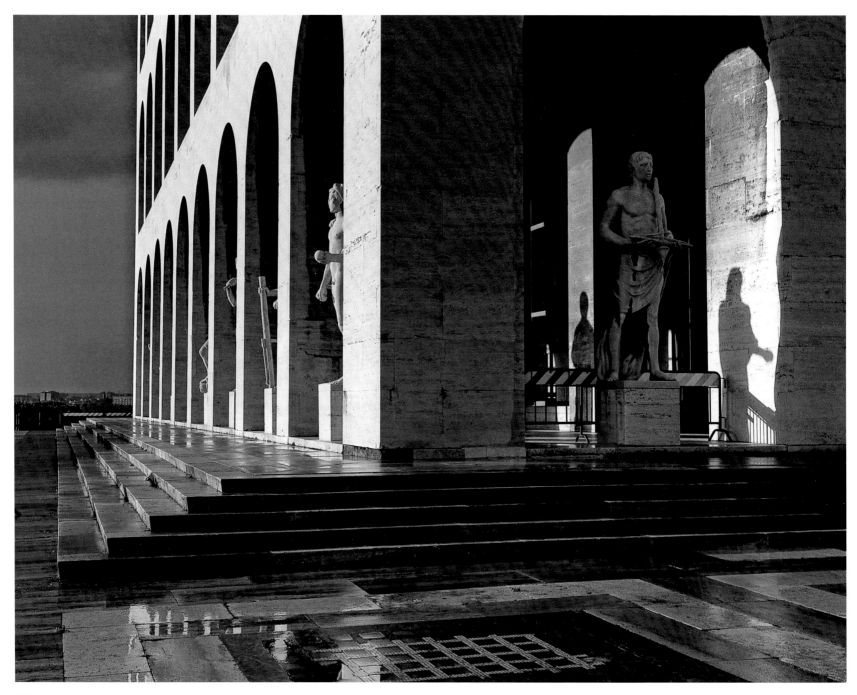

Marialba Russo Rome, 1990–93

Moreno Gentili Marghera, 1995

Moreno Gentili From the series *Nuovo mondo, mondo nuovo*, 1993–98

Massimo Sciacca Youth Centre, Bologna, 1997

Ernesto Fantozzi Smau, Milan, 2002

Stefano De Luigi Rome, 1997

Stefano De Luigi Fashion Show, Rome, 2000

John Davies From the series *The River and the City*, Florence, 1996

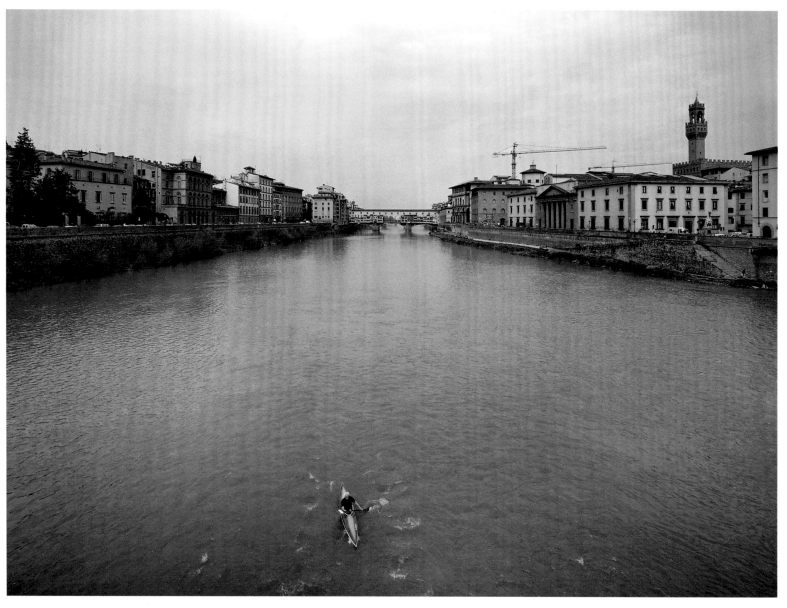

Toni Thorimbert Riva del Garda, 2001

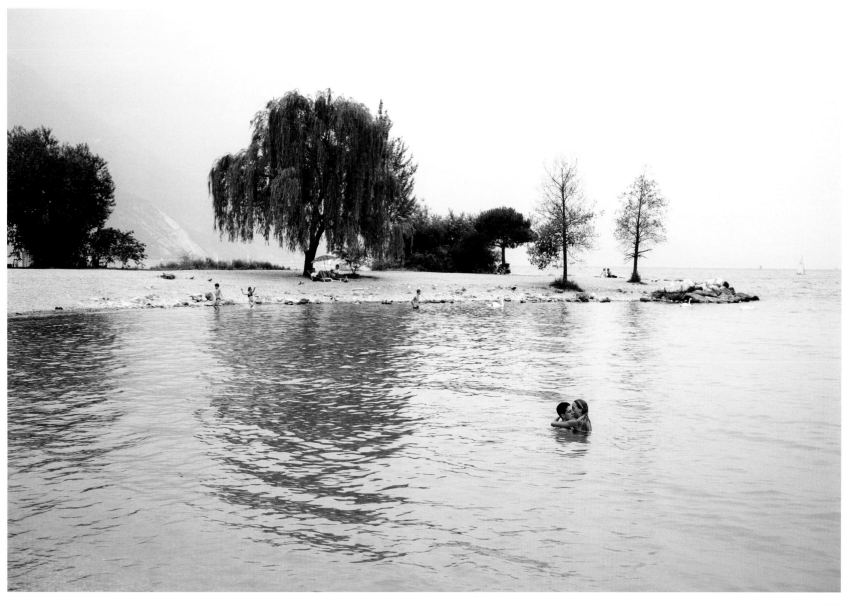

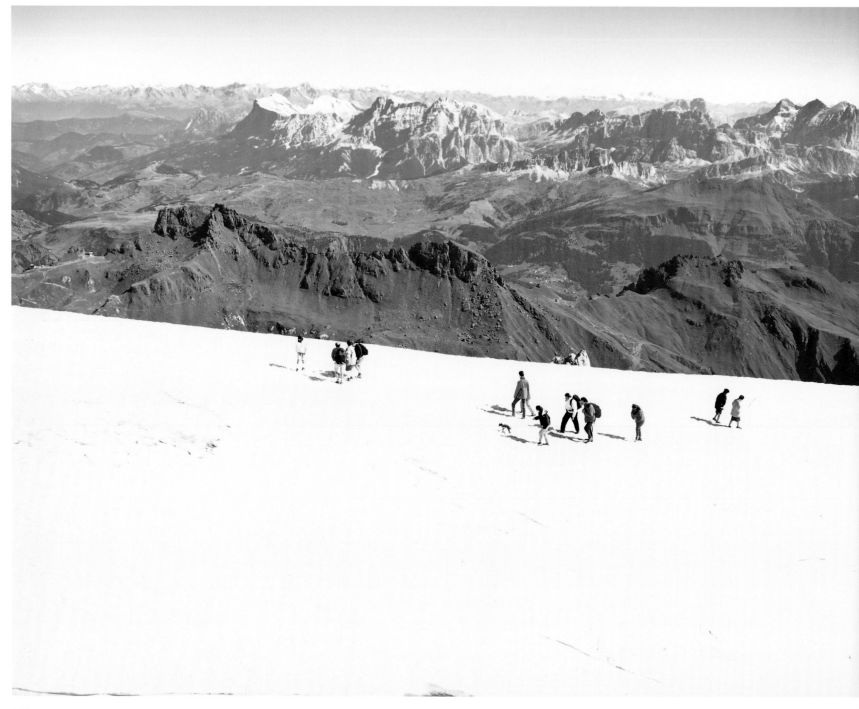

Andreas Gursky Salerno, 1993

Guido Guidi Gardenia, Reggio Emilia, 1996

Shobha Young Ghanaian Immigrants, Palermo, 1997

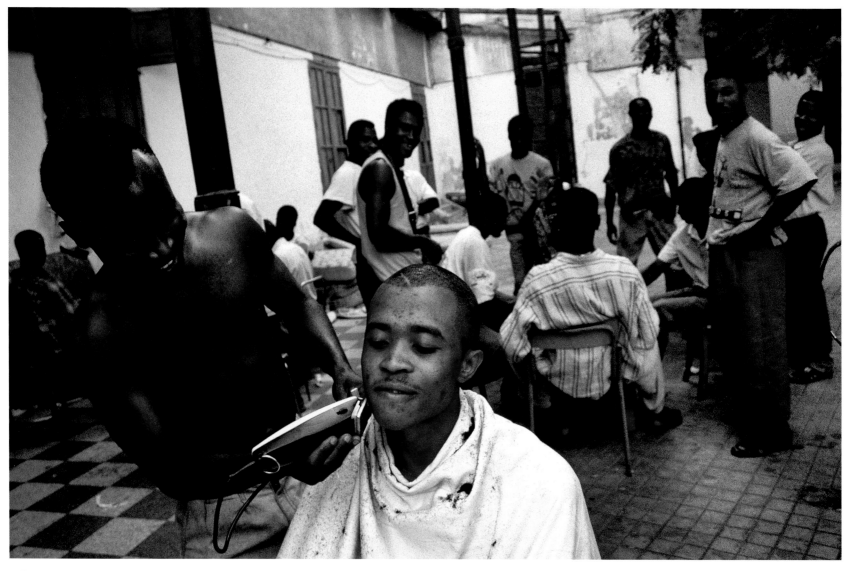

Daniele Dainelli Trieste, 2000

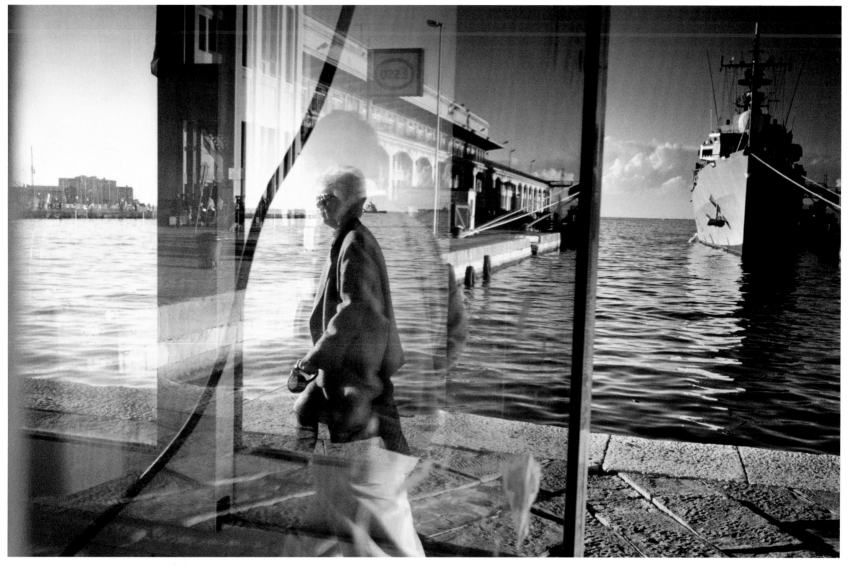

Cristina Zamagni From the series *Soft-city*, 1998

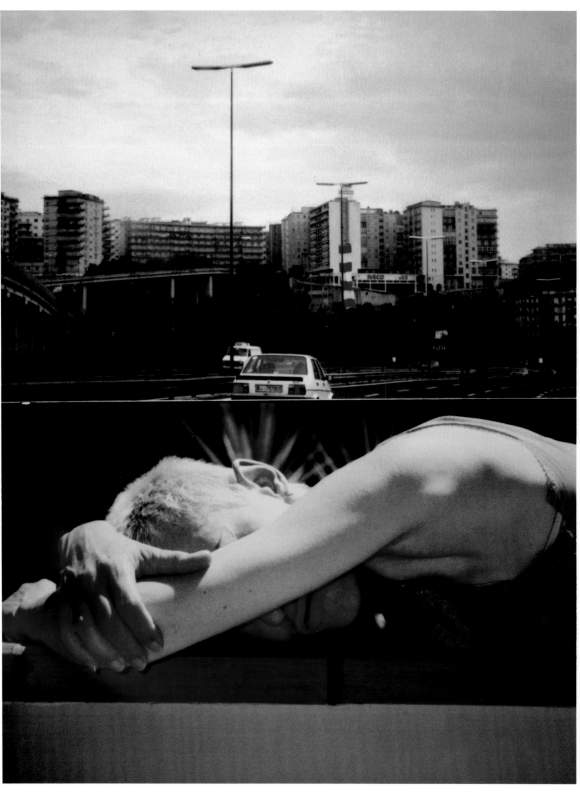

Francesco Radino Linate Airport, Milan, 1989

Vincenzo Castella Turin # 14, 2001

Paola De Pietri From the series *Parco casse di espansione del fiume Secchia (Secchia Flood Basin Park)*, 1995

Paola Di Bello From the series *Fuoricampo (Off-Field)*, Naples, 1997

Roberto Salbitani From the series *Makkine e makkinisti... (Kars and Kar-drivers)*, Rome, 1999

Marina Ballo Charmet From the series *Con la coda dell'occhio (From the Corner of My Eye)*, 1993–94

Josef Koudelka Imperial Forums, Rome, 2000

Michael Ackermann Naples, 2000

Michael Ackermann Naples, 2000

Luca Bruno Carlo Giuliani, Genoa, 2001

Massimo Sciacca G8, Genoa, 2001

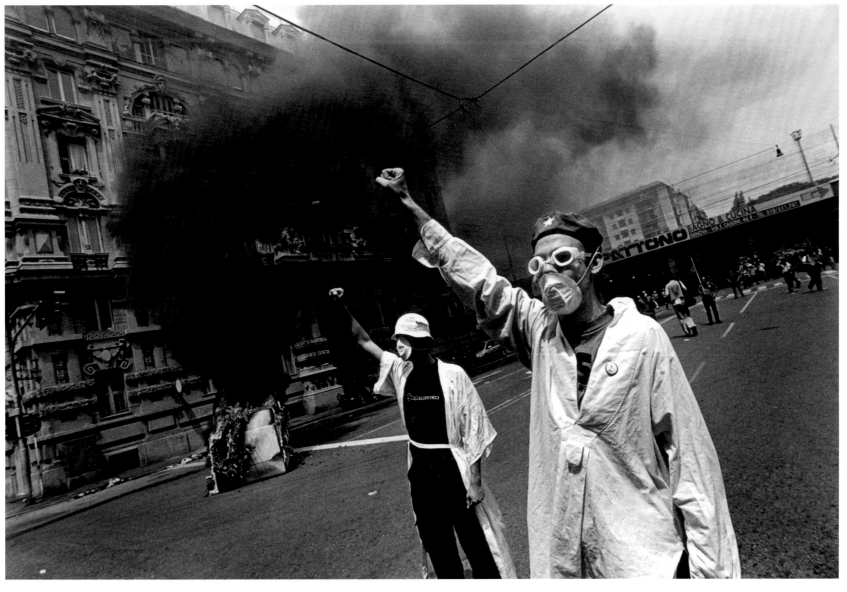

Marco Anelli Roberto Baggio, Naples, 2001

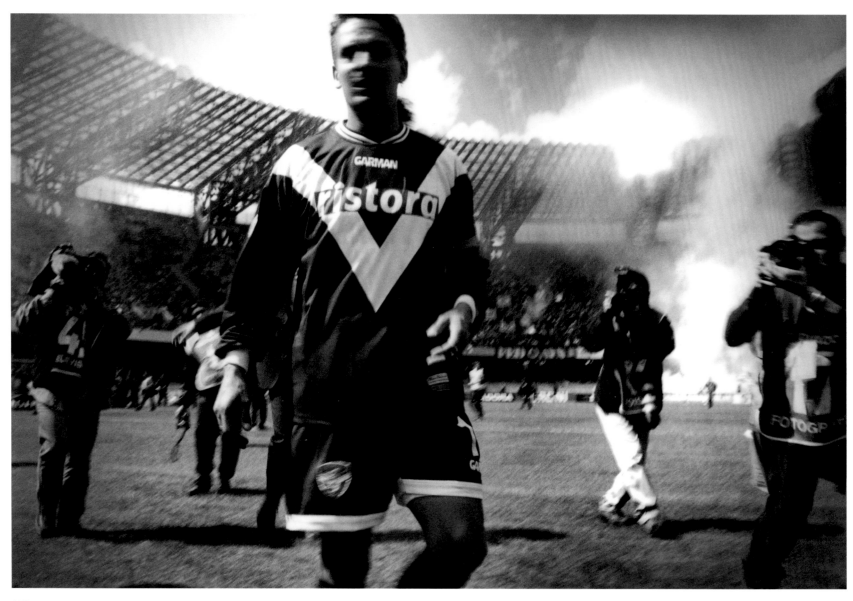

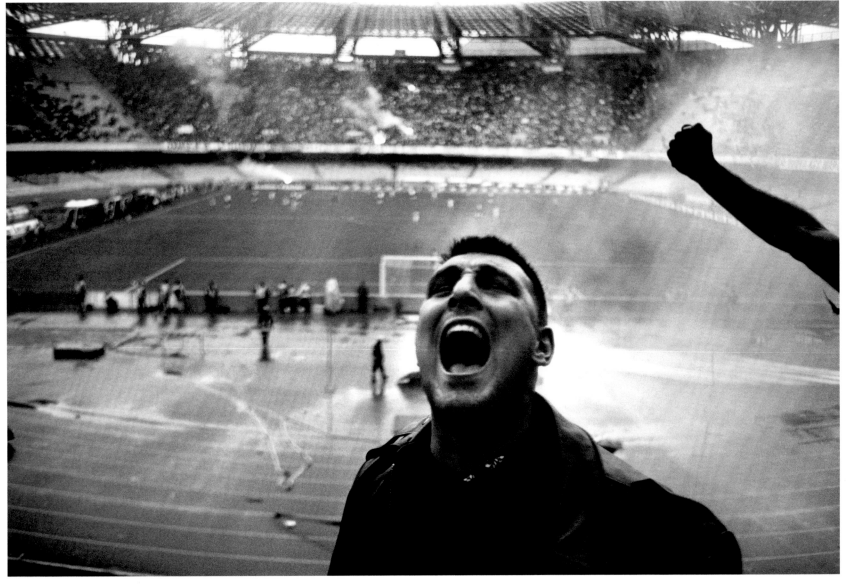

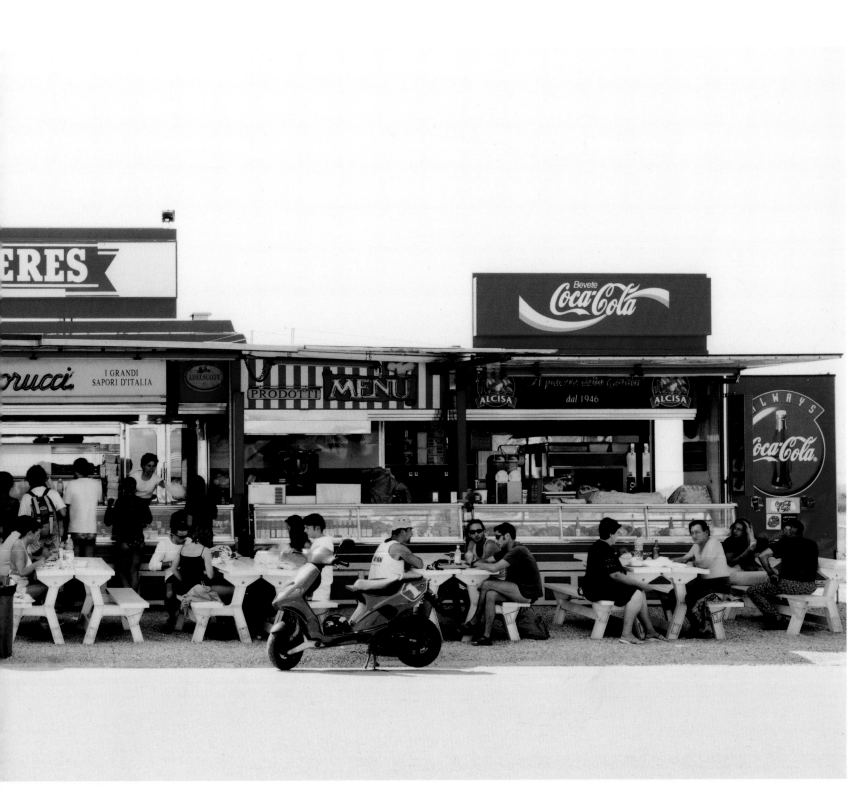

Claude Nori Fabio Resort, Rimini, 1995

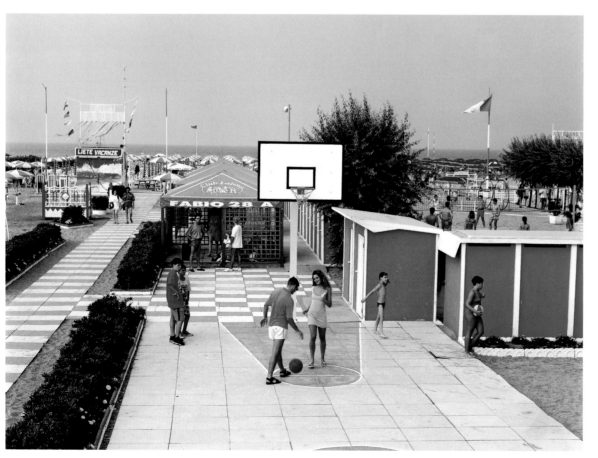

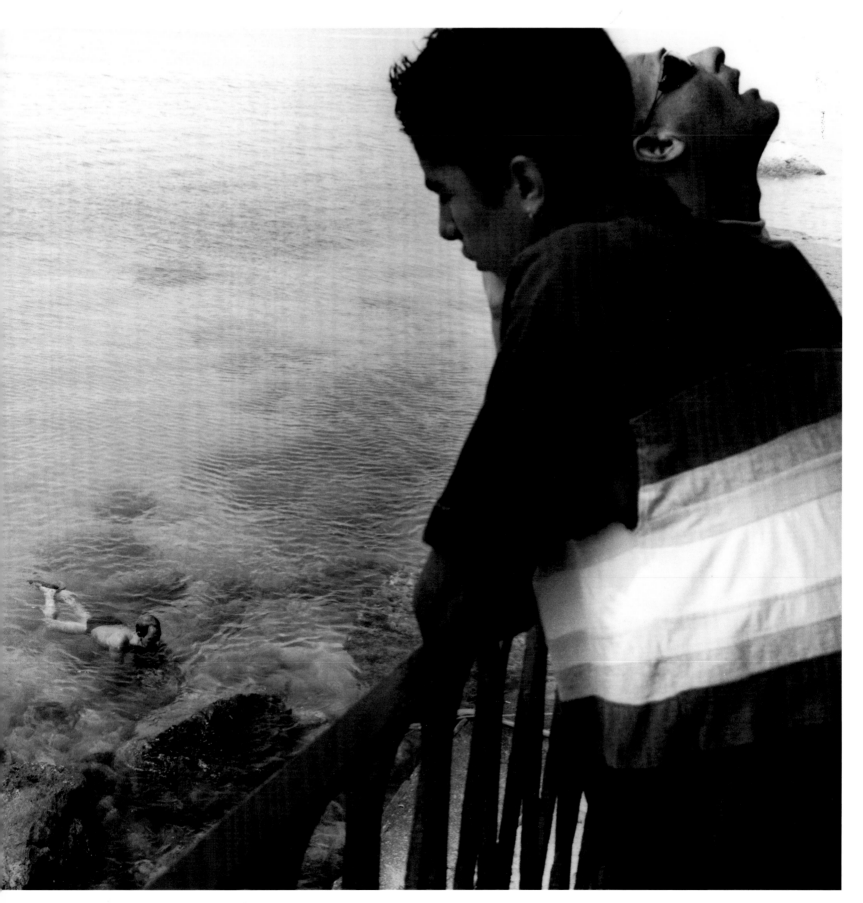

Claudio Sabatino Pompeii, Naples, 2000

William Guerrieri Bologna Law Courts, 2002

Gabriele Basilico Calabria, Waiting for the Bridge to Messina, 2003

Essays

The Birth of Vision

Paper Dreams:
News Weeklies, 1945–60

Neo-realism?

Experiencing Landscape

The Discipline of Design

Confessions of a
Magazine Editor

The Birth of Vision

by Carlo Bertelli

If I were to identify a common theme in the work of photographers as diverse as Eugène Atget, Brassaï, Henri Cartier-Bresson and Jacques-Henri Lartigue, the phrase that comes to mind is *tranche de vie*. Indeed, in the work of all of these masters of photography there is an interest in capturing moments, in crystallizing a continuous action. At the other end of the spectrum of artists working in Paris, the surrealist photographers André Kertész, Man Ray and Florence Henri can be defined as creators of new worlds through the juxtaposition of unexpected objects. Neither of these categories, however, can be applied to what was happening in Italian photography of the same period.

In Italy, photography was seen as something created alongside the action, rather than within it, although no one ever theorized this tendency at the time. It was concerned with making icons, each of which had its own meaning. Time was not important, neither was the decisive moment, nor the jarring mismatching of subjects. Because photography evades time, it is about cessation, arrest. Photography is interruption and, as such, is a denial of continuity. It has no intention of creating an illusion of reality, since its very existence demonstrates the dissolution of that reality with which it had momentary contact. Inevitably, Italian photography found itself conforming to the formal ideals that had passed from metaphysics into 20th-century painting. The increasing awareness that photography could have a role that was collateral to reality, rather than part of it, can be seen in the passage from the reportage of Adolfo Porry Pastorel to the chronicles of Spartaco Appetiti, for instance. The former, working between 1927 and 1930, used a model akin to note-taking, while, ten years later, Appetiti favoured viewpoints which exalted space and transformed the recording of events into a veritable stage production. This metamorphosis was probably also influenced by 'modern' architecture at a time when the simplified monumentalism of Marcello Piacentini was making the fantastical, historicist architecture of Armando Brasini look antiquated. Armando Maugini, meanwhile, demonstrated how photography could also record emptiness, with his images of the imperial architecture at Cirenaica. Architecture, of course, became the subject of photography: Giuseppe Pagano heightened its monumental qualities with photographic brushstrokes reminiscent of Aleksandr Rodchenko, while the way in which new buildings were portrayed in magazines, using long shadows and stark lighting, betrayed the influence of Giorgio De Chirico.

This tendency towards monumentalism was also a consequence of the use of enlargements in the photographic exhibitions sponsored by the fascist regime, and by industrial giants such as Olivetti. Here was a context in which photography came to occupy a place traditionally

Xanti Schawinsky
Advertisement for an Olivetti
Typewriter, 1934

Stefano Bricarelli
Composition for the Turin
Fashion Exhibition, 1932

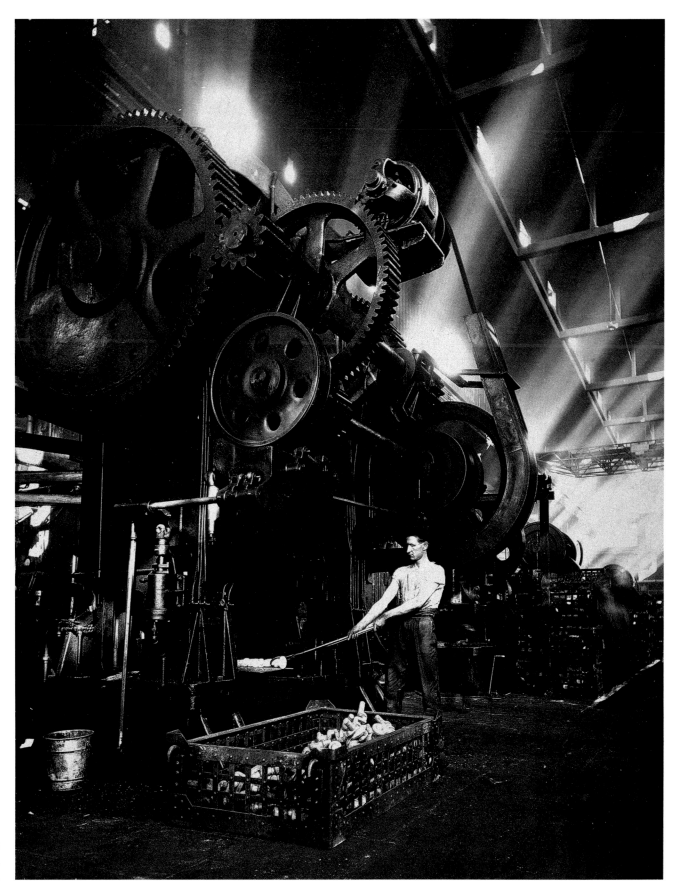

Archivio Fiat Lingotto
The Foundry.
A Polishing Press, 1934.

reserved for great paintings, locating itself within an architectural setting as a narrative or decorative element. As a result, photography found itself competing with the magniloquence of Mario Sironi or the impeccable neoclassicism of Achille Funi. Certainly the propagandistic requirements of the regime created the impetus for press photography to take on themes such as work, motherhood and childhood. The way in which they were presented oscillated between the models of 20th-century painting on the one hand, and foreign photography on the other, resulting in an interesting cross-fertilization. In terms of composition, formalism always won out, once more undermining the connection between photography and reality. A significant example of this can be seen in sports photography. Elsewhere in Europe and America, sports photography had a specific documentary role. Then, as now, it was of the utmost importance to know who had reached the finishing line first and who had committed a foul, as well as providing images of champions who were worthy of veneration, of course. In Italy, meanwhile, the way in which sport and sportsmen were represented was influenced strongly by the regime, which naturally took an interest in anything that enjoyed such popularity and could fuel people's enthusiasm. The powerful, virile, colossal

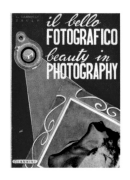

statues of Mussolini's Forum became an inescapable point of reference. Much of the photography dating from this period is anonymous, however, with the result that the catalogue of images tends to be perceived as a collaborative effort, much the same as cathedrals. The names of the artists in question are almost always unknown, and it would require laborious archival research to uncover their identities from the excess of documents charting payments and sales. Such a task would be long-winded and not necessarily fruitful. It might be more productive to identify masters through their stylistic consistency rather than attempting to learn their names. It is possible, for instance, to discern a certain continuity in the photographs taken of the Negri complex in Brescia, with their clear, elegant account of the world of industry and its products. Research in the Fiat photographic archive, for example, has revealed some expert and sensitive interpreters of the Italian automobile industry.

As a result of this prevailing anonymity, 'photography' from the period before 1950 tends to be discussed in a similar way to mosaics or wall paintings in other eras. In fact, this lack of individual identities is almost more prevalent as time goes on, because photography was such a new phenomenon in its earliest days that its practitioners were thrown much more into the spotlight – despite the fact that their work tended to be less personal and was directed at a more 'middle-brow' audience. Those who strove for innovation beyond the arena of

Giuseppe Vannucci Zauli Loneliness

Vincenzo Balocchi Small Landscape

176

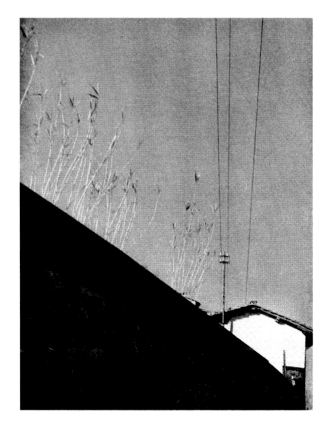
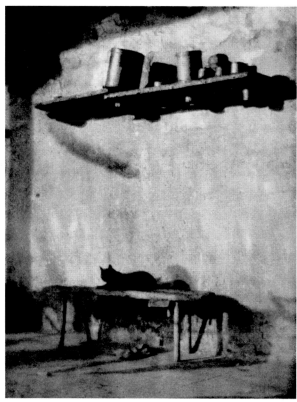

Alex Franchini Stappo Via della Fornace

Vincenzo Balocchi The Cat

professional photography were frequently tied to the old preoccupations of the debate between photography and painting. In the 1930s, it continued to be the more painterly photographs that won the competitions. Once the critics rid themselves of their prejudices, they tended to accept these tradition-alist masters on their own merits, including Giacinto Oriani, who in the 1930s was exploiting the mellow tones of the paper he used (Brovira, I think) to create cosy, intimate works. In 1938 Attilio Podestà published the photographs of Luigi Veronesi in *Natura* (year XI, no. 12). These rare figurative examples reveal the influence of Constantin Brancusi more than Italian experiences.

With the end of Futurism, there was no longer any kind of collectivity in the photographic world, nor was there any collaborative relationship between photographers and artists. Photographers tended to work in an agency, or in a private studio (as Elio Luxardo did in Rome, for instance), making their contact with the wider world relatively limited. This was especially true after contacts with the international community were cut off – possibly due to suspicion on the part of the regime, which found such relationships hard to censor. However, the short-lived Turin-based journal *La fotografia artistica* shows that links clearly had existed at some point.

As is well known, there was considerable opposition to monumentalism in certain quarters, notably from poets such as Sandro Penna, Umberto Saba and Eugenio Montale, but also from some photographers. The polished, refined taste of Leo Longanesi, for instance, introduced a kind of 'photography of the glance', which was unknown in Italy at that time. In *Omnibus*, the illustrated magazine founded by Longanesi in 1937, there are photographs in which entire narratives and personal interpretations were 'hinted' at by objects and details of human figures. These were images taken from everyday life, inviting exploration, but glorifying no one. Fashion photography began to move in the same direction. The photographs of models in *Bellezza e Moda* were now real portraits. Sometimes casual encounters were simulated, or there might be stolen glances, or sudden revelations of beauty, all using a cinematic kind of lighting. Luxardo for one changed his style when he went from studio portraits to fashion photography, although his low viewpoints tend to isolate the figures, lending them a certain grandiosity. These images helped to shape taste rather than merely reflect it. This was a time when photographers such as Stefano Bricarelli, in *Bellezza*, were celebrating an aristocratic, posed kind of beauty, of women destined to become wives and mothers one day. The precedents for these images are not to be found in cinema but in neoclassical painting, in the work of Funi and others. The photographs of Luxardo, on the other hand, reveal characters; the models become real, inaccessible, almost arrogant, certainly not vulnerable.

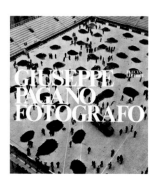

In this way, the thread of monumentality became unravelled and took on new values. It seems appropriate at this point to recall the photographs of 13th- and 14th-century Pisan sculpture taken by Giacomo Pozzi Bellini. These were taken straight after the war, during the great exhibition dedicated to Pisan sculpture. Everything about these images – the subdued lighting, the calculating overexposure – make it impossible to read the works of the great Pisan masters as monumental. A veil of nostalgia is cast over the images, which are neither glorified, nor given a realist treatment – even though Pozzi Bellini himself experimented with the new realism in his film about the pilgrimage to Monte Autore. In our brief consideration of the monumental tendency of much Italian photography, the work of Pozzi Bellini is thrown into relief precisely because he attacks the very notion of these statues and ruins as monuments. It is also important to remember the circumstances in which these statues, which were at one time above the gallery of the baptistery at Pisa, or enclosed in the Camposanto, were made available to the photographer. They were accessible because they had been put in a safe place, away from the horrors of war, and their reappearance signalled a return to peace.

How did the various strands of photographic innovation come together again after the war? And what was left of the more significant trends? In 1942, Cesare Zavattini declared that the best kind of film would consist of a man doing nothing for ninety minutes, with nothing happening to him. This was the manifesto of what Umberto Barbaro would term 'neo-realism'. After the war, Zavattini asked Paul Strand to document a town near Mantua, which the great American master duly captured in all its mundanity. Despite an admiration for America, which was cultivated in literature by Elio Vittorini, realist cinema was inspired more by France. In *Ossessione*, Luchino Visconti adapted a story by James Cane, in a style that was influenced by Jean Renoir. The relationship between film and photography was becoming more complex. The self-sufficiency of the regime had resulted in bolstering the national photographic industry. The companies that produced the raw materials for photography – including Ferrania, which made the films, and Cappelli, producers of glass plates for professional photographers – addressed themselves to a new market and adopted the instruments of modernity, including a new typeface or an ashtray designed by Luigi Veronesi to furnish their shops. The widely read magazine *Ferrania* was run by a literary man, Guido Bezzola, cementing the links between literary culture and industry, which continued to be a defining feature of Italy well into the 1960s. *Ferrania*'s message of modernity had many affinities with the company Olivetti, another great protagonist of the revitalization of Italy, which made extensive use of the images of Xanti Schawinsky.

Ferrania effectively shifted the discourse of the aesthetics of photography, from deference to the pictorial models, as seen in the old competitions, to an embracing of 'straight photography'. At the same time, with the failure of fascism, young intellectuals began to organize themselves into new official

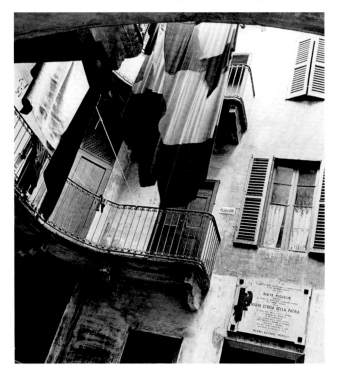

Giuseppe Pagano Covo

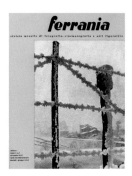
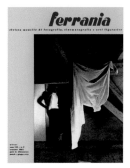

Left, two covers of *Ferrania*:
no. 1, January 1947, photograph by Bruno Stefani;
no. 9, September 1954, photograph by Paolo Monti.

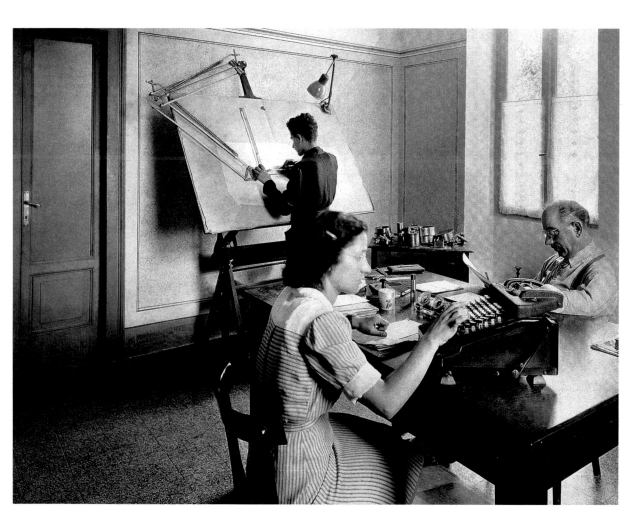

Giovanni Negri 1950s Office

groups which confronted entirely new issues. Inevitably, these photographers were attracted to the new style and were increasingly aware that photography had its own unique language. Their work is well represented in the 1945 book entitled *Il bello fotografico*, which was edited by Giuseppe Vannucci Zauli. Among the artists chosen were Alex Franchini Stappo and Vincenzo Balocchi, as well as Vannucci Zauli himself. The book was characterized by the fact that these artists were not working to commission, and were experimenting with a language which might best be described as 'poetic'. Their subjects were taken from everyday life, leading them to look on the photographic image as a frozen moment, a suspension which invites a consideration of what is not there, of what photography has taken away from the flow of time. What really defined these photographs was a kind of metaphysical expectation of an event, which is perhaps the most characteristic quality of Italian photography prior to the radical upheaval of the 1950s.

Paper Dreams: News Weeklies, 1945–60

by Cesare Colombo

To understand the impact of the photographic news weeklies, which were introduced into Italy in the post-war period, it is important to consider what preceded them in the visual tradition of Italian journalism. From the beginning of the 20th century on, when the use of photographs became widespread, the Italian magazine-buying public was divided between *L'Illustrazione Italiana* (founded in 1873) and *La Domenica del Corriere*, first issued by the *Corriere della Sera* in 1899, and inspired by the precedent of the Neapolitan *Tribuna Illustrata* (1890). Those who read *L'Illustrazione* belonged to the urban upper and middle classes and were attracted by the colourful cocktail of etchings and photographic plates, which portrayed the artistic and worldly myths favoured by the elite of the new unified state. The large colour plates of *La Domenica*, on the other hand, which were designed with a theatrical fancy by Achille Beltrame (and later by his successor, Walter Molino), covered dramas and events both at home and abroad for a semi-literate mass audience. These two models were to persist through the years of fascism, which exploited them for its own propaganda. This was largely due to the fact that the literary culture of the editors and the 'technology' of the photographic idiom remained entirely separate, in contrast to what was happening in the press of the other industrialized nations of Europe and the United States. In Italy, photography remained secondary to written journalism, even when it began to impose itself through the illustrated magazines of the 1930s. In a similar way, Italian cinema continued to defer to the traditions of theatre and opera – and this applies as much to neo-realism as other genres – and even television would stay tied to the artificial atmosphere of Cinecittà.

After the end of the Second World War (the last chapters of which had been documented by *Life* photographers such as Robert Capa and David Seymour), a brave outsider in the publishing world made his debut in Milan. Gianni Mazzocchi had anticipated a new direction for our visual language in

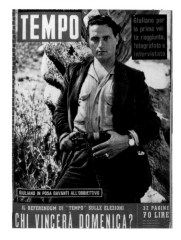

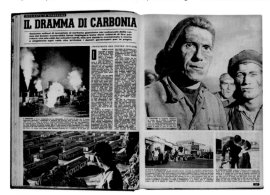

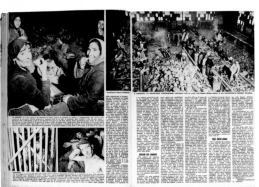

the turbulent year of 1943 with the first annual *Fotografia*. In 1945, he founded *L'Europeo*, edited by Arrigo Benedetti. Benedetti had been a protégé of Leo Longanesi, the ingenious founder of *Omnibus* (1937–39), and was involved in running another leading Roman weekly between 1939 and 1942, namely *Oggi*. In keeping with the ideas of Longanesi, *Omnibus* and *Oggi* had inserted isolated photographs into the middle of articles, which functioned as emotive or intellectual highlighters. The illustrations of Cesare Barzacchi, the photographer responsible for putting Longanesi's ideas into practice, tended to use rather forced literary allusions: second-hand objects from junk shops, urban dead ends, marginalized figures. This was certainly not about social comment and neither of the publications could be defined as organs of opposition to fascism – and yet both were suppressed. After the war, Benedetti and Mazzocchi were to understand that there was no place for obsolete symbols amid the physical and moral ruins of a country, and so they updated everything. They went for a bigger format, similar to that of the newspapers, with dozens of photo stories dramatically laid out to catch the eye of the reader. Even the headlines were unbiased, and the tone of the articles seemed to invite the reader to take the unknown road of democracy, with its scandals and the endless, often unresolved, backroom manoeuvring. Benedetti and his

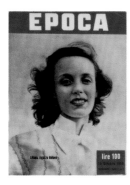

From left to right: cover of the first issue of *Epoca*,
14 October 1950, with photograph by John Phillips;
Mario De Biasi's first cover for *Epoca,* 20 September
1953; an image by Henri Cartier-Bresson from *Epoca*,
27 April 1954.

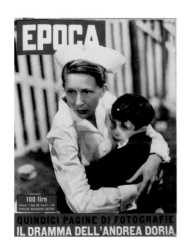

Above and right, a feature
by Eugene Smith on the
survivors of the shipwreck
of the *Andrea Doria*,
from *Epoca*, 5 August 1956.

editors (including Tommaso Besozzi and Camilla Cederna) did not, however, adhere to modern *auteur* photo-reportage, and neither did the new *Oggi*, which was entrusted to Edilio Rusconi in 1946 by the publisher Angelo Rizzoli. Rusconi immediately sought a different audience to that of *L'Europeo*, readers nostalgic not for the fascist regime but for the lost social prestige of the pre-war period: the Savoy dynasty, the surviving leaders, the sagas of the Mussolini and Petacci families. In contrast to *L'Europeo*, *Oggi* favoured exclusive photo shoots, commissioned from the agencies; and later, the famous soft tones of Guido Jarach's use of 'indirect' flash.

The newly formed agencies most used by Benedetti and Rusconi were Publifoto, run by Vincenzo Carrese (with the help of the great Tino Petrelli), Giancolombo News Photo and the agency run by Tullio Farabola. The graphic formats, while different, all tended to box in the images and to crop them mercilessly. The third great illustrated magazine which emerged out of the ruins at the same time as *Oggi*, took a different line. *Tempo*, published by Aldo Palazzi, had also appeared in an earlier manifestation (between 1939 and 1943). It had been founded by Arnoldo Mondadori and edited by his son Alberto, with the expert guidance of Indro Montanelli. In the post-war period, there was an attempt to transpose the format of *Life* magazine, with photographic features which were collaborations between editors and photographers. It was here that Federico Patellani first started out, together with his adventurous colleague, Lamberti Sorrentino. Between them they managed to introduce the use of the 35 mm camera without a flash. Alongside these two, and art director Bruno Munari, the photographic team was completed by a group of artists who would go on to have great success in other spheres:

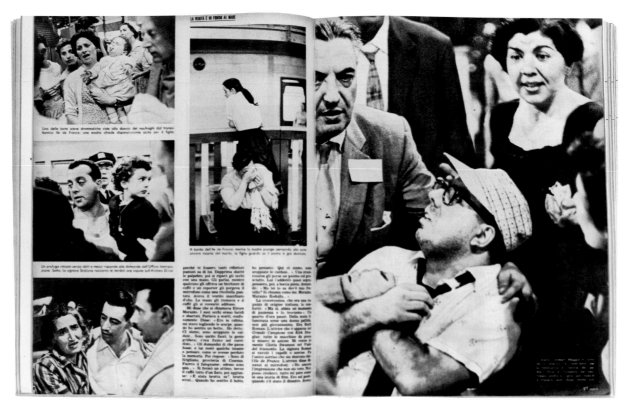

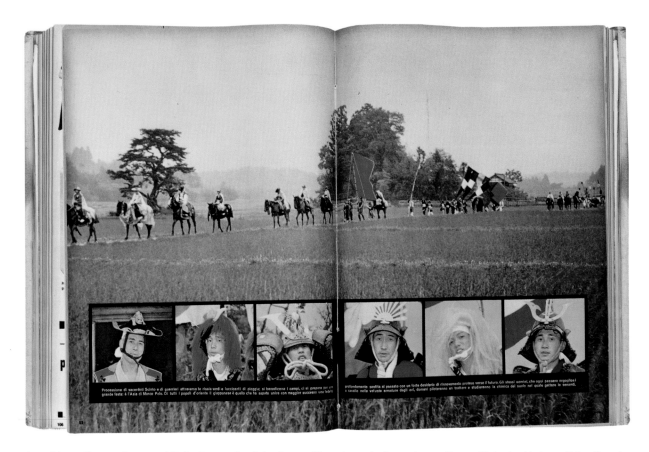

the architects Giuseppe Pagano and Enrico Peressutti and the director Alberto Lattuada. It was the new *Tempo* of Palazzi, with Arturo Tofanelli at the helm, which allowed Patellani and Sorrentino the space to create images that went against the grain of agency photographers. Indeed, they appear greyer and, at the same time, more disarming and believable, proving a formative influence on the young Carlo Cisventi.

Returning to one of the fundamental questions, aside from these three great weeklies (and others which were to follow in 1948, such as *La Settimana*

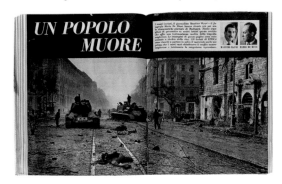

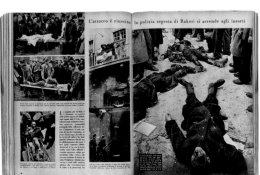

Incom, Settimo Giorno and later on *Le Ore*), how did Italy's visual culture really change? Nello Ajello, in his seminal contribution to the volume, *La storia della stampa italiana* (Laterza, 1976), cites circulation figures for the 1950s: while sales of *Oggi* and *Tempo* went up, from 500,000 to 650,000, and from 150,000 to 450,000, respectively, sales of *L'Europeo* fell from 200,000 to 180,000. Meanwhile, the old *Domenica del Corriere* retained its supremacy at over 900,000 copies sold. Alongside these publications, comic books were also very widely read in the years preceding the arrival of television. These included *Grand'Hotel*, which was still drawn, and the rival photo-based comic strips, *Bolero Film* and *Sogno* (published by Mondadori and Rizzoli). They contained endless complicated love stories set against the backdrop of the post-war period, as well as historical dramas, with actors gesturing naively against cheap backdrops. Once again, we are faced with the Italian anomaly: within the framework of a country politically divided in two, with no alternating between the poles, the comic books sold fantasy images to millions of Italian families, delaying any kind of cultural maturity.

This was in contrast to what was actually happening in the country, with the development towards consumerism, the start of a shift of floods of immigrants

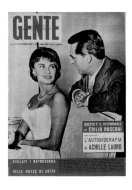
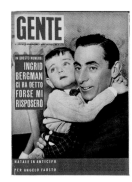
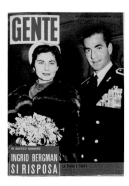

Above, three covers from *Gente*, the first two from 1957, the third from 1958.

from South to North and the transformation of the country from agriculture to industry. These trends had an impact on the dissemination of visual culture: the small advertisements for hair gel, alarm clocks, stock cubes, tinned sardines and sewing machines made way for those selling cars, washing machines and airlines. The new middle classes, more cultured and modern, seemed ready for alternative weekly magazines and for different kinds of images. At the end of 1950, Alberto Mondadori founded a new magazine, *Epoca*, under the tried and tested duo of Cesare Zavattini and Bruno Munari, in an attempt to replicate the favoured formats of *Life* and *Look*. The cover story of the first issue was 'Liliana, an Italian girl', by John Phillips. This was a kind of tribute to neo-realism, depicting normal people, in contrast to the pensive celebrities favoured by rival magazines. But Alberto Mondadori was soon replaced by Renzo Segala and later Enzo Biagi, and the populist Utopia of Zavattini did not succeed. However, *Epoca* did remain the magazine most open to new forms of photographic reporting. It bought in the Magnum spreads of Cartier-Bresson and Capa, alongside those of Eugene Smith and Cecil Beaton. It also established an in-house group of photo-correspondents, who were offered the autonomy and dignity of being able to publish signed images. It was *Epoca* which first employed Mario De Biasi, who would make such an impact with his memorable account of the Hungarian insurrection of 1956. *Epoca* devoted space increasingly to exotic locations in Africa, Japan and Latin America, or to climbing expeditions and the abysses of the sea, or to works of art – all presented in extensive colour supplements. From the ubiquitous Patellani and the diver Raimondo Bucher, to the climber Walter Bonatti, to the film maker Folco Quilici and the great travellers such as Fernand Gigon and Fosco Maraini, the pages of *Epoca* brought the taste for continuous adventures on glossy paper into the modest salons of Italy. Between 1950 and 1955 circulation increased from 200,000 to 500,000 copies.

With its up to date cosmopolitanism (which was always pro-American, as was stated at the time), *Epoca* pushed its rivals increasingly to the other extreme, towards ravaging photo-gossip, populated by princes and countesses, actresses expecting babies or awaiting divorces, family disasters and heinous crimes, all spiced up by heightened rivalry. Amidst this tide of half-length portraits in interiors (which are still an invaluable source of information regarding the interior design favoured by the rich and famous), it was rare to see accounts of the real events taking place in Italy. There are exceptions, including certain features in *Tempo* and *Epoca* on the flood in Polesine, the condition of Italian emigrants, the technology of

the mining, automobile and oil industries, the work of Italian designers and a few other themes. A very different type of magazine was the ironic liberal weekly *Il Mondo*, which was run by Mario Pannunzio (another old pupil of Longanesi) and was published between 1949 and 1966. The photo editor was the exceptional Ennio Flaiano. With its limited circulation of around 15,000 to 20,000 copies, and its preference for isolating images from text, it is impossible to compare it with the other illustrated weeklies. Nonetheless, *Il Mondo* remained a

Right, a cover of *Oggi*, in which Gina Lollobrigida announced the birth of her son, and the cover dedicated to Rachele Mussolini of August 1957.

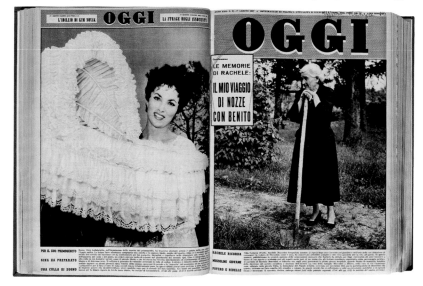

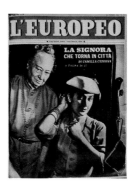

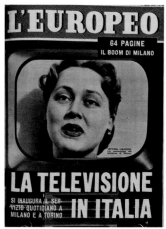

Left, a cover of *L'Europeo* from 1951, with photography by Camilla Cederna. Below, a feature on the birth of television by the Publifoto agency, from *L'Europeo*, 1952.

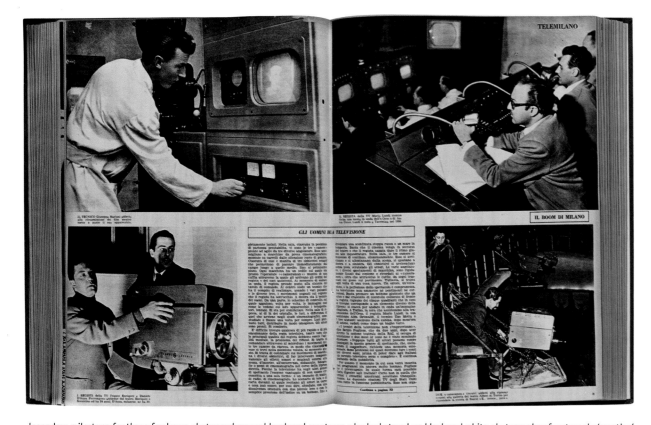

legendary milestone for those freelance photographers and hardened amateurs who had stored up black and white photographs of a strongly 'creative' bent, which they now began to publish in its pages – including Caio Garrubba, Paolo Di Paolo, Antonio and Nicola Sansone, Piergiorgio Branzi and Gianni Berengo Gardin. In fact, it was in the context of *Il Mondo* – and of *Vie Nuove* and *Noi Donne*, which were associated with the left-wing parties – that the 'Roman School' of photo-journalists was born. This was a group of courageous globetrotters who personally sold their photos to the most notable European publications, such as *Paris Match*, *Stern* and *The Guardian*, during their work assignments. According to Ermanno Rea, who counted himself among them, these Roman photographers were characterized collectively by political rigour, but individually they were neo-Romantics. They did not manage sufficient control over their output, or impose themselves as a viable alternative to the agencies in the big-selling weeklies produced in Milan. A new name emerged in 1957: *Gente*, which was a clone of *Oggi*, and with which Rusconi began his own activity as publisher, having left Rizzoli.

Another rather different entity was *L'Espresso*, which first appeared in 1955 under the aegis of Arrigo Benedetti. *L'Espresso* took up the radical political tone (anti-fascist, anti-communist, anti-Christian Democrat) which had characterized the elite of *Il Mondo*, and repeated the large format of *L'Europeo*. It was to launch scorching polemics against an Italy riddled with economic and political scandals. The big photographic portrait-caricatures of ministers (largely by Vezio Sabatini) and the irony aimed at clergy and dignitaries, were to characterize the visual politics of the weekly magazine for twenty years. It also developed alongside the Fellini-esque worldliness of the capital, chronicling its scandalous episodes with a certain complicity.

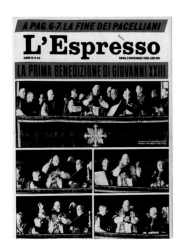

Above, cover of *L'Espresso*
from 2 November 1958.
Right, a feature by Tazio
Secchiaroli, published in
L'Espresso on 16 November
1958, in which the actress
Aiché Nanà stripped during
a party in Trastevere.

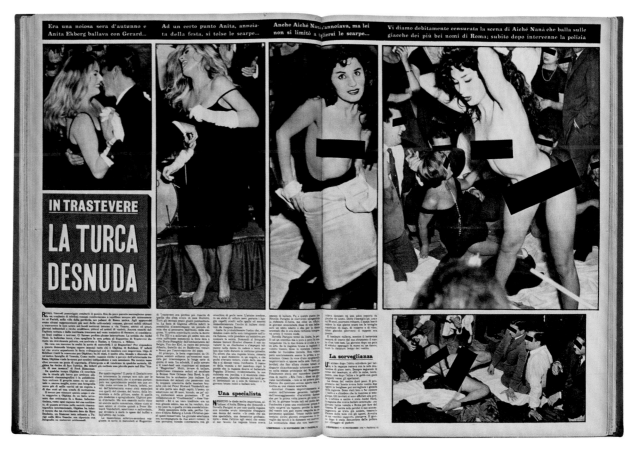

We have reached the 1960s and the end of this summary. By now the true rival to the illustrated magazines was RAI television, which in less than a decade had hypnotized the Italian family. On the other hand, the stars of the small screen were the subjects of fawning interviews in the magazines, and brought with them valuable advertising money. What won the day were the 'promotional' features, namely subliminal advertising; and photography ceased to have a narrative or an evocative function. Not all of the titles whose ascendancy we have charted were to last the distance. *Tempo*, for instance, folded in 1977, and *L'Europeo* and *Epoca* followed in 1979 and 1997 respectively. *Oggi* and *Gente* are still published today, although in very different formats. As is the case in the rest of Europe and the United States, the news magazines which prosper nowadays are in a much reduced format, comprising a mass of small close-up images of celebrities on one column and the odd double-page cover story on some event already dealt with in the television news. In Italy, the battle every week between *Panorama* (launched by Mondadori in 1962 as a monthly) and *L'Espresso* (very different from Benedetti's original magazine) is fought predominantly through the multimedia supplements sold with them. Video cassettes, CD-ROMs and DVDs offer readers music, moving images and dramas already seen at the cinema or on television. There is no longer any 'documentary' content, at least not in the same way as the old style of photo-journalism.

Neo-realism?

by Christian Caujolle

The emergence of neo-realism in cinema after the Second World War was a defining and undeniable phenomenon, and one that left its mark on the history of Italy, Europe and the cinema. In fact, it made Italian cinema the major cultural event in a continent that was still trying to deal with the atrocities of the dictators, fascists and Francoists, which had culminated in the horror of the Nazis. This brief but intense moment of cinematic creativity saw the invention of a new way to create, narrate, use actors and encapsulate the tension between fiction and reality. It was somewhere between documentary and fantasy, and could not be ignored by those working in the field. The moment was actually quite brief and should not be straitjacketed into a 'school', which in reality never existed; in fact, what is most interesting about it is how it was made possible in the first place, and how it transmuted into something entirely different.

Since Italian cinema was able to invent and then impose neo-realism at the highest level, the term itself has become something of a logo, and one that has subsequently been applied to other areas of creativity from the 1950s and 1960s. In particular, photography dating from this period has been termed as neo-realist, and exhibition catalogues have not hesitated in applying this label to all kinds of work which, while interesting, does not really belong to this category.

One particularly telling episode was the touring exhibition organized by the Galerie du Château d'Eau in Toulouse in the 1990s. One reads in the catalogue that: 'In Italy, after the Second World War, young idealists threw themselves into the great human and visual adventure of making sense of a terrible and ambiguous reality. They focused on a section of society racked by uncertainty and emigration, that sought to express itself through any means possible: the unemployed, delinquents, peasants, children... The group that grew up around Cesare Zavattini, comprising screenwriters, intellectuals, photographers and authors, represented the neo-realist movement, at once poetic and moral, but above all concerned with encountering and discovering. The work of six photographers is presented here: Carlo Bavagnoli, Mario Cattaneo, Toni Del Tin, Enrico Pasquali, Franco Pinna and Enzo Sellerio.' The exhibition, consisting of sixty-six black and white photographs, was insured for ninety-nine thousand French francs.

Without going into the ins and outs of promoting a touring exhibition, this declaration provokes a certain amount of perplexity. One thing that jars is the identification of neo-realism with the subject (the unemployed, children, ordinary people), since neo-realist cinema is characterized above all by the tension between ethics and aesthetics, using devices of demonstration and realization, rather than thematics, as André Bazin has shown splendidly. What is also curious is the list of artists included, or rather, those excluded.

Catalogue of the exhibition
Mario De Biasi.
Neorealismo e realtà.
Vintage photographs
1947–1960, Photology
Gallery, Milan, 1994.

Mario De Biasi
Courmayeur, 1953

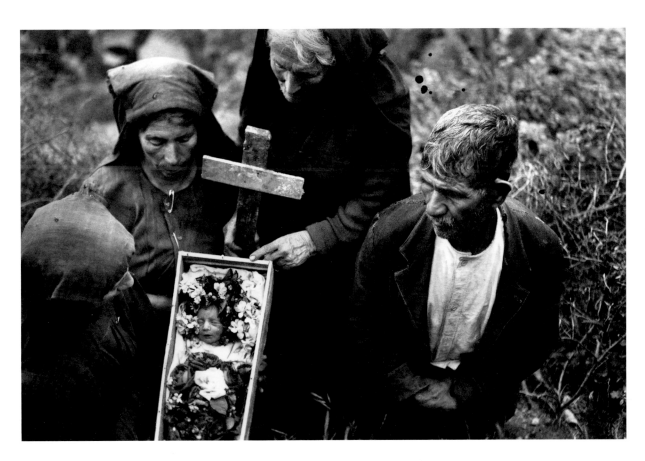

Federico Patellani
Funeral, 1947

While not wanting to cast aspersions on the quality of the photographers included in the exhibition, anyone who knows about Italian photography during the period in question would be surprised to note the absence of Mario Giacomelli and Ugo Mulas, who were the foremost artists of their day. Equally, one again cannot help but be surprised at the exclusion of Federico Patellani, who was such a success in the field of photo-journalism, precisely at the time when Roberto Rossellini was developing his epoch-defining cinematic realism, or the young Berengo Gardin was busy exploring social and political themes. The reason for these oversights is essentially quite straightforward: for all their quality, these artists do not fit into a mould. The very fact that these important figures cannot easily be defined as neo-realists must surely pose the question of how relevant this concept – so magnificently developed in film – is in relation to photography.

Clearly, Giacomelli, who was the most significant creator of images of his time, cannot be classed as a neo-realist. And yet, there is one aspect of his work which could be termed 'neo-realist', insofar as it shares a fundamental interest with neo-realist cinema – namely the creation of a unique relationship between the external world and the image, in which the latter is entirely dependent on the former but also goes beyond it. Giacomelli concerned himself with, among other things, peasants, country folk, children, the elderly and popular beaches (although whether it was a real interest, or whether he merely made use of them, is another matter). Poet that he was, he melded together worlds on the point of extinction, obliging us to look at them in a different

way in the process. To achieve this, he chose unconventional viewpoints, physical and otherwise, and dared to shock, by confronting the viewer very directly with the effects of ageing, heightened by unforgiving lighting. While it would not be entirely inappropriate to rethink Giacomelli's oeuvre in relation to neo-realism, it would also be dangerously limiting. His evident preoccupation with reality is only relevant in terms of how he managed to sublimate it, to throw it into crisis, or distance himself from it. But Giacomelli is Giacomelli, a unique creator, and I have not the slightest intention of putting him into any kind of box.

The same could be said of Mulas, whose *Verifications* series says more about his exploration of the nature of photography than any text could possibly do. Patellani, meanwhile, was without a doubt one of the most interesting documentarians of the period. And yet he was primarily an effective professional, notable for his efficiency, but in no measure a neo-realist because he had no aesthetic agenda. The best one can say is that he was a shrewd aristocrat who had a commercial agenda, which he pursued with astounding ability.

Mario Giacomelli
from the series *There Are No Hands to Caress My Face,* 1961–63

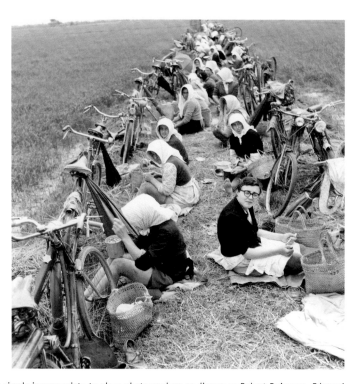

Catalogue of the exhibition
El neorrealismo en la fotografía italiana, **ed. Enrica Viganò, PhotoEspaña, Madrid, 1999.**

As for Gianni Berengo Gardin, who in my opinion came closest to the risks of neo-realism, he was too constrained by the requirements of the press at that time to propose any radical new visual themes.

The question of whether there ever was such a thing as neo-realist photography in Italy forces us to take a new look at that other great trend in European photography of the same time, which has now been renamed romanticism, or humanism, by the French. It has been evident for some years now that it is simply inappropriate to place photographers as diverse as Robert Doisneau, Edouard Boubat, Izis, Willy Ronis, Daniel Frasnay and Sabine Weiss in the same category, as if they constituted a 'school'. They might have shared an interest in ordinary people, in anecdote, in a certain visual poetry, in a tenderness and capacity for humour that tied them to Jacques Prévert, but this is not enough to justify calling them a movement, or to ignore how distinct each of them was. When someone has the courage to exhibit the 'dark' Doisneau, at times despairing of his own painful tenderness for borderline characters, we shall be forced to tear up our simpering image of 1950s French photography – and to re-evaluate someone like Frasnay, whose impossible character and suicide attempts have obscured a great body of work. It is also time to put artists such as Christer Strömholm, Gotthard Schuh and Jakob Tuggener back in the spotlight where they belong. Nowadays, there is a strong tendency to do anything to avoid looking history in the eye, including putting artists into categories created fifty years ago, even though they are entirely unique – although it has to be said that they themselves often accepted being bunched together, out of laziness or weariness, or simply in order to survive.

Let us return to neo-realism, and so to André Bazin; to Gilles Deleuze, who identified and analyzed this extremely significant moment in the history of representation; and to Serge Daney, who, in an exemplary fashion, highlighted the aesthetic, and also political, risks taken by Roberto Rossellini in the making of *Rome, Open City*.

One should dismiss, or at least place into historical context, the declaration which Bazin made in 1945 that 'the originality of photography, in contrast to painting, comes from its essential objectivity.' Aware that his first assertion could be open to criticism, he concludes subtly, saying that 'the personality of the photographer only comes into play through the choice of subject matter; and however much it may be visible in the completed work, it is never as present as it is in painting.' His approach to the 'Ontology of the Photographic Image' is evidently influenced by a desire to underline the 'realism' of cinematography. In this way he poses the question of the perverted temporality of the image, sadly without providing an answer.

On the other hand, one should reread closely what Bazin has to say about Italian cinema, and about neo-realism: 'The topicality of the script, and the veracity of the acting are still the raw materials of the aesthetics of Italian films. And one should be careful not to sacrifice aesthetic refinement to the immediacy of a realism which is content merely to depict reality. In my opinion, Italian cinema should be applauded for remembering once again that there never was "realism" in art that was not profoundly "aesthetic".'

If we exclude Giacomelli – whose work it is neither useful nor legitimate to reduce to trends – this is precisely what was missing from Italian photography, and what has often, for the sake of convenience, been termed 'neo-realism'.

Italian neo-realism was a cinematic movement lasting only a decade, made possible by the infrastructure put in place under Mussolini, and owing much to Jean Renoir, as well as something to René Clair. It represented, through its own cinematic fiction, a model of reality that was different to that offered by Hollywood, German expressionism or the French tradition. It was innovative, unique and legendary. But this does not mean that it contaminated other expressive media, and certainly not photography. The assertion that there is no such thing as 'Italian neo-realist photography' does not belittle the work of artists who were passionate and talented. One merely has to avoid mistaking the product because of the label. Leaving aside Giacomelli and Mulas, who were very different kinds of artists, one must conclude that Italy provided no new solutions in the immediate post-war period. And neither of these two were neo-realists. It was only in the 1970s that brilliant new solutions were put forward in Italy, giving particular attention to issues of space, landscape and colour. The originality of this work only serves to accentuate the fact that, apart from the two exceptions already cited, what we had before were excellent documentarians and photo-journalists, who might have been in

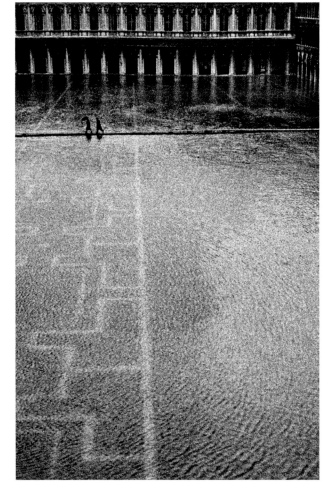

tune with their time, but never constituted a neo-realist movement in photography.

On 10 December 1950, in issue no. 50 of *L'Europeo*, Alberto Moravia penned an article which is useful to consider in reference to the images collated in this book: 'Neo-realism in film is far from having exhausted its potential to inspire or be topical. It responds, in relation to cinema, to the need felt immediately following the war, to take account of all the deficiencies which brought about our national undoing and disaster.' He continues: 'Italy, in the course of its history, has never, or at best rarely, engaged in theatre or novel writing – a sign that Italian society has never wanted to know or criticize itself, nor really to improve itself. In effect, what was needed to instil in large numbers of Italians a real curiosity about the "real" events that were unfolding was a catastrophe of the magnitude of 1943, with Italy cut in half, divided between two foreign armies which fought on her land, like the Goths of Totila and the Greeks of Belisarius. One should be aware of the fact that it was cinema, to an even greater extent than literature, which satisfied this praiseworthy curiosity, at least in part. The poor and the unemployed, who comprise the vast majority of the Italian population, have made their appearance on the big screen, which up until now only concerned itself with secretaries, white telephones and adulterous love triangles. But still not everyone is happy. I remember hearing in a Roman salon a woman, who was much

Left, catalogue for the exhibition *Realismo Lirico. Il gruppo friulano per una nuova fotografia*, ed. Italo Zannier, Centro di Ricerca e Archiviazione della Fotografia, Spilimbergo, 2002.
Above, Ennery Taramelli, *Viaggio nell'Italia del neorealismo. La fotografia tra letteratura e cinema*, SEI, Turin, 1995.

Gianni Berengo Gardin
Flooding in Venice, 1960

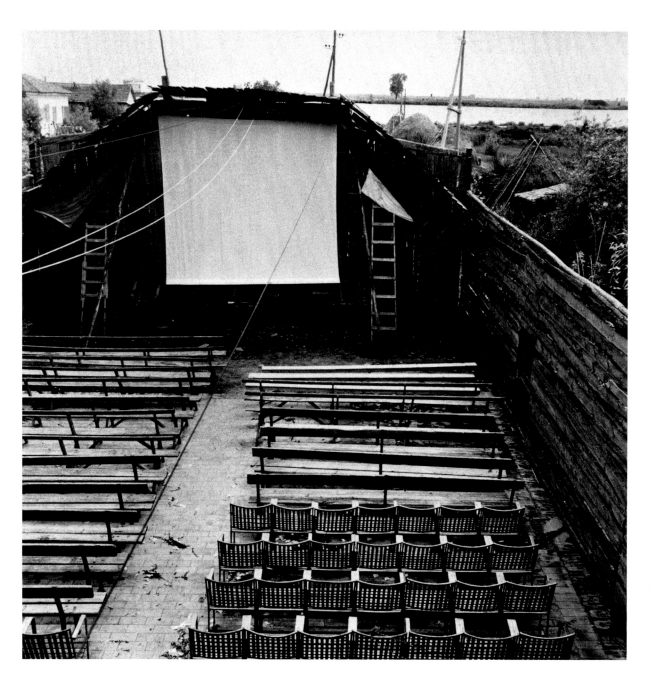

travelled, complain because neo-realist films denigrate us in other countries, by presenting us as a people in rags. "There are so many beautiful views in Italy", she said, "why not make a film of all of those beautiful views?" I answered, of course, that the only way to stop the poor appearing in films was to make them disappear, by making them better off. But the woman was not convinced.'

Quite apart from this contemporary anecdote, a more serious and fundamental issue remains: that of realism in photography. Since photography could not exist if it were not preceded by something in the three-dimensional universe, it is constrained to enter into a dialogue with tangible reality and with realism. It is a witness of a vanished reality, while at the same time expressing a subjective viewpoint of reality. It does not bring with itself any reality and it cannot be condemned for falsehood, wavering instead between representation and interpretation. It was obviously at the heart of the possibilities of neo-realism. But unfortunately it missed its chance and, unless the contrary is proven, between 1944 and 1975, there was no realist photography, only passionate artists.

Experiencing Landscape

by Roberta Valtorta

It is well known that 19th-century Italian photography had important roots in the landscape. We still refer to Italy as the *Bel Paese* (the beautiful country), citing, often unwittingly, the title of the fundamental work published in 1878, by the abbot Antonio Stoppani. It is a place of great natural and artistic beauty, and a classic destination of visitors on the Grand Tour. It inspires a sense of the antique, an admiration of the beauty afforded to it by nature, an awareness of great art treasures, and the search for the typical and folkloristic. On the one hand, photography could act as a unifying cultural tool, while on the other, more concretely, it could give photographers a profession: that of reproducing works of art, and creating views and images of architecture, monuments and landscapes. In this way, the photographers took the place of engravers and draughtsmen and, as a result, photographic studios sprang up in many important cultural centres. One emblematic example is the studio founded by the Alinari brothers in Florence in 1852, which developed a consistent editorial tradition and eventually also became a museum. The Alinari brothers created an absolute vision of the Italian environment, which was strongly linked to the Renaissance perspective and became imprinted on the international collective memory. In contrast, by the turn of the 20th century, the Italian Touring Club developed the 'illustrative' style, which in turn imposed itself on the Italian consciousness, confirming Italy as a place of art, nature and holidays. With the advent of television, the familiar topoi of landscapes of the *Bel Paese* were perpetuated, with RAI showing black and white photos of views and monuments, similar to postcards and accompanied by music, in the intervals between programmes.

Despite all of this, there was a lack of continuity in the relationship between Italian photography and landscape, which resulted in a dearth of significant landscape photographers. Nor did the important developments of 18th-century landscape painting have a sufficient influence, even though Italian photography continued to make reference to painting in its struggle to find its own cultural space. While pictorialism was dominant, photography in Italy, as elsewhere, created poetic visions of landscape, of a symbolist or impressionistic bent. With the advent of modernism, photography turned its attention to the industrial environment of the 1930s and 1940s – but it was not until the post-war period that artists emerged who concentrated on landscape as the object of sustained enquiry. For them, the external environment was a canvas onto which they projected more general preoccupations about the world and existence. This was, of course, a critical period for the future of a country which had experienced a haphazard and violent process of industrialization. Chief among these artists was the great Paolo Monti, with his dense, austere images of Venice, Milan and other major cities. He also paid attention to the countryside, most particularly the Val d'Ossola, and was personally involved in public development projects. The other great protagonist of this period was Mario Giacomelli, whose interpretative vision was still very much linked to a linear-pictorial style, through which he transformed the rural landscape into an expressionistic palette, uniting nature with the peasants who worked it.

Above, *Paolo Monti e l'età dei piani regolatori (1960–1980)*, Edizioni Alfa, Bologna, 1983. Right, *Viaggio in Italia*, eds. Luigi Ghirri, Gianni Leone, Enzo Velati. Il Quadrante, Alessandria, 1994.

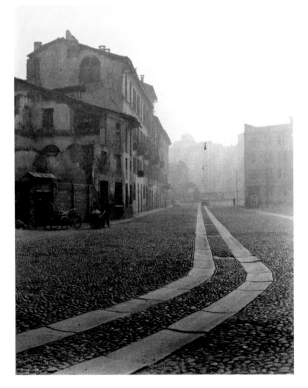

Paolo Monti Milan, 1955

L'Insistenza dello sguardo.
Fotografie italiane 1839–1989,
eds. Paolo Costantini, Silvio Fuso, Sandro
Mescola, Italo Zannier.
Alinari, Florence, 1989.

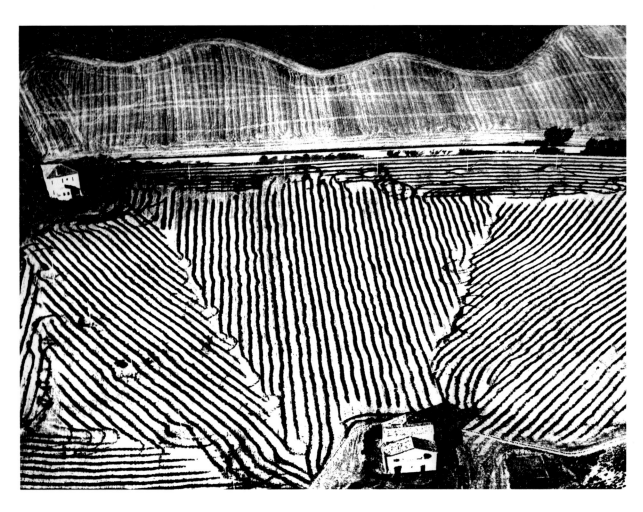

Mario Giacomelli The Dying Earth, 1962

If Giacomelli was an isolated case during his own time, subjecting the reality of landscape to abstraction and sublimation, then the older Monti was more modern in the way in which he represented the environment. He worked systematically and vigorously in the public sphere (during the 1970s he was assiduously employed by the Istituto dei Beni Culturali [Ministry of Culture] of the Reggio Emilia region to make surveys of historic towns), an experience which makes him all the more significant as both an artist and an intellectual – and very contemporary. Monti grasped how important photography could be with regards to the consciousness of conservation and building work in the historic towns and elsewhere, realizing that it could have new civic functions, which were only really understood later during the 1980s and 1990s.

From the post-war period to the 1960s, Italian photography was still largely dominated by reportage – by the narration of human stories and customs, as encouraged by the proliferation of illustrated magazines and the climate of neo-realism. Yet with the political, social and cultural upheavals of the 1970s, photography was no longer able to limit itself to this role of illustration and narration, however noble. It embarked instead on a period of

self-exploration, prompted to a certain extent by the dominant role that had been assumed by television. In the frenzy of activity, and of flux, the poetry of the 'decisive moment' no longer seemed enough, nor was it tenable on a conceptual plane. In fact, this was a time when many photographers moved away from their interests in society and in narrative. It was to the landscape that these artists turned, in their pursuit of 'verification' (to use the title of the famous works by Ugo Mulas from the early 1970s) and their attempts at updating the photographic language. The external world, as experienced through the apparatus of photography, was the catalyst for an exploration not only of the subject, but also of the photographic process itself, and of the artist's role within that. A case in point is Mimmo Jodice, who abandoned his early, screeching, accounts of Neapolitan society, to explore the reality of landscape and the photographic image, using a conceptual vocabulary. For Gabriele Basilico, who had begun as a reporter, the urban, industrial landscape provided the starting point for his journey of reflection, which he continued to pursue over the years. Roberto Salbitani also made a definitive break from traditional modes of reporting, to cast a melancholy glance at the urban environment as a place of solitude and alienation. In the early 1970s, Guido Guidi began his work on small, banal, everyday locations, while Mario Cresci moved from working on the area around Lucano in an urbanistic-anthropological vein, to a semantic 'measuring' of both landscape and photography. Finally, Luigi Ghirri embarked on a fundamental exploration of conceptual art, as in his emblematic *Atlante* (Atlas) of 1973, which represents a mental voyage across every possible global terrain, using the visual language of cartography. This was the start of an extensive interrogation of landscape which was to occupy Ghirri up until his premature death in 1992. He involved numerous other photographers in his projects, including those mentioned above, in addition to Fulvio Ventura, Giovanni Chiaramonte, Carlo Garzia and Gianni Leone. He also encouraged a younger generation, which included Olivo Barbieri, Vincenzo Castella and Vittore Fossati, all of whom shared Ghirri's sensitivity to the international scene, and to landscape as a way of exploring their own interests. They were influenced by a variety of trends and artists, including Eugène Atget, Paul Strand, Walker Evans, Robert Frank, Lee Friedlander, the New Topographics, Bernd and Hila Becher, Lewis Baltz, Robert Adams, Stephen Shore, and Americans like Joel Meyerowitz and William Eggleston. They were open to pop art, conceptual art, land art and minimalism, and were influenced by the neo-realist attention to the provinces and everyday life. A new poetry of landscape emerged among these photographers, as they looked above all at areas undergoing a process of transformation. In the 1970s and 1980s, these artists were grouped under the banner of the 'New Italian Photography', although in the 1990s they came to be known as the 'Italian School of Landscape'. They worked at creating a new vision of landscape in photography, while taking Italian photography itself in a more contemporary direction – one which was more problematic, and capable of entering into a dialogue with the international artistic community.

Luigi Ghirri From the series *Atlante*, 1973

Right, Arturo Carlo Quintavalle, *Muri di carta. Fotografia e paesaggio dopo le avanguardie*, Electa, Milan, 1993. Far right, Achille Sacconi and Roberta Valtorta (eds.), *1987–97 Archivio dello Spazio. Dieci anni di fotografia italiana sul territorio della Provincia di Milano,* Art&, Udine, 1997.

The first constructive moment in this new tendency was Ghirri's *Viaggio in Italia*. Conceived between the end of the 1970s and the beginning of the 1980s, and preceded by certain publicly funded projects on Naples (the first being 'Naples '81. Seven Photographers for a New Image'), it came together in 1984 with an exhibition and a book containing the work of twenty photographers. The school was a composite one from the beginning, comprising many different personalities, who were joined over the years by other artists, including Francesco Radino, George Tatge, Roberto Bossaglia, Andrea Abati, Gianantonio Battistella, Bruna Biamino, Martino Marangoni, Paolo Rosselli, Moreno Gentili, Giampietro Agostini, Marina Ballo Charmet, Luca Campigotto, Walter Niedermayr, William Guerrieri, Paola De Pietri, Piero Delucca, Marco Zanta, Francesco Jodice, Marco Signorini and many young talents whose work still bears the mark of that important period.

This project proved to be a real turning point. The emphasis was not only on the Italian provinces and the margins, but also on cities, gardens and country houses. The economic boom had already done its damage and Italy was filling up with advertising posters, ugly villas, warehouses and endless suburbs, although at this point the chaos was still contained. The photographers of *Viaggio in Italia* not only analyzed this aspect of the country, but they lay the foundations for others to study the new landscapes of shopping centres, dead industrial sites, the density of built-up areas, the new residential districts, and the incoherent way in which people live cheek by jowl with the needs of commerce.

The renewal of the aesthetic language went hand in hand with a cultural strategy which saw public bodies sponsoring the experiments of the photographers, who were busy constructing a new identity for themselves: no longer professionals in the traditional sense, nor amateurs, but artists who conceive an idea of landscape, while also performing a cultural function

Mario Cresci From the series *Rotazioni*, 1974

by communicating with the public. The 1980s were characterized by public commissions, with local governments funding numerous projects to explore the contemporary landscape. Variations of these projects continued into the 1990s as well. One such instance was 'Archivio dello spazio', a big, systematic project, promoted by the Province of Milan. Between 1987 and 1997, fifty-eight photographers from different generations worked in almost two hundred locations to produce a detailed reading of the complex and tortured environment around Milan. It constituted a kind of laboratory, which collated and brought to maturity the full range of work and conceptual elaborations on the theme of landscape that had been developed up to that point in Italy. In this sense, the 'Archivio dello spazio' should be viewed today not only as a point of arrival, the coming of age as it were of a whole cultural season of Italian photography, but also as a symbolic moment of reflection on the relationship between traditional architectural forms and the transformation of the post-industrial landscape – a relationship that is central for the country.

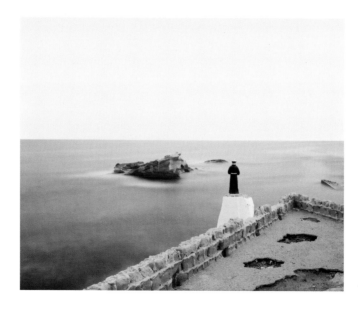

Vincenzo Castella Posillipo, Naples, 1985

Many other important publicly funded projects were emerging in both Italy and Europe, at around the same time as the Milanese experiment. In fact 'Archivio dello spazio' itself was to be taken up by other sponsors, continuing under the titles of 'Milano senza confini' between 1999 and 2000 and 'Idea di metropoli' between 2001 and 2002. One initiative commissioned by the French Government was the seminal 'Mission Photographique' of the Délégation à l'Aménagement du Territoire et à l'Action Régionale (1983–89); another was the 'Mission Photographique Transmanche', which began in 1987 under the auspices of the Centre Régional de la Photographie Nord-pas-de-Calais. Other projects in Italy included the 'Linea di confine per la fotografia contemporanea', sponsored by Rubiera and other local governments in Emilia-Romagna in

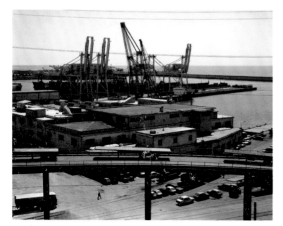

1990, and the 'Osservatorio Venezia-Marghera', which was set up in 1997. These are just some of the numerous initiatives which testify to the central position of the theme of landscape in contemporary culture.

Several important exhibitions further underline the importance of landscape in the development of contemporary photography. We shall here cite only those that had particular relevance for Italy: 'Ciutat fantasma' held in Barcelona in 1985; 'Dialectical Landscapes. Nuovo paesaggio americano', in Venice in 1987; the broad historical collection 'L'insistenza dello sguardo. Fotografie italiane 1839–1989', also held in Venice (1989); the 1993 'Muri di carta', at the Venice Biennale; and, finally, 'Da Guarene all'Etna', in 2001, sponsored by the Fondazione Re Rebaudengo, which attempted to bring Ghirri's *Viaggio in Italia* to completion, using different artists.

In 2000, the Italian Ministry of Culture took contemporary landscape photography into account for the first time. At the opening ministerial session of the European Convention on Landscape, held at the Uffizi in Florence, the state presented the exhibition 'Luoghi come paesaggi', together with the group Linea di Confine per la Fotografia Contemporanea. These brought together the most important public commissions of the 1990s. Immediately following this, at the end of 2002, the Ministry set up the commission/competition entitled 'Atlante italiano 003', involving thirty Italian photographers. Their brief was to provide interpretations of certain locations in the complex Italian landscape, which were

Gabriele Basilico Genoa, 1985

Mimmo Jodice Syracuse, 1990

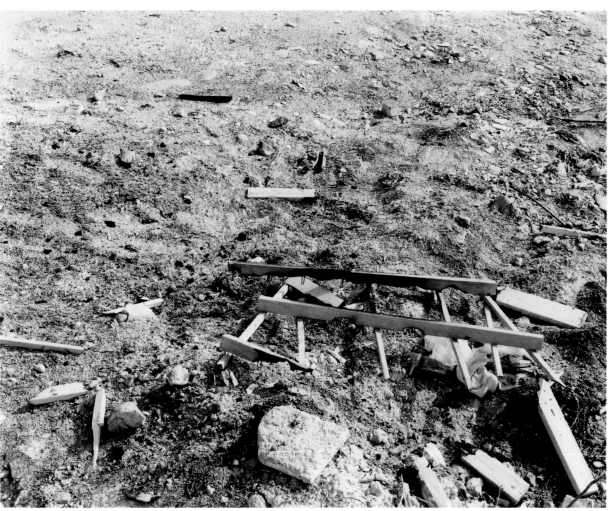

Guido Guidi 13,863 km 29, Ex Zuccherificio, Cesena, 2000

considered 'hotspots', forever divided between past and present, between beauty and economic development. The word 'atlas', used by Ghirri in 1973, makes a reappearance after thirty years and confirms the need felt in our culture – expressed in this case at the highest official level – to enter into a relationship with the landscape through photography.

The Discipline of Design

by Aldo Colonetti

Looking at sixty years of Italian history through the journals of architecture, design and graphic art requires an initial consideration of the aesthetics of the country – of cities, houses and the broader culture of visual communication which mirror our everyday lives. We are faced with a strange dichotomy in Italy: we produce more journals on architecture and design projects than anywhere else in Europe, journals which are known and quite rightly respected throughout the world as belonging to the avant-garde; and yet, the quality of the architecture that is actually built in this country is problematic to say the least. It is as if there is a gulf in taste between how we live collectively and the private dimension of our homes, where the average quality of space and decoration is without a doubt superior to the rest of Europe, and perhaps even the world. Italian style works better where there is no need for significant structural investment, or complex project management. The Italian journals dedicated to the disciplines involved in the design process during the period in question reflect this fundamental ambiguity, demonstrating a real willingness to engage with international developments, to debate the problems peculiar to Italy, and to enter into theoretical debates. And all of this is presented within an exceptional editorial framework, with high-quality images and layouts that are a characteristic of our aesthetic tradition.

The way in which the design process is documented in Italy comes out of two fundamental tendencies: on the one hand, there is the propensity towards reflection and eclecticism that is typical of our culture, while on the other, everyone, from the critics and designers to the modes of production, the market and the oscillations of taste and custom, is represented as one entity on the international stage. All of the protagonists, even when operating in isolation, still feel that they belong to an idea, a tradition, a brand: 'Made in Italy'.

In this way, despite the contradictions and anomalies of the Italian system, where it is actually easier to emerge as an individual than as part of a coherent and homogeneous whole, entirely separate disciplines work alongside each other, in order to document and communicate an aesthetic vision of the world. This vision encompasses cities, landscapes and everyday objects, and is articulated in journals which play with the traditional roles of form and content. For Italian design culture, a journal dealing with architecture and design is not merely a publication, but is a work of art in itself, akin to the more traditional works of building, industrial products and urban planning. An historical analysis of the last sixty years, from the end of the Second World War to the present, reveals how a new concept of our country emerged out of a series of significant moments and problematic transitions, and was nurtured and disseminated in tandem with the design journals. Italy had been beaten politically and militarily, and only gradually rediscovered its identity. There were two main aspects to this: on the one hand, there was a successful return to the country's artisan roots, which were based in the Renaissance workshop, where everything contributed to the unique and inimitable whole, be it master and apprentice, the respectful attitude towards materials and technology, or, above all, those philosophical or literary skills which would seem far removed from workshop practice. On the other hand, Italy was also getting to grips with the transformation of the production process, on both a practical and a theoretical level.

It is hardly coincidental that the most revolutionary phases in the development of design publishing were instigated by exceptional people, who do not fit into the world of academic disciplines. Chief among these was Elio Vittorini, founder and editor of the journal *Il Politecnico* (1945), which was designed by Albe Steiner and represented the first journal in Italy, and probably anywhere, in which words and images work together on an entirely equal footing. *Il Politecnico* is a cultural journal, which looks at the design process and workshop practice, at cities and architecture. The journal itself is a complete work, with the same characteristics as an architectural project. It is a serial product with a double significance: aesthetic and semantic. The content determines the form, but at the same time, the use of the most advanced experiments in visual communication and design become a determining factor in how the writing is organized. In the words of Paolo Fossati, who was one of the most perceptive scholars in the relationship between

Front page of the first issue
Il Politecnico, 29 September
1945, designed by
Albe Steiner and edited
by Elio Vittorini.

From the left, covers of: *Stile e industria* no. 8, 1956, designed by Michele Provinciali; *Pirelli* no. 5, 1959, by Giulio Confalonieri and Ilio Negri; *Pagina* no. 3, October 1963, by Pino Tovaglia; *MarcaTre* no. 11/12/13, 1964, by Giulio Confalonieri.

Cover of the first issue of *Ottagono*, 1966, designed by Unimark International, edited by Sergio Mazza and Giuliana Gramigna.

Luigi Ghirri Parma, 1985

publishing and the culture of design: 'A highly sophisticated game was being played in the publishing world between 1945 and the 1960s, which involved all aspects of the work of a graphic designer such as Albe Steiner. If graphic design really can add clarity to the way in which information is presented, and to the verbal and visual nature of a book or journal, it is also the quality of graphic design that gives a newspaper or a magazine a value which transcends the object itself. It was having to address a mass audience which really triggered the full potential of such publications.'

In a country still behind the rest of Europe in terms of industrial development, the world of design found its cultural redemption in specialist publications dedicated to the applied arts. The contributors to these journals came from many different disciplines: there were philosophers such as Antonio Banfi, Enzo Paci and Gillo Dorfles; architects like Gio Ponti, Ernesto Rogers, Alberto Rosselli and Vittorio Gregotti; men of industry such as Augusto

Morello, Adriano Olivetti and Cesare Brustio; poets such as Leonardo Sinisgalli and graphic designers, including Albe Steiner, Max Huber, Bruno Munari and numerous others. They were thrown together, with no thought for disciplinary boundaries, and they interpreted the term *progetto* (design/plan/project) as one of anticipation. In Italian, the word *progetto* implies, first of all, a reference to the future and, secondly, an awareness of possibilities. The process of designing is therefore an act of anticipation, which can be qualified as possible in the future. Leaving aside the various categories of design, which we shall go into shortly, these journals can all be placed under the same umbrella category of 'the possible', which does not always necessarily correspond to that other category of 'reality' – especially in the Italian context. This helps to explain the often problematic relationship between the incredible quality of theoretical elaboration, as seen by an international audience in the journals on architecture and design, and the reality of what is actually built in Italy, which is always inferior, or at least constantly bringing up the rear in terms of innovation.

It is difficult to draw up a complete list of the design journals that have come out in Italy over the last sixty years, because sometimes they came out of a very particular theoretical or political contrivance and, as such, did not have a lasting impact on the market of ideas. In any case, there are more than fifty titles which have made a real contribution in this area, and even those that are no longer being published can still have contemporary relevance for our understanding of Italian culture. Certain key figures, such as the great critic of art, design and architecture, Gillo Dorfles, were so present in the cultural debate on design, that they contributed pieces on both theory and practice to almost all the journals that came out during this period. In fact, a recent collection of Dorfles's writings on architecture, edited by Letizia Tedeschi and published by the Architectural Academy of Mendrisio (Switzerland), contains over one thousand seven hundred articles.

This specialist sector of publishing can be divided into four main categories. Journals on architecture, design and graphics are accompanied by those on theory, which provide the main forum for debate where these disciplines are concerned. Regardless of the quality of their content, these journals are all identifiable as belonging to the culture of design from the way in which they are put together: the visual material, the layout of articles, the rigorous

choice of lettering, which are all fundamental characteristics of these creative disciplines. This effectively means that content and form are inseparable, one of the key points of modernism, which transcends fashion and is one of the vital differences between chronicle and history. Furthermore, my categorization is by no means absolute and, in fact, it is precisely the multidisciplinary nature of the Italian design culture that makes it unique.

The list of architectural journals is extensive, and must begin with *Domus*. This was founded by Gio Ponti in 1928, with the fundamental input of Cesare Casati, using the photographs of Giorgio Casali and later, from the 1980s on, Gabriele Basilico and

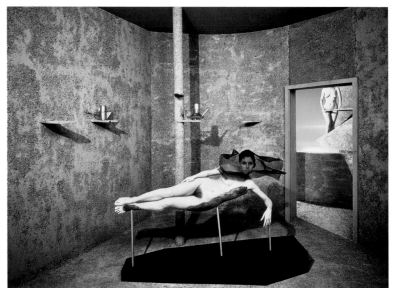

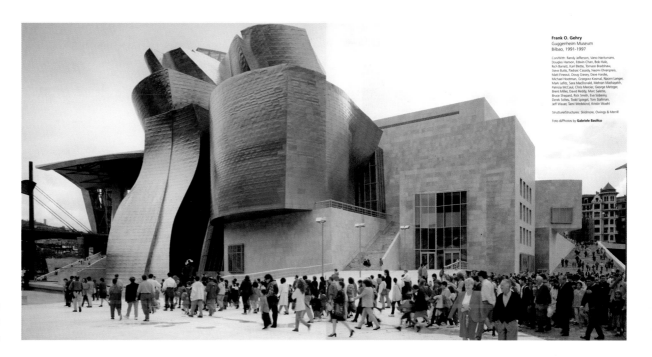

Frank O. Gehry
Guggenheim Museum
Bilbao, 1991-1997

ConWith: Randy Jefferson, Vano Haritunians,
Douglas Hanson, Edwin Chan, Bob Hale,
Rich Barrett, Karl Blette, Tomaso Bradshaw,
Steve Butts, Padraic Cassidy, Naomi Ehrenpreis,
Matt Fineout, Doug Geisey, Dave Hardie,
Michael Hootman, Grzegosz Kosmal, Naomi Langer,
Mark Lehtz, Sara MacDonald, Mehran Mashayekh,
Patricia McCaul, Chris Mercier, George Metzger,
Brent Miller, David Reddy, Marc Salette,
Bruce Shepard, Rick Smith, Eva Sobesky,
Derek Soltes, Todd Spiegel, Tom Stallman,
Jeff Wauer, Tami Wedekind, Kristin Woehl

Strutture/Structures: Skidmore, Owings & Merrill

Foto di/Photos by Gabriele Basilico

Double-page spread from *Lotus* no. 98, September 1998, with photography by Gabriele Basilico.

others. This was edited over the years by a series of key figures in the field: Alessandro Mendini, Mario Bellini, Vittorio Magnago Lampugnani, François Burkhardt and Deyan Sudjic. In the words of that perceptive writer on customs and culture, Beppe Finessi: '(*Domus*) is always open to the whole world, just as it is open to the smallest of things'.

Other titles include *Casabella*, *Abitare*, *Costruire*, *l'Arca* and *Area*, all of which document architectural and design projects, alongside major cultural debates. Above all, this is the context which saw the emergence of the great Vittorio Gregotti, an intellectual with extensive theoretical and philosophical interests, who 'lent' himself to architecture, as a place where ideas were allowed to happen. He frequently worked with another important figure on the international scene, Tomás Maldonado, who produced seminal work on the problems of utopian planning and the environment. *Rassegna*, meanwhile, which came out three times a year rather than four, was also edited by Gregotti, and contained a series of articles by the greatest architectural theorist of the 1950s, Manfredo Tafuri. Other journals include *Lotus*, edited by Pier Luigi Nicolin, using the images of Luigi Ghirri, Giovanni Chiaramonte and Paolo Rosselli; *Zodiac*, an incredible cross between a book and a journal, with art directors Massimo Vignelli and Roberto Sambonet; *Hinterland*, the creation of Guido Canella; Luigi Moretti's *Spazio*; *Contropiano*, *Controspazio*, *Habitat* and *l'Architettura*, all edited by Bruno Zevi; and *Edilizia Moderna*, with its extraordinary covers designed by Michele Provinciali.

Pier Luigi Cerri and Italo Lupi have not only been great editors (the latter at *Abitare*, for instance), but they have also been exceptionally innovative in terms of the presentation of design projects. In fact, one might discuss their work in terms of 'meta-designing', reflecting their own particular vision of architecture. Let us not forget, among the most recent additions, the weekly *Crossing*, edited by Burkhardt, which is a veritable goldmine of ideas for the future, and *Il Giornale dell'Architettura*, which is a monthly newspaper in tabloid format edited by Carlo Olmo.

In the forefront of industrial design was *Stile Industria*, founded and edited by Alberto Rosselli (1954–63),and then relaunched for a while in the 1990s by Augusto Morello. Other titles include *Interni*, which since 1954 has charted 'the traditions and habits of domesticity and good taste'; *Casa Vogue*, the brainchild of Isa Tutino Vercelloni, and a visual training ground thanks to the contributions of Studio Ballo & Ballo and Studio Azzurro; *Gran Bazaar*, edited by Barbara Nerozzi, with images by Occhiomagico and Studio Azzurro, among others; *Modo*, which was one of the most open venues of the 1980s, under the direction of that brilliant seismographer of style, Alessandro Mendini, and later edited by Andrea Branzi and Franco Raggi; *Ottagono*, the journal that came out every three months between 1966 and 1988, charting the development of Italian design, under Sergio Mazza and Giuliana Gramigna, followed, up until 1992, by ten 'definitive' issues on architecture, edited by Marco De Michelis. This latter contribution

has now become a monthly, under the stewardship of Aldo Colonetti, and is a real instrument for the documentation and dissemination of design as a language of difference. It is published by Editrice Compositori, which is also responsible for *Rassegna*.

Casabella, under the current direction of Francesco Dal Co, has now also opened up to design through the work of Alberto Bassi, who edits the only online design magazine, *Design Italia*, which was founded by Valerio Castelli. One figure who has always been around in this arena is Ugo La Pietra, currently responsible for the journal *Artigianato tra Arte e Design*, the only publication to cover the important area of artisan production. As far as graphics and visual communication in general are concerned, we should cite, alongside the fundamental *Campo Grafico*, the relaunched *Linea Grafica*, edited by Giovanni Baule and designed by Vando Pagliardini, who was awarded the Compasso d'Oro (Golden Compass) in 1987; and *Grafica*, founded by two intellectuals and designers from Salerno, Gelsomino D'Ambrosio and Pino Grimaldi, which is a storehouse of ideas and theoretical and philological elaborations. As for graphic design, the unique *Pagina*, which was designed by Pino Tovaglia, from the early 1960s, deserves a mention. Then there is the most recent contribution to the theoretical side of things: *N.B.*, edited by Fulvio Cardarelli.

Casabella no. 644, March
1997, designed by
Tassinari/Vetta Associati
and edited since 1996
by Francesco Dal Co.

Entirely removed from any concept of distinct disciplines is the poetic vision of Ettore Sottsass. As Finessi observed: 'He has transformed his desire to communicate into a series of journals'. Namely, *Room East 128 Chronicle* (1962), *Pianeta fresco* (1967), with Fernanda Pivano and Allen Ginsberg, and *Terazzo* (1987), edited by Barbara Radice.

Finally, there is that uniquely Italian sector of publishing that is made up of the journals dealing with the whole culture of design, both in terms of publishing and theory. One need only think of *Il Politecnico* of Elio Vittorini and Albe Steiner, or the philosophical journal, *Aut Aut*, founded by Enzo Paci, and designed by Bob Noorda. This latter journal has featured writings by Gillo Dorfles, Augusto Morello, Vittorio Gregotti and many others and has dedicated itself to the problems of design and architecture. There is also *Il Verri*, which was founded by Luciano Anceschi and has now been relaunched by Giovanni Anceschi, taking on board problems of experimentation in both word and image. Other titles include *Op.Cit*, edited by Renato De Fusco; *Sfera*, founded and edited by Giulio Macchi; *MarcaTre*, *Civiltà delle Macchine* and *Pirelli*, with graphics by Giulio Confalonieri and Ilio Negri.

Two other journals stand out as original contributions to the international panorama of design publishing, in its broadest and most open sense. One of these is *Alfabeta*, which was founded and directed by a group of intellectuals, including Umberto Eco and Gianni Sassi, probably one of the most knowledgeable graphic designers and cultural instigators in Europe (he created the Festival Milano Poesia). Sassi was also responsible, along with the cultural critic Alberto Capatti, for the journal *Gola*, the first initiative in the design world to confront the problem of food, in terms of rituals, models of behaviour and its relationship to graphics, design and architecture. These journals set an example which was soon followed by others, such as *Campo*, created by Francesco Leonetti, Enzo Mari, Arnaldo Pomodoro and Eleonora Fiorani; and the monthly *Slow*, a key point of reference in the area of food design, and the strategic tool of the international 'Slow Food' movement.

I am sure we have not exhausted the list of the publishing initiatives that have accompanied the past sixty years of our design history, but I hope to have at least outlined a model of interpretation, a key to reading Italy from an articulated vantage point, both complex and full of possibilities. From this point of view, the future is present not so much as a utopian meta-history, but rather as the desire for something new, for transformation, a desire which must also take on board the reality of production and the economy. Memory, when it is selective, can show the way ahead. Memory and the future are the themes that have been chosen for the Milan Triennale 2003–2004, by its president Augusto Morello; and they represent the foundations that allow utopian design to engage with problems, in a human and identifiable way.

Left, covers of: *Crossing*, December 2000; *N.B.*, January–April 2001; *Ottagono*, directed by Aldo Colonetti, June 2002; *Abitare*, March 2003, directed by Italo Lupi.

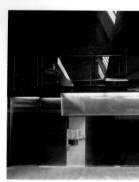
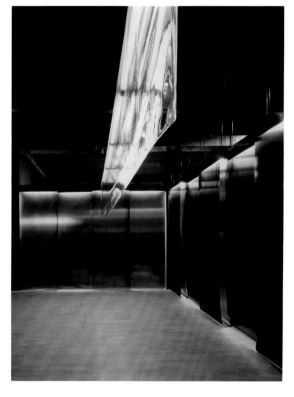

Lusso ruvido
Rough luxury

Johanna Grawunder progetta uno showroom a Milano, trasformando l'ordinario in straordinario.
Testo di Laura Bossi
Johanna Grawunder's design for a showroom in Milan makes the everyday out of the extraordinary. Text by Laura Bossi
Fotografia di/Photography by Santi Caleca

Contro il concetto di loft minimale, algido luogo dai toni chiari, Johanna Grawunder ha scelto per questo showroom milanese una tinta scura, color cioccolato: che fornisce uno sfondo inquietante alle 'meduse' luminose che galleggiano nello spazio
Rather than accept that industrial loft spaces are necessarily cool and minimal, Grawunder chose a dark shade of chocolate for the showroom, creating an uneasy backdrop for the luminous 'jellyfish' that float in space

Double-page spread from *Domus* no. 848 (the legendary magazine founded by Gio Ponti in 1928), May 2002, with photography by Santi Caleca.

Confessions of a Magazine Editor

by Paolo Pietroni

Out of the twelve magazines that I have founded during my career, only one could claim to have been entirely original. It is in fact the only Italian magazine to have set down roots outside of Italy: *Max*, which I have described as the magazine of heroes great and small. It is probably not a coincidence that the first magazine that I encountered and fell in love with as a child had a hero, or rather, a heroine, as protagonist, and was an Italian invention: *Pantera Bionda* (Blonde Panther). It was 1948. I was at school in Milan, reading books by Emilio Salgari, from the *Corsaro nero* (Black Pirate) to the *Corsaro verde* (Green Pirate), and in the adventures of the Blonde Panther I found something similar, but also an added something. The Blonde Panther was a beautiful woman, with very long legs for those days, before supermodels were even dreamed of. Her exploits took place in the forests of Borneo and the islands of the Sonda archipelago. My heroine wore a leopardskin bikini and was accompanied by a faithful orang-utan called Tao; she had an old Chinese nurse called Lotus Flower, and fought against all kinds of criminals, not to mention Japanese soldiers who refused to surrender, despite the fact that the Second World War was over. To say that the Blonde Panther was the female alter ego of Tarzan is not giving her her due: Tarzan was not erotic, but the Blonde Panther was, in a hidden, implicit, unconscious way. Never a kiss, nothing lascivious or ambiguous, never a swear word, no

vulgarity, and yet my father forbade me to keep reading the comic and, though it seems strange today, Catholic censorship struck out against its publisher, Giurleo, who was condemned for pornography at the beginning of the 1950s. Publication was suspended and only recommenced several months later, when Giurleo convinced the authors, Gian Giacomo Dalmasso and Enzo Magni, to replace the bikini with a mini skirt and red sweater.

So they killed off *Pantera Bionda*: from hundreds of thousands of copies sold every week (a huge circulation in those days), it slipped to just thirty thousand, and then even less until it was stopped altogether. In the world of comic books, legend has it that this was personally instigated by a young man of great potential: Giulio Andreotti, with the blessing of Alcide De Gasperi. Who knows?

I wanted to begin this brief glance at Italian magazines of the second half of the 20th century with this personal anecdote from my early life because *Pantera Bionda* taught me a lot. And I think it can also cast light on the particular nature of all serial publications, big or small, created to communicate a new world to people through paper and ink, with the help of words and images: one which encompasses facts, news, photographs, opinions, drawings, stories and even dreams.

In order for a magazine to be born, to grow and to be successful, it must satisfy some profound need of the readers to whom it is addressed.

Cover of the First Issue of
Pantera Bionda, 1948.

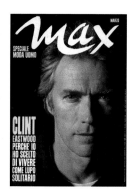

Given that one always desires what one does not have, it must be entirely new the first time it reaches the news stands: if it is not really new, if it looks like something already out there, its life will be short, even if it enjoys a brief faddish success.

The newer a publication is, however, the more it will transgress the established order of things. The more it is transgressive, the more it will attract criticism and the opposition of the censors, of whatever faith or party. Every journal has a kind of genetic code, a strong and unmistakable nature: whoever goes against that nature, for moral, economic or political reasons, will cause decay and the end of its publication. *Pantera Bionda* did not die because she had to forsake her bikini for a red sweater, but because the red sweater went against her nature and mortified her.

Every week I ran, with my heart in my throat, to the news stand, not to buy the railway timetable, or the sports gazette with the football results, but to get to a date with someone I loved. Everything that we love is naturally anthropomorphized. I gave my favourite pencil the name Ombretta, I raised little snails, each one of which had its own personality. So imagine the extent I went to for a magazine. And not just those children's comics which already bore the name of their protagonists such as Tarzan, The Man in the Mask, Mandrake the Magician, Mickey Mouse and Donald Duck. The psychology of perception has shown that even adult magazines are unconsciously anthropomorphized, transformed from things into people. This is patently true of the women's magazines that still bear women's names: *Annabella*, now called *Anna*, *Grazia*, *Gioia* and *Arianna*. This last one was published by Mondadori, and, in the 1960s, often used Rosanna Armani, the sister of the future designer, Giorgio, as its cover girl. But the same is true of all magazines.

It does not stop there, however. After the initial process of anthropomorphizing, there is a second phase of personification, whereby every magazine becomes a person. Then, there can be a third phase: that of 'characterization'. Every magazine has the potential to become a character, that is to say, a person who wears a mask, a mythical person who is somehow beyond time, immortal.

This explains the title of the lecture I gave in the spring of 1995: 'Magazines as Masks'. The audience was made up of journalists and actors from the school I had studied at thirty years earlier. I had enrolled thinking I would learn how to become an actor; what I did not know was that I would actually learn, in an indirect but profound way, how to become a journalist. In order to really understand what people on the other side of the typewriter (now my laptop) demand, what they want and dream about, a journalist must put himself in other people's shoes, must pretend to be them.

If a magazine becomes a person, whether through love or effort, whoever gives it a soul (or, more prosaically, a personality), is surely a kind of demi-god. Very often this demi-god is the founder, dreaming up the idea of the publication, and bringing it to life – as Eugenio Scalfari did with *La Repubblica* (the only truly new newspaper of the 1970s). Before him, Gaetano Baldacci created the wonders of *Il Giorno* of the 1960s, at the behest of Enrico Mattei (I am thinking particularly of its graphic design but also the articulation of the contents). More recently, Giuliano Ferrara has given life to that real gem, *Il Foglio*, one of the shareholders of which is the wife of Silvio Berlusconi. In a similar vein, moving from dailies to weeklies, the demi-god of *Panorama* was Lamberto Sechi, that of the golden days of *Epoca* was Nando Sanpietro and that of *Oggi* was Edilio Rusconi.

These demi-gods are often composite divinities, made up of several key collaborators, from the art director to the assistant editors and the photo editors. But the fundamental point is that the group is capable of moulding itself into a single person.

What happens when the person/demi-god leaves and someone else takes over? History teaches us that this can be disastrous, like when Nando Sanpietro left *Epoca* and was replaced by a series of editors who tried to give the magazine a new life, a new soul: Andreina Vanni and later Sechi could not cure the decay and in time it proved fatal. There was a brief period of improvement under the direction of Carlo Rognoni. And then the hot potato was passed to Nini Briglia, who created a nice, practical magazine, full of lots of useful things, coming one after another like a caravan of camels. It was the

Left, *Max* no. 1, March 1985: Robert De Niro, photo by Eddie Adams. Above, *Max* no. 3, March 1986: Clint Eastwood, photo by L.D. Gordon; *Max* no. 7, July 1986: Christopher Lambert, photo by Greg Gorman.

Below, first issue of *Sette*, a supplement of *Corriere della Sera*, 12 September 1987: Madonna photographed by Herb Ritts. Right, from left to right: *Sette* covers by Abbas, Eve Arnold, Leone Nani and Barry McKinley.

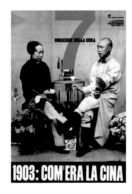

beginning of the end: the nature of *Epoca*, the Italian *Life*, was damaged. As the saying goes, the operation was a complete success but the patient is dead. Have any successful magazines survived? Certainly. Vittorio Buttafava at *Oggi* adopted the natural line laid down by Edilio Rusconi, just as Paolo Occhipinti has done since taking over from Buttafava. The story of *Amica*, meanwhile, is exemplary. Founded in 1962, it was the first truly transgressive women's weekly: it introduced news, culture and even politics into the traditional mix of fashion, beauty, cooking and decoration, particularly during the tenure of Antonio Alberti. It was again transgressive in 1974 (during Pietroni's first stint), when it rode the wave of feminism, and once more in 1982 (again Pietroni), when it fully embraced the philosophy of freedom, by having women appear as they want to appear, rather than how men and conservative thinking would have them.

Indeed, *Amica* deserves a study of its own, since it was responsible for sowing the seeds of a bigger revolution. Prior to *Amica*, the principal women's magazines bore women's names, not just *Grazia*, *Annabella* and *Gioia*, but also *Rossana* published by Paolazzi, and *Eva* and *Novella* from Rizzoli (later to become *Novella 2000*). *Amica* (Friend), on the other hand, is not a specific but rather a symbolic name: 'I am your friend, your best friend, you give me a name, whatever identity you prefer.' This was indeed a revolution!

Furthermore, the *Amica* 'character' does not solely invite the reader to identify with her, as is the case with the *Grazia* character or the *Gioia* character. Instead, for the first time, the door is opened to a relationship of complicity, friendship and love between women, with Sapphic overtones, in the poetic sense of the word. This latter characteristic, strongly transgressive, was to be taken up and developed in a new way by *D*, the women's magazine published by the newspaper *La Repubblica*, founded by Daniela Hamaui (who was to take up the editorship of *L'Espresso* in 2002). The bisexuality of *D* opened up new possibilities for those at the forefront of women's publishing, enabling a discussion of life before and after men. Here was a different kind of emotional education, an affirmation of different female ideas and values, independent of those imposed by masculinity.

The revolution of *D* was presented in an elegant, refined style, and played out in a tone of complicity, always implied, yet never explicit or vulgar. It is telling that an urban myth began to do the rounds in Milan, where the magazine is published, straight after its launch: conservative, orthodox thinkers, always the enemies of publications which open up to new ideas and new horizons, started an incorrect, vicious rumour saying that all the journalists of *D* belonged to a brigade of lesbians.

The same thing happened to *Max*, which I founded in the spring of 1984: immediately, a rumour began (curiously enough, from within the *Corriere della Sera*, the great newspaper from the same publishing house as *Max*) that *Max* was a (disguised) magazine for the gay market. The myth of *Max*'s gay orientation is useful for further explaining the thesis of the magazine as a mask or character. *Max* was, without a doubt, the first Italian mass market publication (with monthly sales of over one hundred thousand) to cater for diversity.

What kind of diversity? All those who could identify with the mythical character of the hero. Every month the pages of *Max* were the forum for a dozen different characters, who personified the legends of heroes: men who had been given a mission to fulfil (whether great or small), and who set themselves up against everyone in order to carry it out – whether that opposition came from parents, society, school, partners, wives or friends. They were not only actors, singers and dancers, but also painters, art directors, athletes, writers, advertising agents and journalists.

These were people apparently 'born to create scandals', but actually driven by the irresistible force of their consciences to stay on track, to know themselves and the world, whatever the cost. So, every month, big and little heroes of our time presented themselves in the theatre of *Max*, people who were somehow different and who were persecuted by those who were normal. And then, as now, gay men were welcome to take part.

I have spoken of a knowledge of the world at any cost, and of the desire/duty to make this knowledge known to people. It is no coincidence that the first name that came to mind when I conceived *Max* was that of a mythical hero: Ulysses. Ulysses was different from all other Homeric heroes – and indeed he was so transgressive that Dante placed him in hell – but *Ulysses* was already the name of the magazine of the airline Alitalia. The word *Max* implied 'maximum', which seemed especially fitting for the philosophy and the destiny of heroes. Furthermore, *Max*, like Ulysses, is a proper name, and for the first time in Italy (and, the world, I think, since *George*, founded by the young and ill-fated Kennedy, did not appear until several years later), a men's magazine bore a man's name, following the example of many women's magazines. Ulysses was therefore renamed (or better still, masked) as *Max*. And this is the character that is inside, behind and in front of *Max*.

Looking at this more deeply, what is the difference between person and character? It is like the difference that exists between Ulysses or Hamlet, and one of the many editors of *Corriere*, who have succeeded each other over time. The person is born, grows, gets old, and leaves amid applause or boos. The character, in itself, does not grow old, does not die. It can be forgotten, can lose people's interest, but it does not deteriorate; it is an Arabian phoenix, forever being reborn. Hamlet is also reborn, and can be because people want him to be. 'Bravo, encore!', and again, 'Bravo, encore!' As a character and not a person, Hamlet is not contradictory but is symmetrical, and symmetry is beauty. To further explain myself, I would say: 'Hamlet always wears black stockings', whether he speaks of love, politics, war, death, to be or not to be. But we love those black stockings and there would be trouble if Hamlet, all of a sudden, appeared before us with red ones.

The same is true of the character inside every magazine: we believe that we know, intuit and foresee what his point of view is every time that something happens and the magazine tells us about it, commenting on it, making it real for us in our minds. We can agree or disagree. But each time it's the black stockings that we want, desire and love to know once more and find again. The graphics, the cover, the way the title looks, the style of recounting, of commenting.

This is why it is important that it is always the same person who picks the image on the cover: only one in ten times will that person make a wrong choice. For the same reason, even the layout of a magazine is important. The restyling must never be entrusted to an art director (however famous and good) who is indifferent to the history and nature of that magazine: he will design a beautiful but ill-fated look. What would be the point of dressing the Prince of Denmark like Giacomo Casanova? What would be the point of using a typeface that upsets the tone and timbre of its voice? Many such errors have been made in Italy! *Amica* has taken many wrong turns with its legendary and natural transgression. *L'Espresso*, on the other hand, after a long, tormented period, has now rediscovered its thoroughbred stature of the old days, thanks to the restyling of Daniela Hamaui. Hamaui has a maniacal interest in graphic design and images, in contrast to most other editors.

Anyone that is putting together the design of a magazine's character, will put the images on the same level as the words and will give the photos the same importance as the text. He or she will not choose fake photos, only real ones. He or she will throw away the photos that merely pay lip service to the manipulated images of television, or the impressionistic and evanescent images from the cinema. The great return to photography-as-sculpture as opposed to the teasing photography-as-painting was the mark of magazines of the 1980s, including *Amica* and especially *Max*. In their pages Helmut Newton found glory once more and new talents such as Toni Thorimbert were born.

Left, cover of the first issue of *Myster*, October 1990: Sylvester Stallone photographed by Toni Thorimbert. Right, Matt Dillon in a photo by Albert Watson.

When things are going wrong with a magazine and it is selling badly, publishers often think: 'Things have changed, life has changed, let's change the magazine, let's change the editor!' And in this way the character inside the magazine gets changed as well. Instead of finding someone else to interpret Hamlet who can keep abreast of how things have changed, Hamlet is replaced by Othello. There have been many such disastrous episodes in Italy. How could one put Giulio Anselmi, with his talent for calming things down, in charge of *L'Espresso*? Or Tiziano Sclavi, with his esoteric way of loving women, at the helm of *Amica*? And how could you entrust *L'Europeo*, once edited by the poet Tommaso Giglio, to someone as uncultured as Vittorio Feltri? Hamlet may be interpreted differently today to one or two hundred years ago – but Hamlet is still Hamlet.

To return to our point of departure (journalists, like actors, love circular arguments), I said that the *Pantera Bionda* had taught me a great deal. I haven't told the half of it. Who created that comic? Gian Giacomo Dalmasso, born in Voghera in 1907. Not a great deal is known about him. At the age of fourteen he enrolled voluntarily in the Military Academy in Modena. He became an officer in the Light Infantry, then in the Parachute Regiment. In 1943, he fought for the liberation. He reached the rank of colonel in the army. In 1947, he created the *Pantera Bionda* for the publisher Giurleo, and then *Miss Diavolo* (Miss Devil) and *Aquila Bianca* (White Eagle). Ten years later he was employed by Mondadori as an editor and writer for *Topolino* (Mickey Mouse). His first story for Disney was called *Paperino e gli uomini leopardo* (Donald Duck and the Leopard Men), surely a homage to the bikini of his (and my) *Pantera Bionda*.

That an army colonel wanted to give life to a female character such as this has always seemed to me to be the gesture of a hero.

Paolo Pietroni, photo by Toni Thorimbert for *Amica, c.* 1983.

Double Visions

text by Giovanna Calvenzi

Italian photographers and international photographers, by choice or by chance, have worked on the same themes and in similar locations. But their vocabularies reflect different personalities, eras and cultures.

Scanno

When Henri Cartier-Bresson first went to the town of Scanno, in the Abruzzi, in 1951, it was not his first trip to Italy. He was yet to publish his famous *Images à la sauvette* (which came out the following year), but he was already responsible for co-founding the legendary photographic agency, Magnum. He had been involved in painting and cinema, had travelled widely and had met important people. At Scanno, he found himself face to face with a world seemingly untouched by modernity, a world which was static, still set apart from the pulsating energy of a country rising out of the ruins of war. The town that he depicts is inhabited by men and women dressed in black, immobile on the streets and in the squares, apparently observing the flow of time. Cartier-Bresson walked the narrow, climbing lanes, as if invisible, capturing images, small occurrences, meetings and the geometries of architecture *in flagrante delicto*, as it were. His limpid and serene account was to become the model for much of Italian photography, in the same way that his famous collection *The Decisive Moment*, of 1952, lay the foundations for a poetic vision which has never been bettered in its incisive simplicity: 'For me, photography is finding a rhythm of surfaces, of lines and of values in reality; the eye crops the subject and all the camera has to do is its job: to imprint onto the film the decision made by the eye.' Mario Giacomelli, who went to Scanno in 1957 and again in 1959, knew the work of Cartier-Bresson but was not afraid of a comparison between himself and the great French master. His background as an amateur photographer enabled him to create a narrative solely out of his own artistic interpretation of what he saw, or rather out of his emotional responses. In 1958, he wrote to his friend, Alfredo Camisa: 'For me, Scanno was a fairy-tale village, full of sun and little black figures. I tried to burn the details, to get rid of anything that could appear documentary; that way I could find more poetry. I never thought to treat Scanno, or anything else, with realism, but only to present those things, however small, that expressed my state of mind in that moment.' His is a free reading, anticipating and even going against what was happening in photography at that point. He used out of focus, blurred and contrasting images as expressive means, as the provisional rules of a syntax to be invented from scratch in every new photo. Giacomelli had no rules, no dogmas. He boasted complete technical ignorance. For him, photography and poetry were the same thing, to be utilized for his own self-expression. He would never be a professional photographer, and he rarely left his native city. Nonetheless, Scanno gave him an international notoriety, and for years he was the only Italian photographer known and exhibited abroad.

henri
cartier-bresson

mario
giacomelli

Henri Cartier-Bresson Midnight Mass, 1951

Henri Cartier-Bresson A Street, 1951

« Reportage is a progressive action, using the mind, eye and heart to express a problem and establish events or impressions.

(from the preface to *Images à la Sauvette*, Paris, 1952)

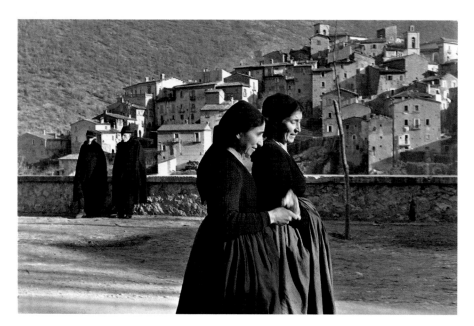

Henri Cartier-Bresson Scanno, 1951

Henri Cartier-Bresson Scanno, 1951

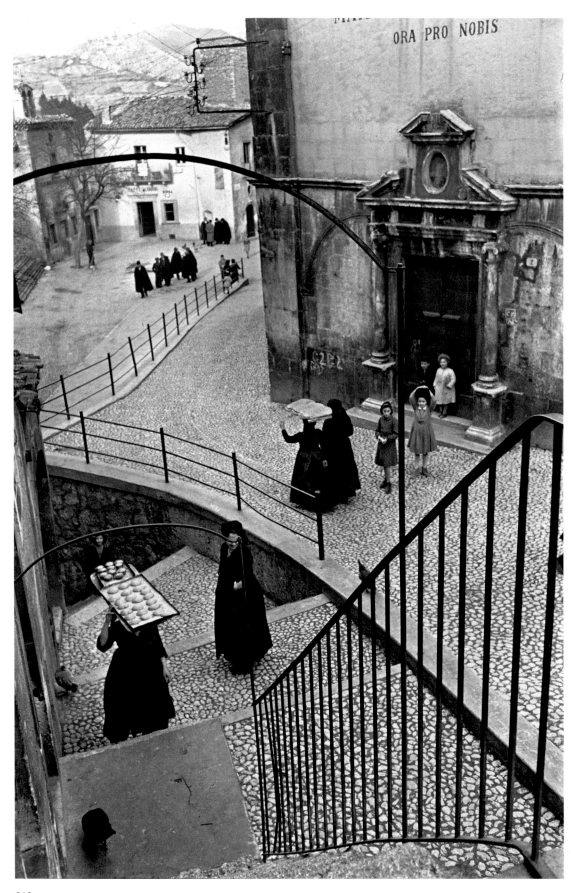

ORA PRO NOBIS

Henri Cartier-Bresson *Scanno*, 1951

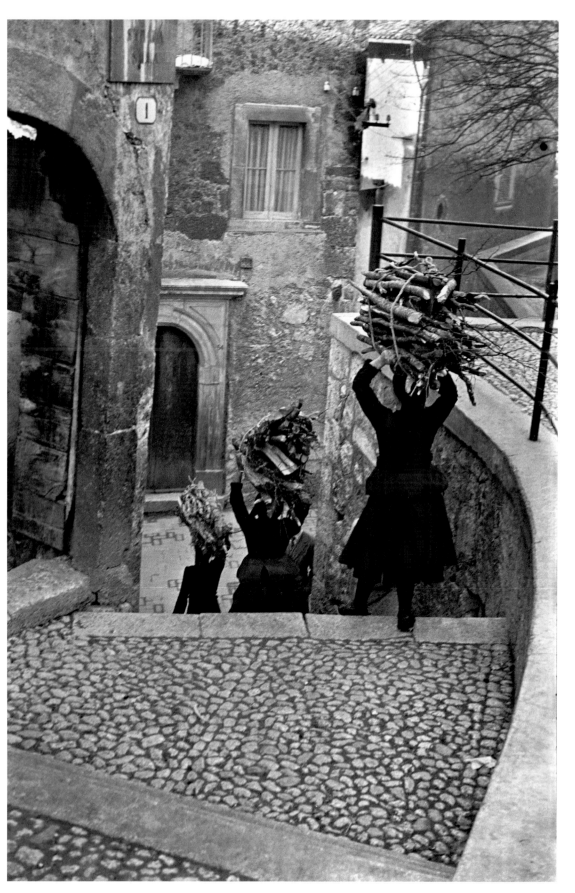

Henri Cartier-Bresson Scanno, 1951

« Scanno is a fairy-tale village of simple people, with beautiful contrasts between cows, chickens and people, white streets and black figures, white walls and black cloaks.

(from *Mario Giacomelli*, London, 2001)

Mario Giacomelli Scanno, 1957–59

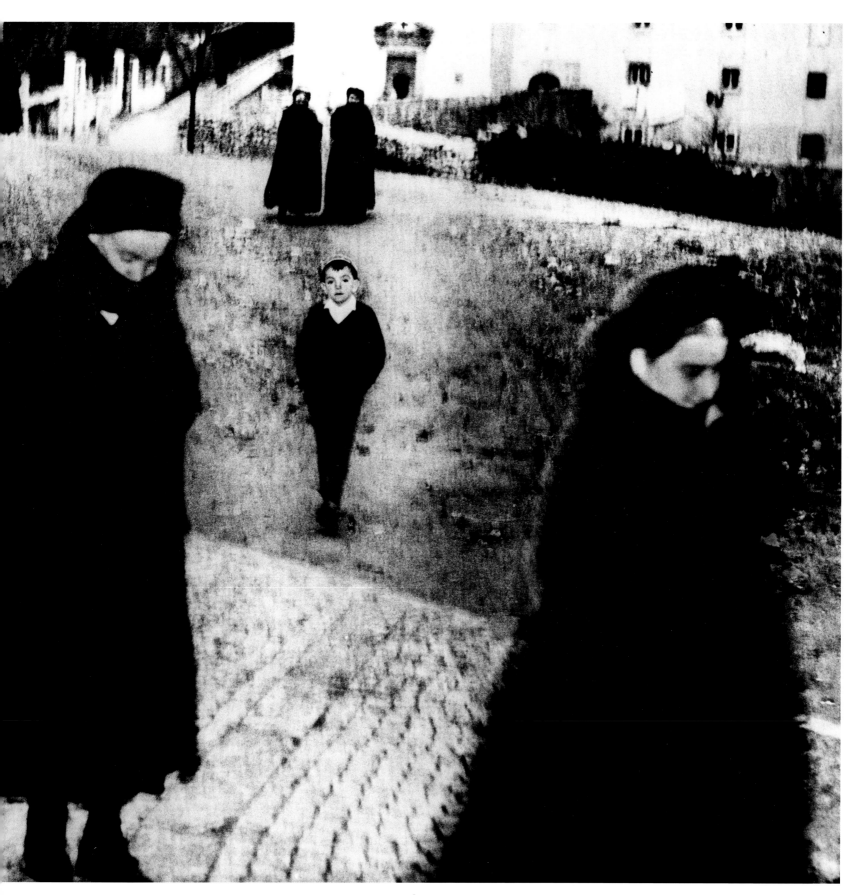

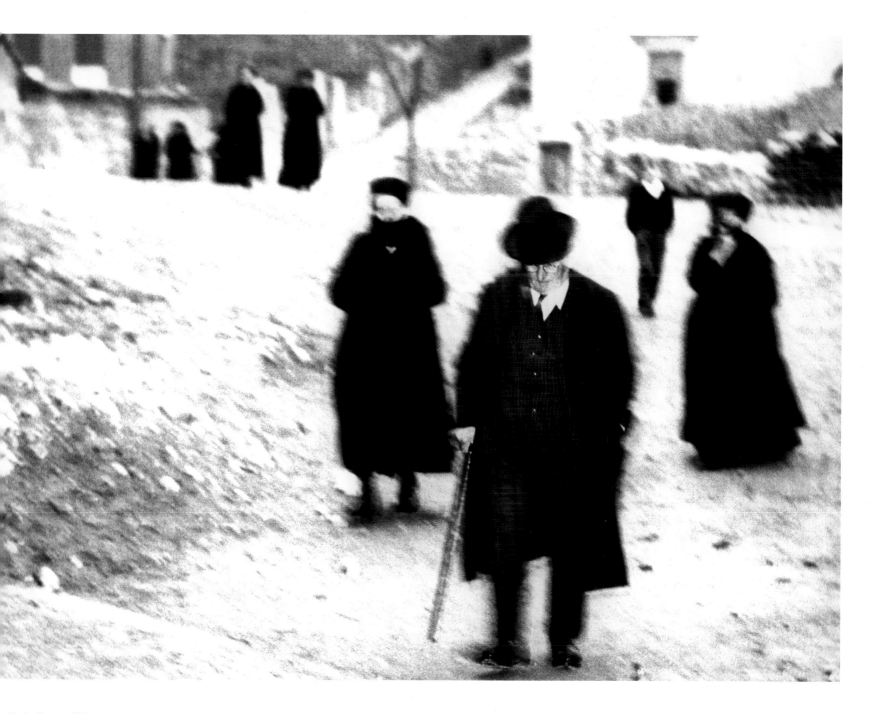

Mario Giacomelli Scanno, 1957–59

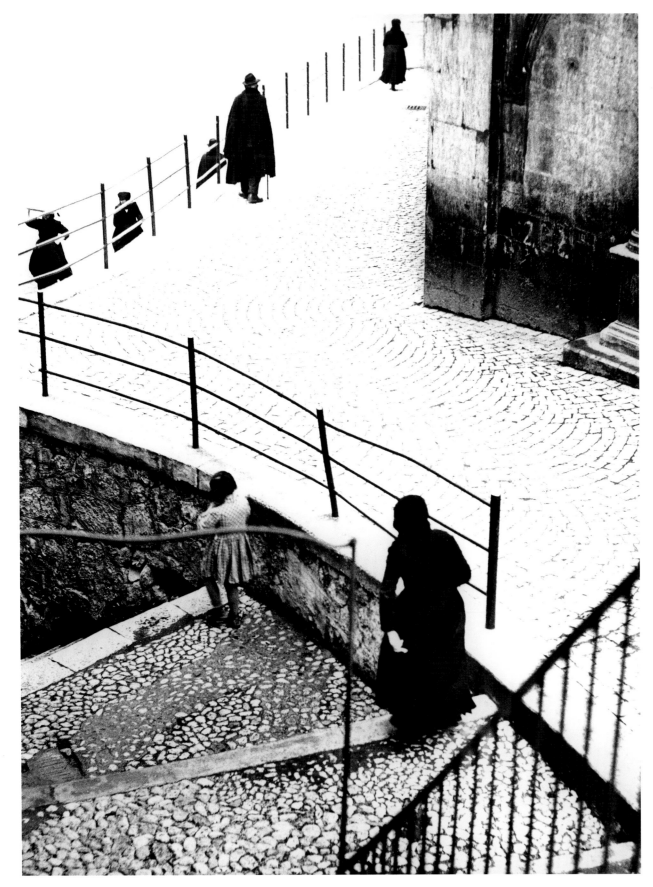

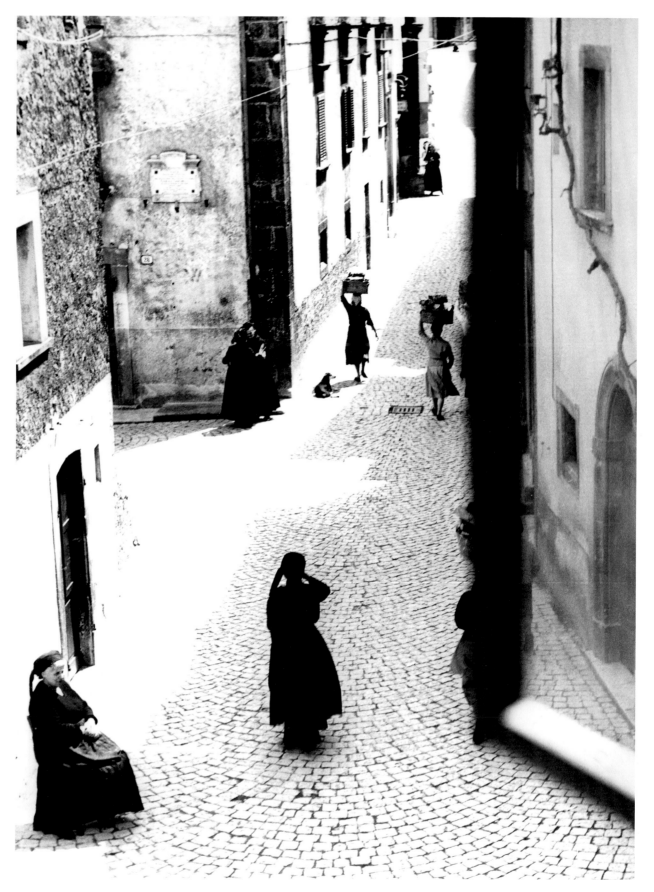

Mario Giacomelli *Scanno*, 1957–59

225

Luzzara

Paul Strand and Cesare Zavattini met in Perugia in 1949. Strand was already a famous photographer, while Zavattini was one of the protagonists of neo-realist cinema, and had written the screenplays to some of Vittorio De Sica's most extraordinary films, including *Sciuscià* and *Bicycle Thieves*. It was almost a chance encounter, but in 1953 Strand suggested to Zavattini that they collaborate on a book on an Italian town, where the habits and rhythms of life were still tied to nature and the land. With some reluctance, Zavattini proposed his own home town, Luzzara, a small agricultural place in the Po Valley, although on completion of the book he was to declare: 'I am grateful to Strand for forcing me to really live with the people from my home town for the first time; it was hard to begin with, but then it was wonderful.' For a month and a half, Strand went around Luzzara and the surrounding countryside, taking photos of people, objects, bits of houses and vegetation. Zavattini, meanwhile, interviewed the people of Luzzara, recording a slice of local history through their testimony. *Un paese* was published in English and Italian in 1955 and soon become a cult book, judged by the critics as a kind of visual *Spoon River Anthology*. Some years later, Gianni Berengo Gardin, one of the masters of Italian photography and close friend of Zavattini, cast doubts over Strand's reading, suggesting that it was a poetic vision which left areas of the town unexplored. Zavattini invited him to follow Strand's itinerary. The challenge was arduous: it was several years later, and the American's pictures were by now famous, known and displayed throughout the world. Berengo Gardin therefore approached Luzzara from his own narrative viewpoint, to create a documentary work very different from the lyrical vision of Strand. *Un paese vent'anni dopo* came out in 1976. Berengo Gardin's work opens with an intentional homage to Strand: he finds and photographs the original protagonists in the same locations, before going on to a freer, more journalistic narrative. While Strand had isolated, glorified, highlighted and created an ode to peasant life, Berengo Gardin enlarges the vision, articulating it through the rhythm of a narrative in which the landscapes, the roads and the houses become the heroes. Strand recounted Luzzara through a close reading of faces and things; Berengo Gardin recounts the town through the way of life and the nature of its spaces. The two vastly different readings, equally moving, compete to provide a portrait of a microcosm, 'with its own scale, finite and infinite at the same time', precisely as its most famous citizen, Cesare Zavattini, would have wanted.

paul strand

gianni berengo gardin

Paul Strand Luzzara, 1953

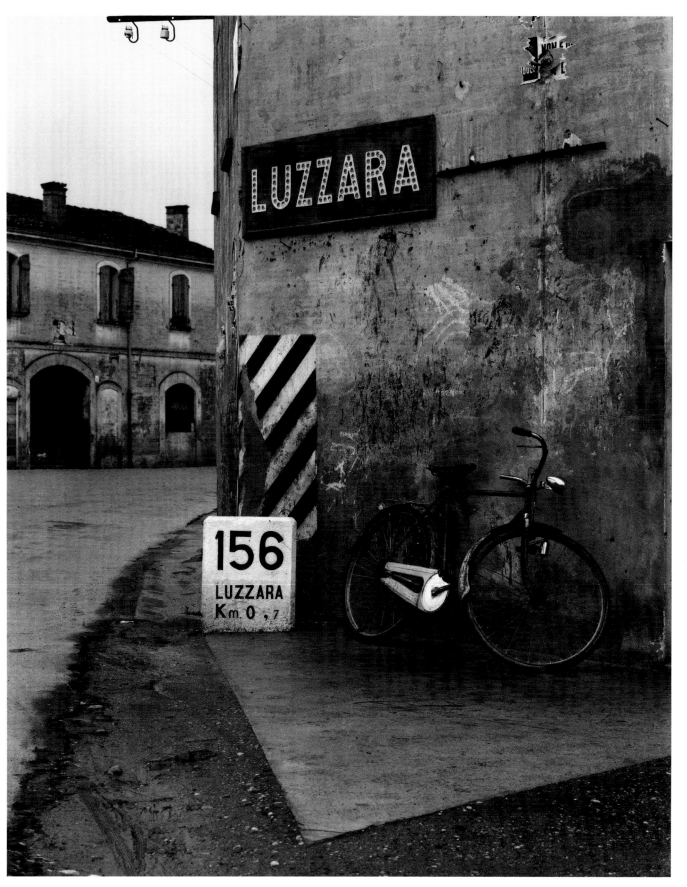

Paul Strand Luzzara, 1953

229

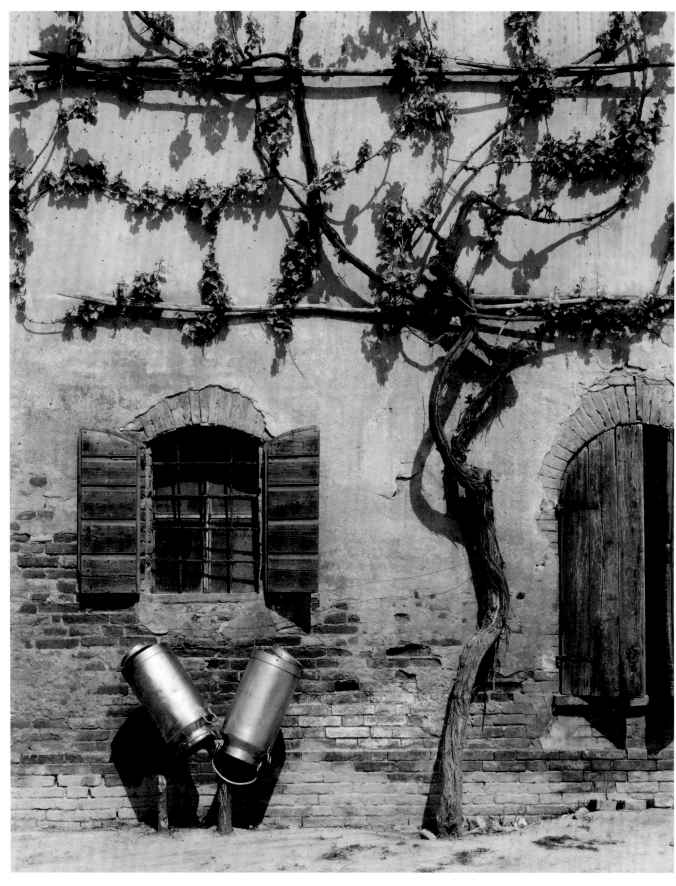

Paul Strand Luzzara, 1953

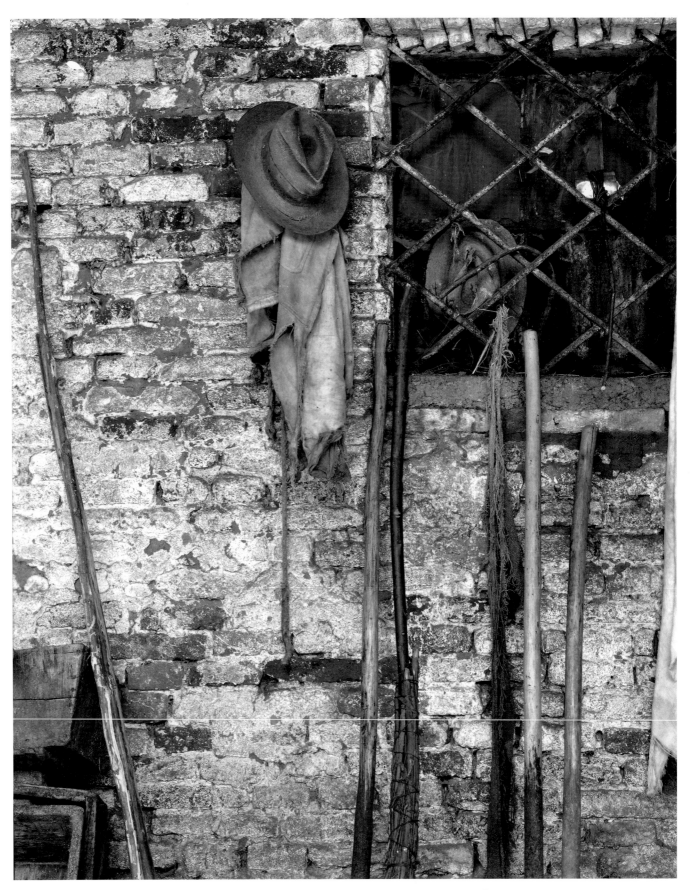

Paul Strand Luzzara, 1953

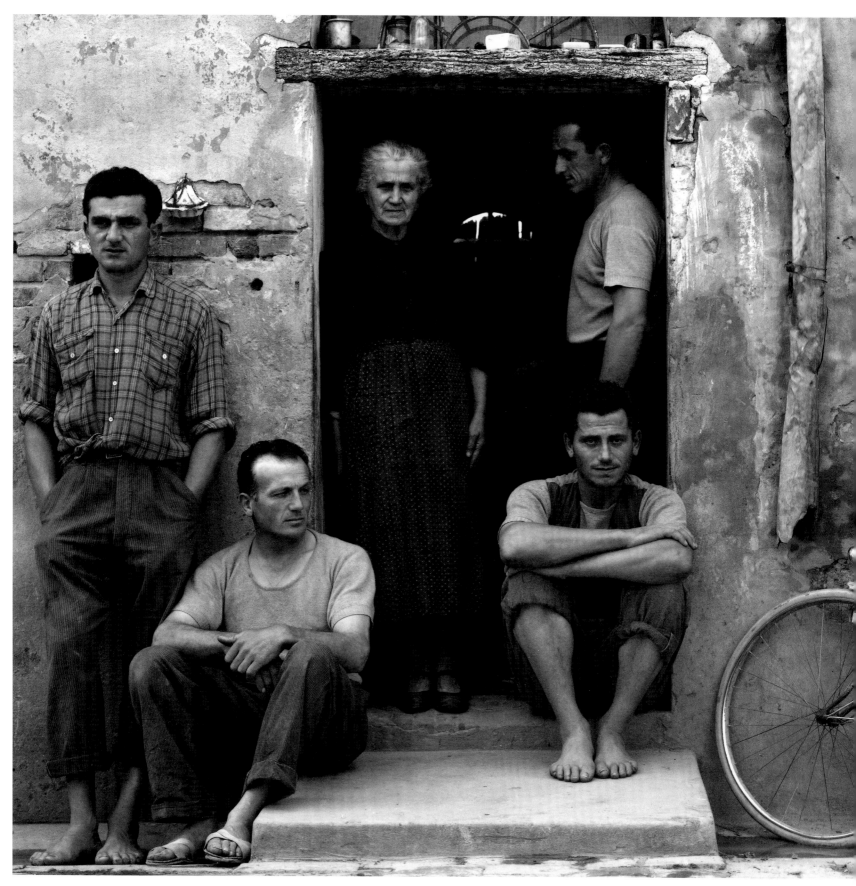

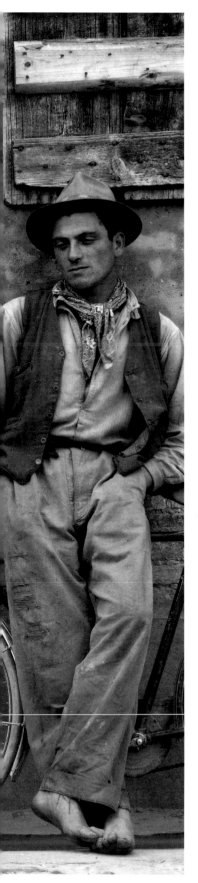

Paul Strand Luzzara, 1953

I am grateful to Strand for forcing me to really live with the people from my home town for the first time; it was hard to begin with, but then it was wonderful.

(Cesare Zavattini, from *Un paese*, Turin, 1955)

Gianni Berengo Gardin Luzzara, 1973

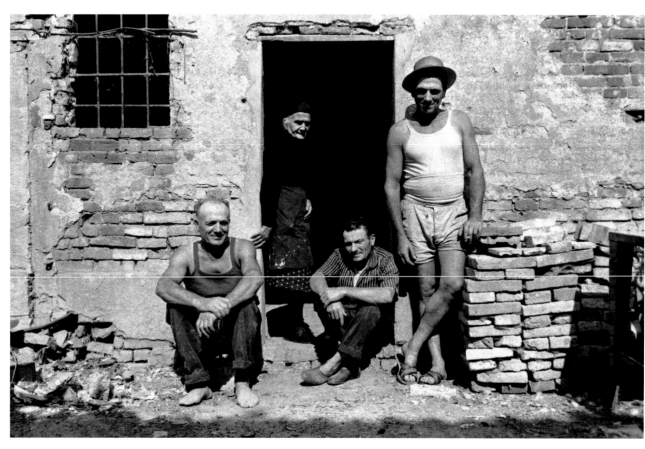

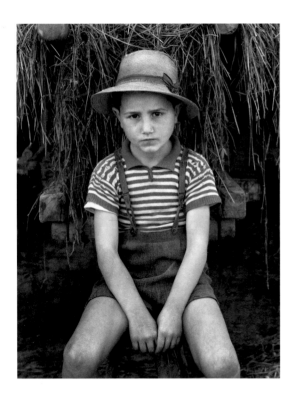 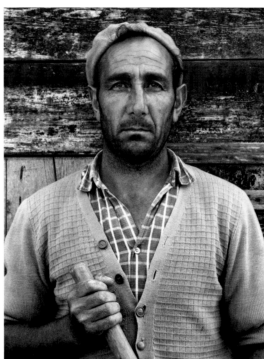 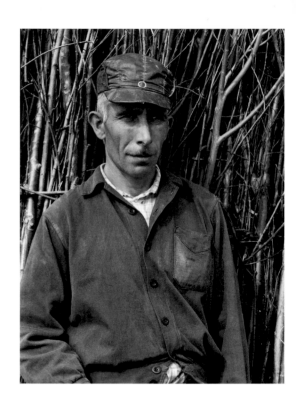

Paul Strand Luzzara, 1953

Gianni Berengo Gardin Luzzara, 1973

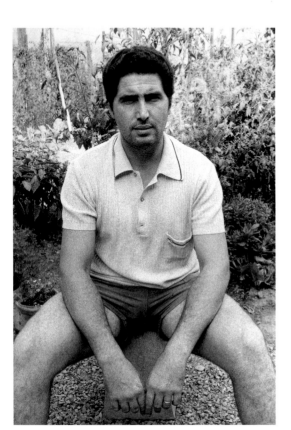 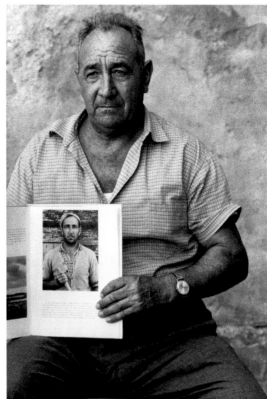 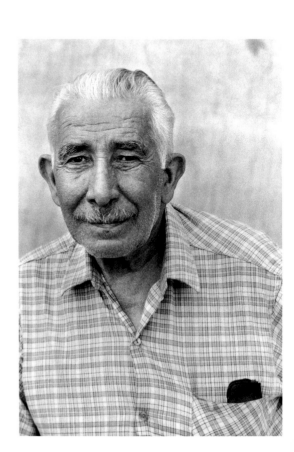

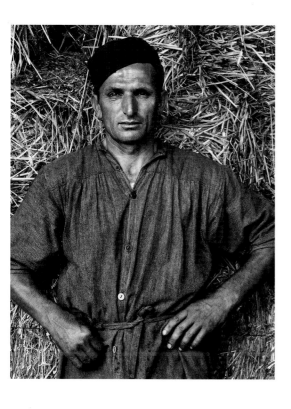
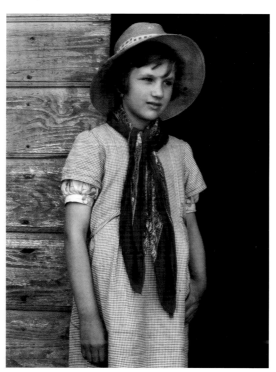
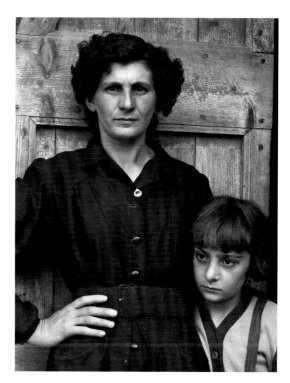

Paul Strand Luzzara, 1953

Gianni Berengo Gardin Luzzara, 1973

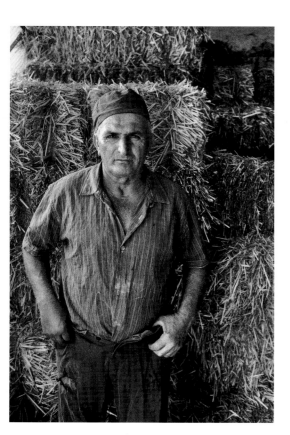

» I was and still am a great admirer of Strand, and think that *Un paese* should be counted among the ten books of photography that should be on every photographer's bookshelves.

(from *Un paese vent'anni dopo*, Milan, 2002)

Gianni Berengo Gardin Luzzara, 1973

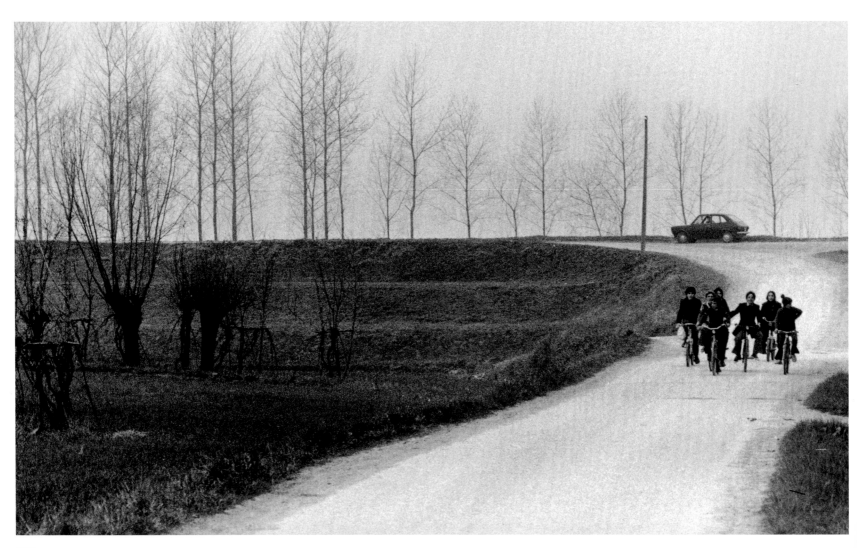

Gianni Berengo Gardin Luzzara, 1973

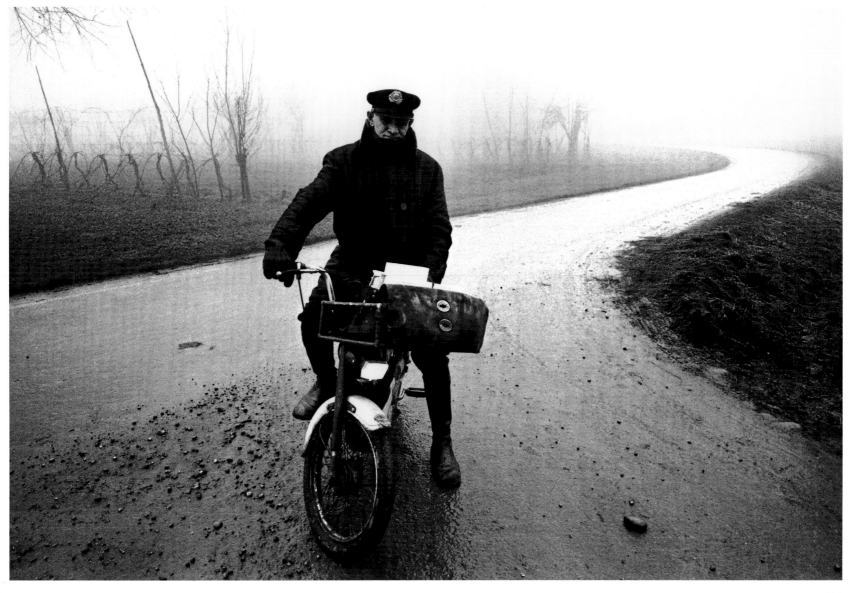

Gianni Berengo Gardin Luzzara, 1973

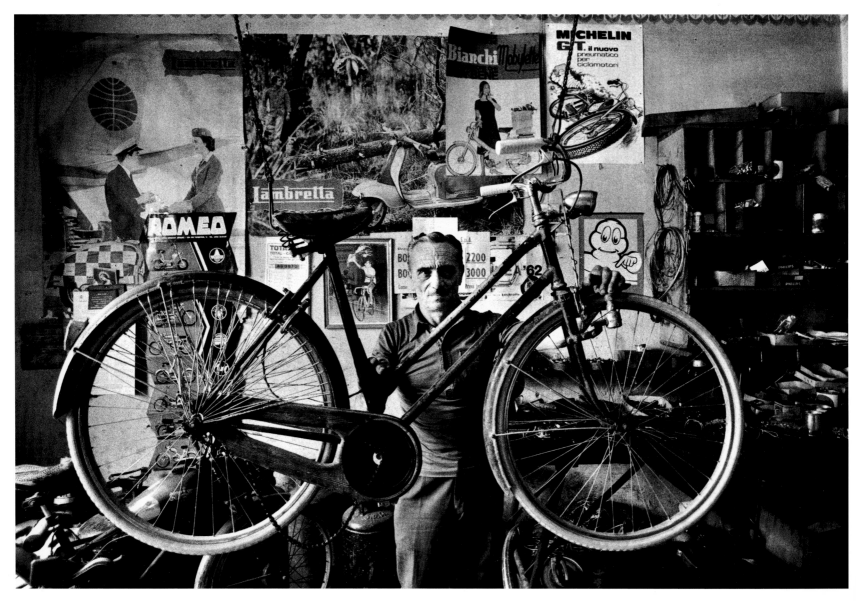

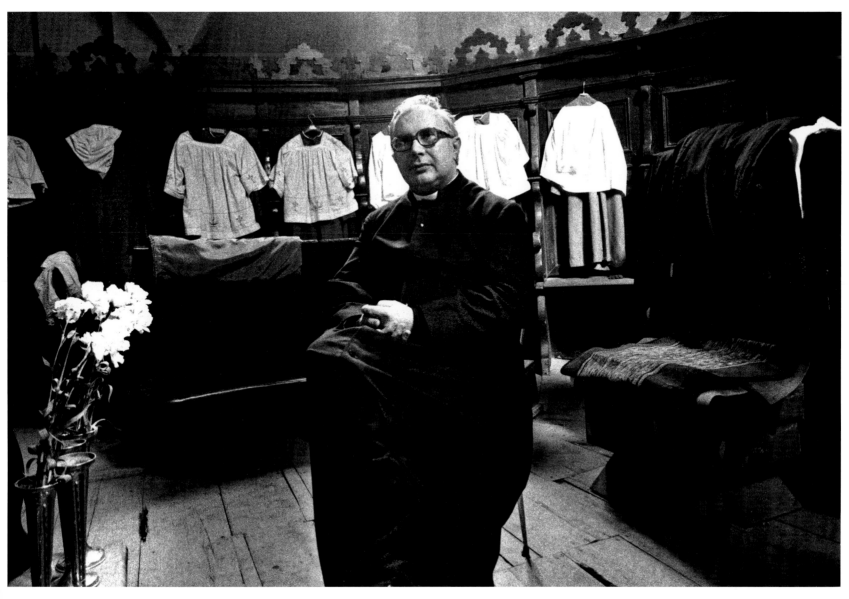

City Visions

William Klein's first book, *New York*, was published in 1956 and marked a radical turning point in the history of contemporary photography, although it would take time for the lazy international photographic community to realize it. Klein had been involved in painting and graphic design and, when he approached photography, he did so in an innovative and anarchic way: he used a harsh, direct language, full of constrasts, in open antithesis to the humanistic vision that reigned uncontested in international photography at that time. After *New York*, Klein arrived in Rome and began photographing the city, while waiting to work with Federico Fellini. His account of the city has a cinematic rhythm to it, pressing and fast, the language always frontal, involved and involving. His black and white photos are intense; the grain is evident, and he is not afraid to show blurring, deformities or imprecise shots. Some years later, reflecting on his photography, Klein wrote: 'Painters freed themselves from the rules, why not photographers? Maybe for me, outsider and heretic, it was easier.' *Rome* was published in 1959 and the graphic layout, designed by Klein himself, underlines and emphasizes the narrative. Like *New York*, *Rome* was ahead of its time, and yet did not receive the praise it deserved. But a new vision of reality and a new way to represent it were in the air. Mario Carrieri, son of the writer Raffaele Carrieri, had started out at a very young age as a reporter for *Epoca*, and had also been a cameraman and director, working in advertising. He was a fan of American expressionism and, in 1957, began to photograph Milan. He did not know Klein's work, and in fact confessed to not particularly liking photography; instead he confronted Milan with the experienced eye of the film maker. *Milano, Italia* was also published in 1959, after a couple of years of gestation in which it had been refused and misunderstood by numerous publishers. Carrieri's reading is surprisingly close to that of Klein. Like Klein, Carrieri preferred harsh tones, a fast rhythm, an almost unexpected use of constrasts and single images shown in a determinedly arbitrary sequence. Both wanted to be on the inside, to determine the photographic event, not merely record it. It is the cities, Rome and Milan, which put themselves on show, which react to the presence of the photographers, who in turn attempt to construct a film from which the only thing missing is the soundtrack. Carrieri himself would write: 'I wanted to produce, rather than reproduce a city. No photographic "tricks", no formalism, no enquiries. Only the choice of a language and a narrative that are beyond objective reality, and that are tightly directed, in a series of rapid images.'

william
klein

mario
carrieri

William Klein Piazzale Flaminio, Rome, 1956

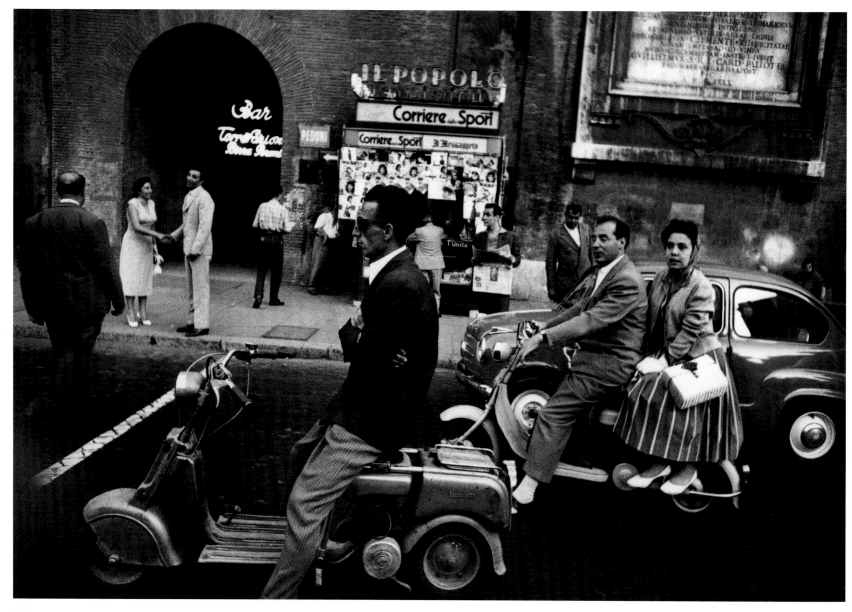

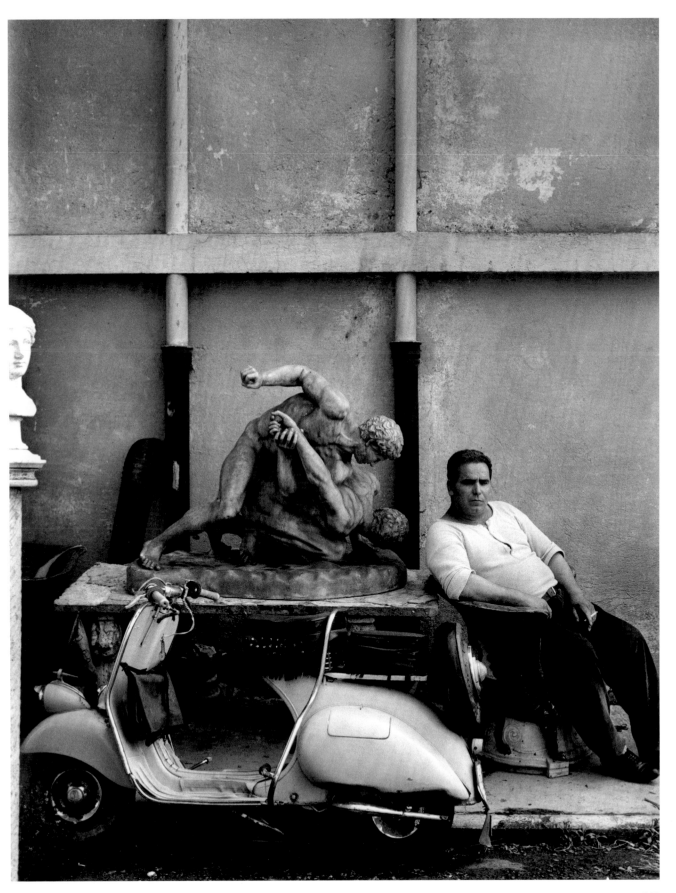

William Klein Guard at Cinecittà, Rome, 1956

« Rome is a fantastic puzzle in space-time, the pieces of which come in all the dimensions, shapes, styles and periods that make up Western civilization.

(from *Rome*, New York, 1959)

William Klein Eur, Rome, 1956

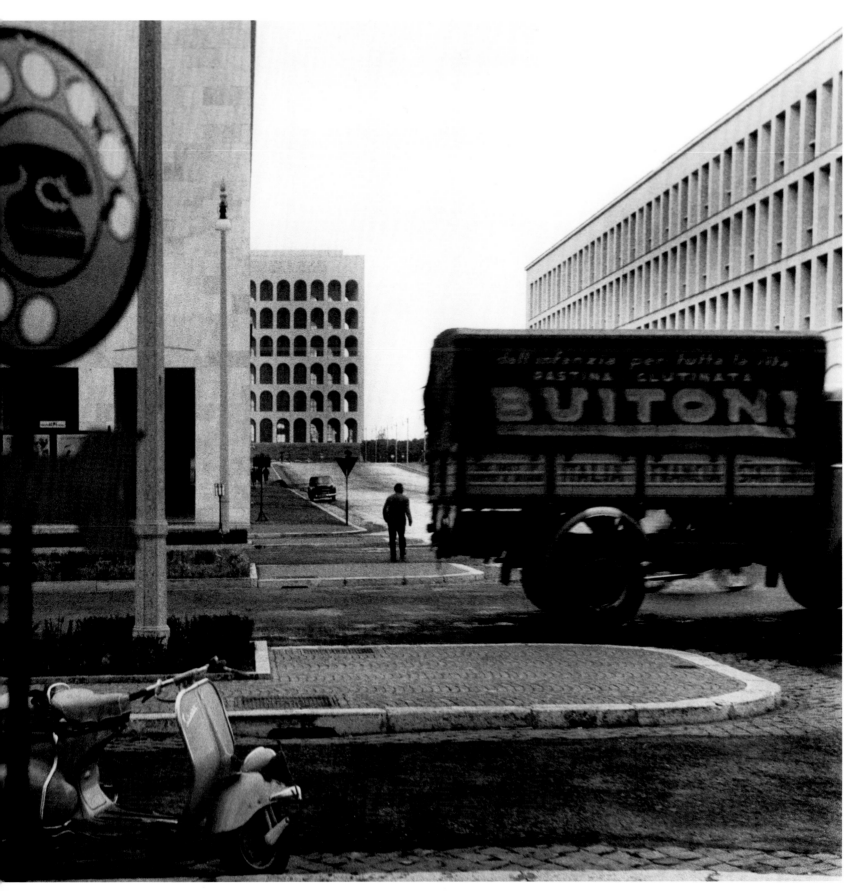

William Klein Via dei Fori Imperiali, Rome, 1956

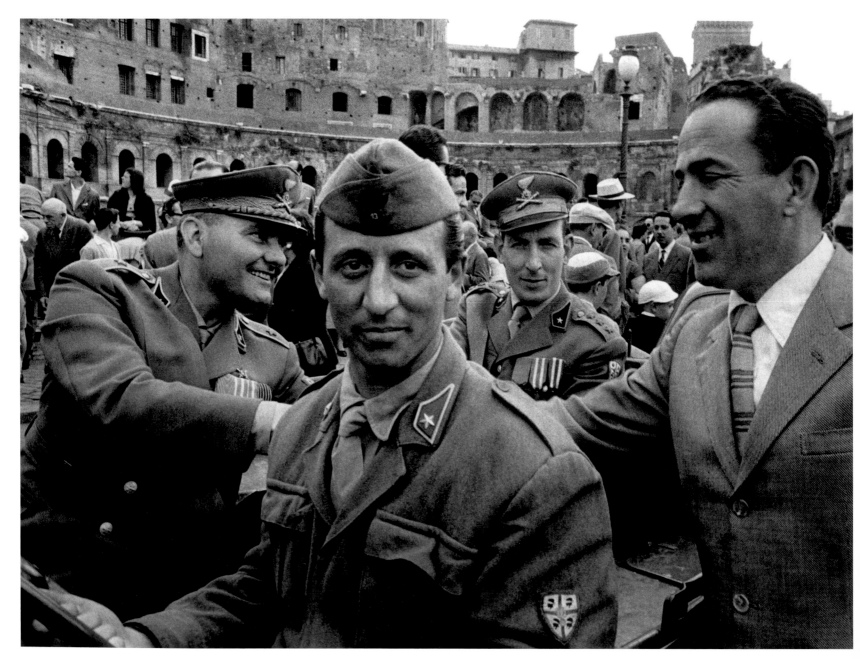

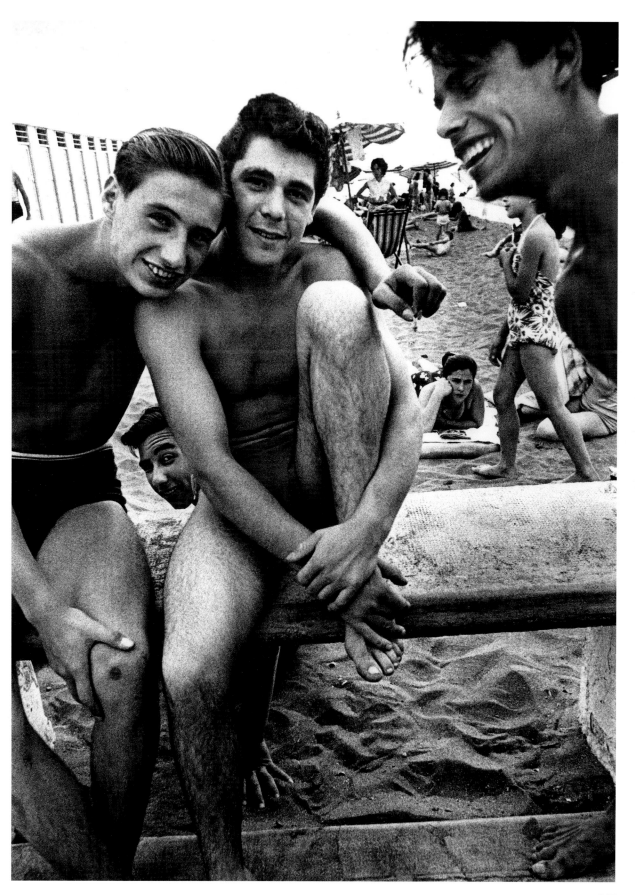

Mario Carrieri Piazza del Duomo, Milan, 1958

Mario **Carrieri** Via Monte Napoleone, Milan, 1958

Mario Carrieri Stella d'oro, Milan, 1958

« I wanted to produce, rather than reproduce a city. No photographic 'tricks', no formalism, no enquiries. Only the choice of a language and a narrative that are beyond objective reality.

(from *Milano, Italia*, Milan, 1959)

Mario Carrieri Piazza della Scala, Milan, 1958

Asylums

Morire di classe. La condizione manicomiale fotografata da Carla Cerati e Gianni Berengo Gardin (To Die of Class. The Conditions in Asylums Photographed by Carla Cerati and Gianni Berengo Gardin), edited by Franco Basaglia and Franca Basaglia Ongaro, was published in 1969. The title itself is a declaration of intent and a sentence on the cover adds further clarity to this intent: 'At the end of this process of dehumanization, the patient, who was put into the psychiatric institution to be cured, no longer exists, but has been embraced by and incorporated into the rules that govern him or her. The case is closed. Labelled in an irreversible way, he or she can no longer delete the marks that defined him or her as something other than human, and he or she has no right of appeal.' Franco Basaglia and Franca Basaglia Ongaro were believers in anti-psychiatry and lobbied for years for Italy's asylums to be closed down. They enthusiastically accepted Carla Cerati's offer to put her experience as a photojournalist at the disposal of what she saw as a highly important project. Along with Gianni Berengo Gardin, Carla Cerati visited asylums in Gorizia, Ferrara, Florence and Parma over a period of several months. Their objective was to tell the story of these institutions, to record and denounce the conditions, the bars, the reclusion, the isolation and the abandonment in which the mentally ill lived. In harmony with the cultural and political climate of the end of the 1960s, Carla Cerati battled to create a project with a social conscience, and her commitment and the evocative strength of her images became an extraordinary contribution to Basaglia's mission. At the end of the 1970s, the interest in alternative psychiatry was becoming more widespread. Raymond Depardon went to Trieste to do a feature and met Franco Basaglia. His report turned into a long-term project: he went to hospitals in Arezzo, Turin, Naples and then the San Clemente hospital in Venice, which was actually a hospital rather than an asylum and where there were patients being cured, rather than madmen who had to be locked away. If Carla Cerati was protected from voyeurism by her determination to denounce what was happening, Depardon found himself helpless when confronted with the aesthetics of suffering. With respect and discretion, he faced illness, entering into the lives of the patients, into their solitude. He moved lightly through an atonal world, devoid of colour, and conveyed his own suffering when confronted with so much pain. In 1980, Depardon returned to San Clemente, this time to make a film about it, in collaboration with the sound technician, Sophie Ristelhueber. The hospital was about to be dismantled, and with his usual respectful distance, he records the everyday life, the conversations between patients, doctors and relatives. *San Clemente* was published in 1984, four years after the documentary. Ten years later, reflecting upon his cinematic experience in the *Cahiers du cinéma*, he suggested a possible motivation for the double commitment that tied him to the Venetian hospital: 'Part of me followed the footsteps of the photo-journalist, but with a new instrument: the film camera, as if I had to work through what I had experienced, as a passive witness.'

carla cerati

raymond depardon

Carla Cerati Parma, 1968

« In the enclosed courtyard, a woman came towards me who seemed to have no arms, dressed in a sack of cloth, which was drawn together at the neck by a cord; only later did I realize that the sack was there to hide her straitjacket, as well as to make it more efficient. The impact of that violated humanity communicated to me a sense of lacerating, unbearable suffering, and a smell of constant and apparently irredeemable misery.

(from *A Traumatic Experience*, unpublished, 1998)

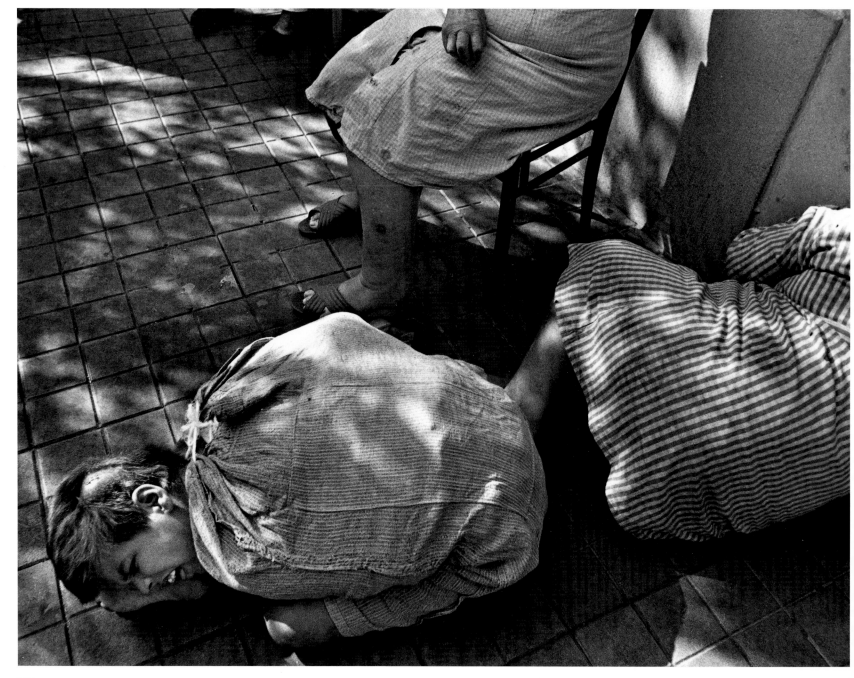

Carla Cerati Florence, 1968

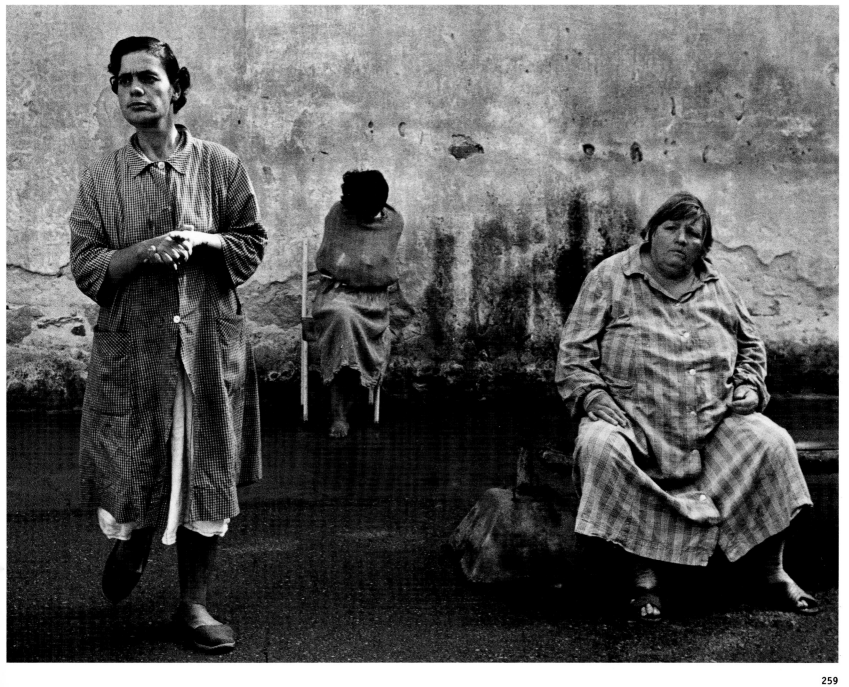

Carla Cerati Gorizia, 1968

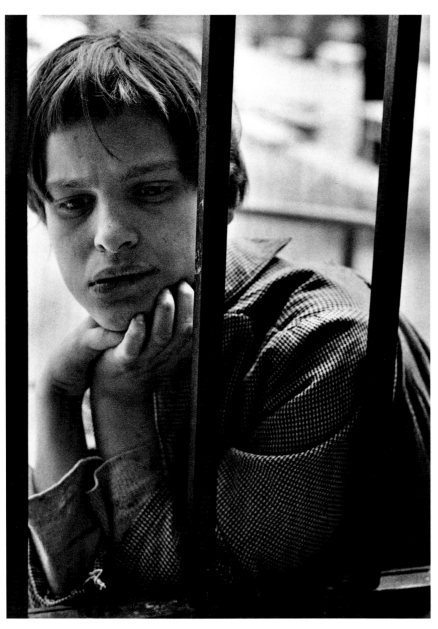

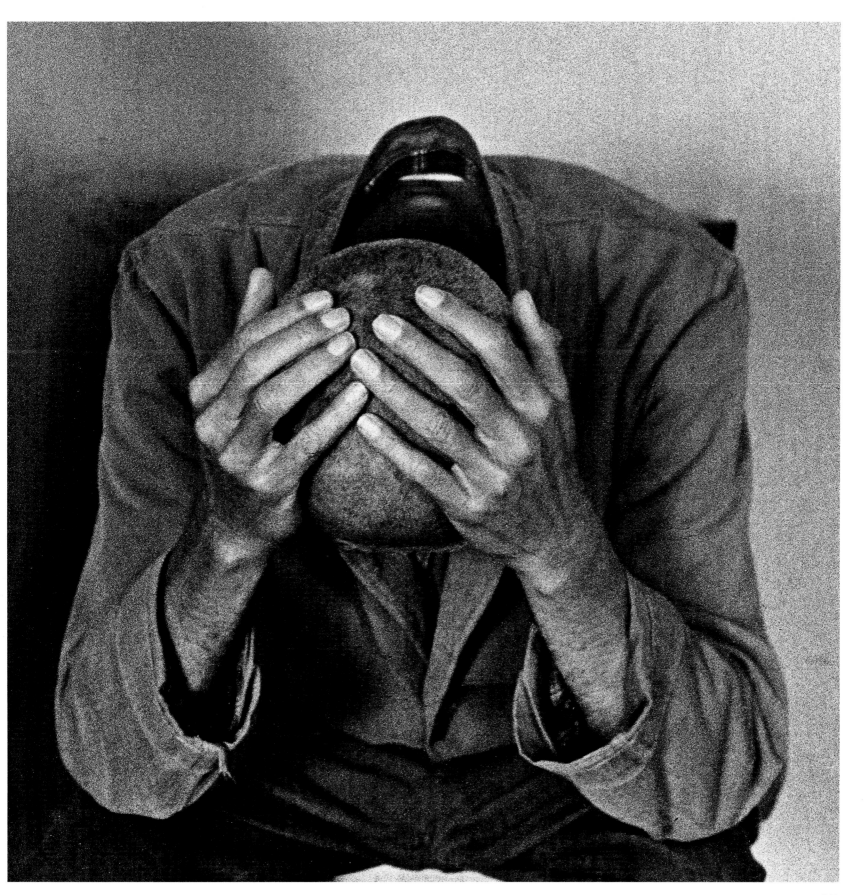

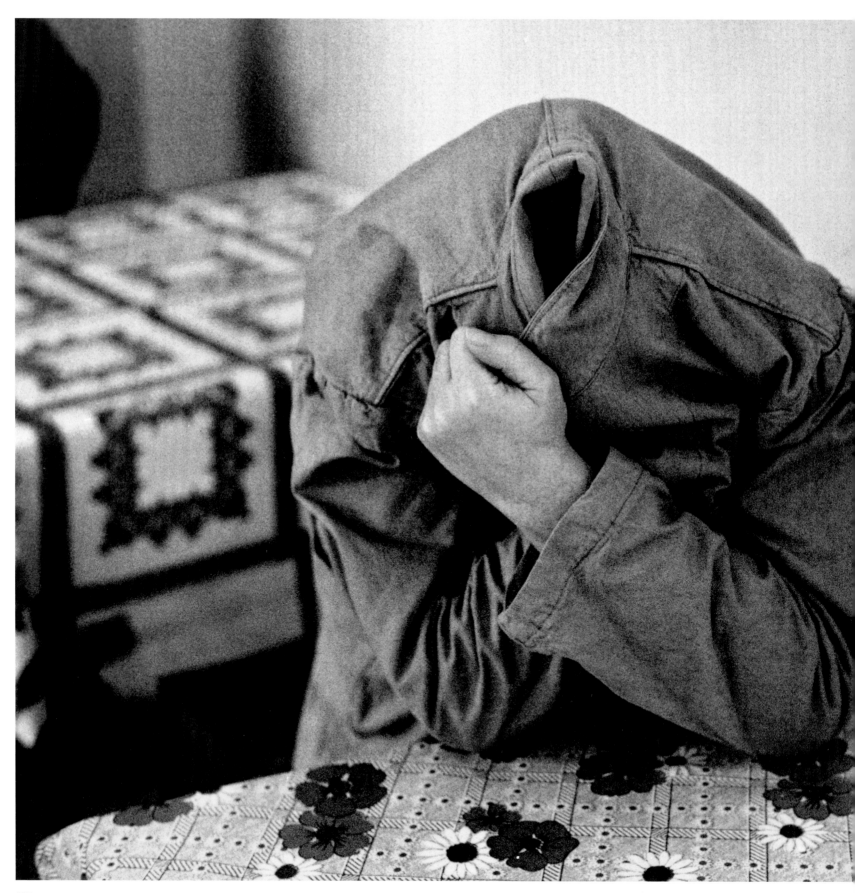

Raymond Depardon San Clemente, Venice, 1984

Raymond Depardon San Clemente, Venice, 1984

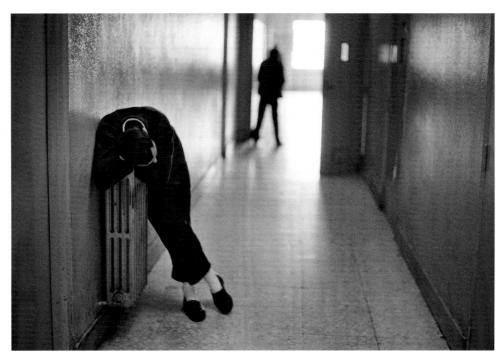

Raymond Depardon San Clemente, Venice, 1984

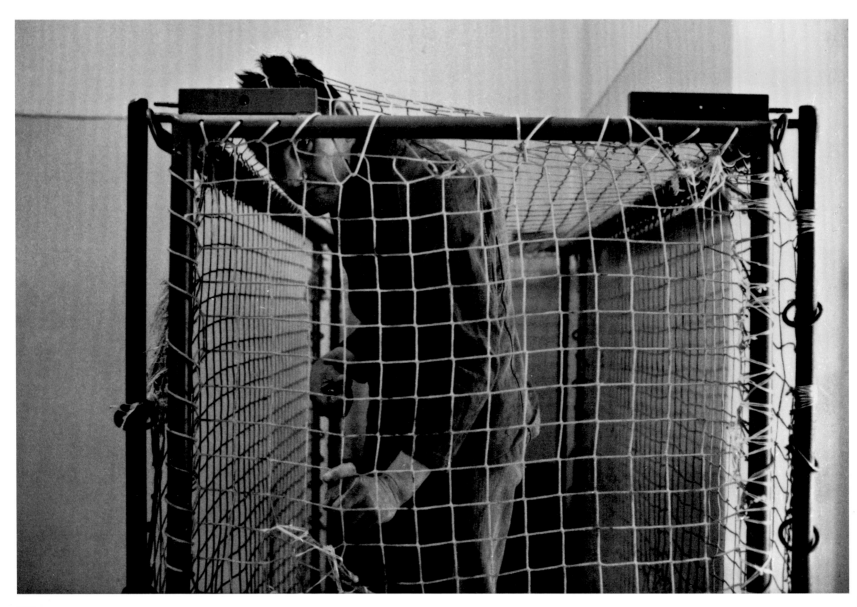

Raymond Depardon San Clemente, Venice, 1984

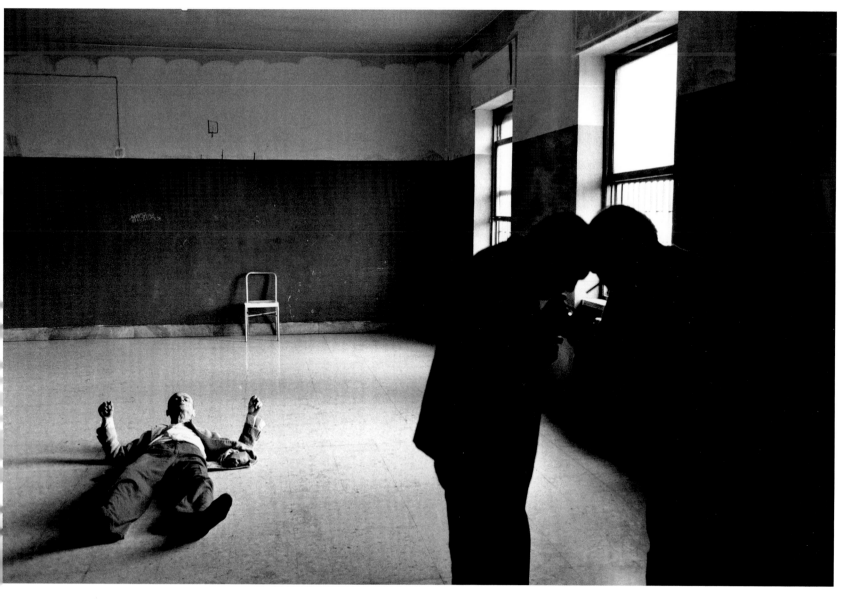

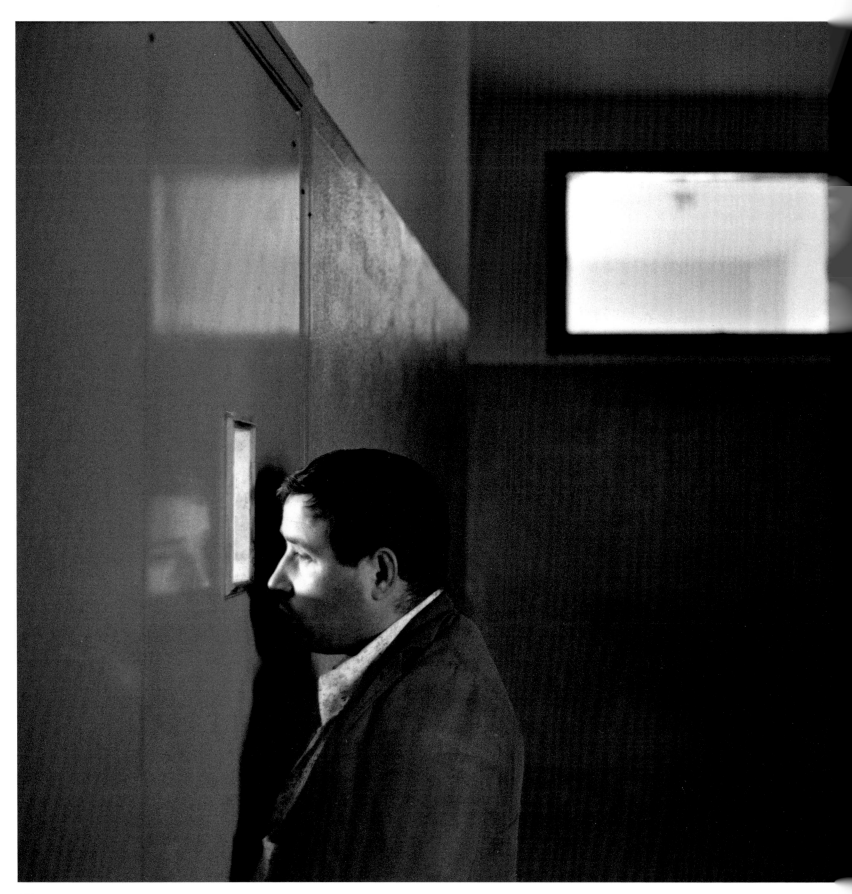

Raymond Depardon San Clemente, Venice, 1984

Raymond Depardon San Clemente, Venice, 1984

« I realized that I was finding it very difficult to take photos: I felt like I was living in a nightmare... and yet the shock of it was a determining factor in the continuation of my work.

(from *San Clemente*, Paris, 1984)

Raymond Depardon San Clemente, Venice, 1984

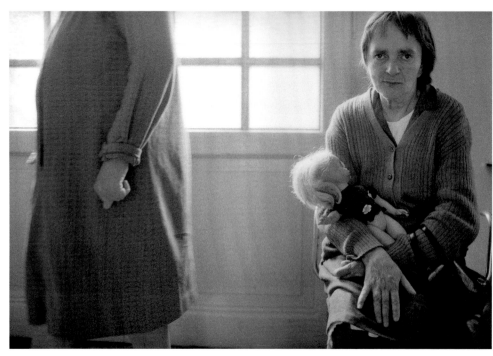

Venice

The rereading of the magic of Venice is an exercise to which hundreds of artists have devoted themselves. Among the many possible visions, those of Ernst Haas and Luca Campigotto are perhaps the most antithetical and yet also the most interesting and innovative. Haas, the great Austrian photo-journalist of the period directly following the Second World War, began to experiment with colour and the dynamics of movement at the beginning of the 1950s. For him Venice was a pretext for continuous exercises, lending itself easily to descriptions through details and allusions, to be reinvented according to the rhythm of his chromatic intuitions. He did not want to document it, just as later he did not want to document Vienna or New York, but instead he wanted to put himself to the test, to suspend the changing flux of his vision. In 1957, he wrote in *Popular Photography Color Annual*: 'I am no longer interested in a pure and simple reality; the only thing which fascinates me is to transform it into a subjective viewpoint. Without touching my subject I want to get to the moment when, through the pure concentration of seeing, the composed photo becomes more "made" than "taken"'. In the course of repeated visits to Venice, from 1951 to the end of the 1970s, Haas pursued his stated intent to create, through beauty, a kind of fourth dimension of sight which goes beyond reality and time to create a personal poetic synthesis in a two-dimensional image. Luca Campigotto, on the other hand, is Venetian, and grew up with Venice right before his eyes. It was inevitable that he would take his own city as his subject. He approached it as an historian, searching out, in his words, 'distant nights that I have not known', looking for a physical space that would recreate the mystery of suspended time. After dark, the city offered itself to him, deserted and silent, still and timeless. Campigotto's vision has the rhythm of a 19th-century stroll through alleyways and past palaces, surrounded by reflections off the water of the canals. Aware of the 'sweet infidelity' of the image, he recreated a theatrical Venice, a magnificent stage set where anything is possible. *Venetia obscura* was published in 1995; this is a Venice born out of absence, silence and the brackish perfume of the night, where the urban space, approached with a classic documentary lucidity, is revealed as an architectural set, with wings and escape routes. If Ernst Haas used the city's charm in pursuit of his own personal poetic creation, Luca Campigotto, in his enchanted journey through the Venetian nights, tries instead to reconstruct a dream, in which the city and its history are the indisputable, much-loved protagonists.

ernst haas

luca campigotto

« To discover a new way of seeing is the most difficult and most worthy goal of our medium. The important thing is not to be seen as rebels, but to convince others with a new philosophy of seeing.

(from 'Haas on Color Photography', 1957, in *Le più belle fotografie a colori*, Milan, 1989)

Ernst Haas Guitar Player with a Gondolier, 1955

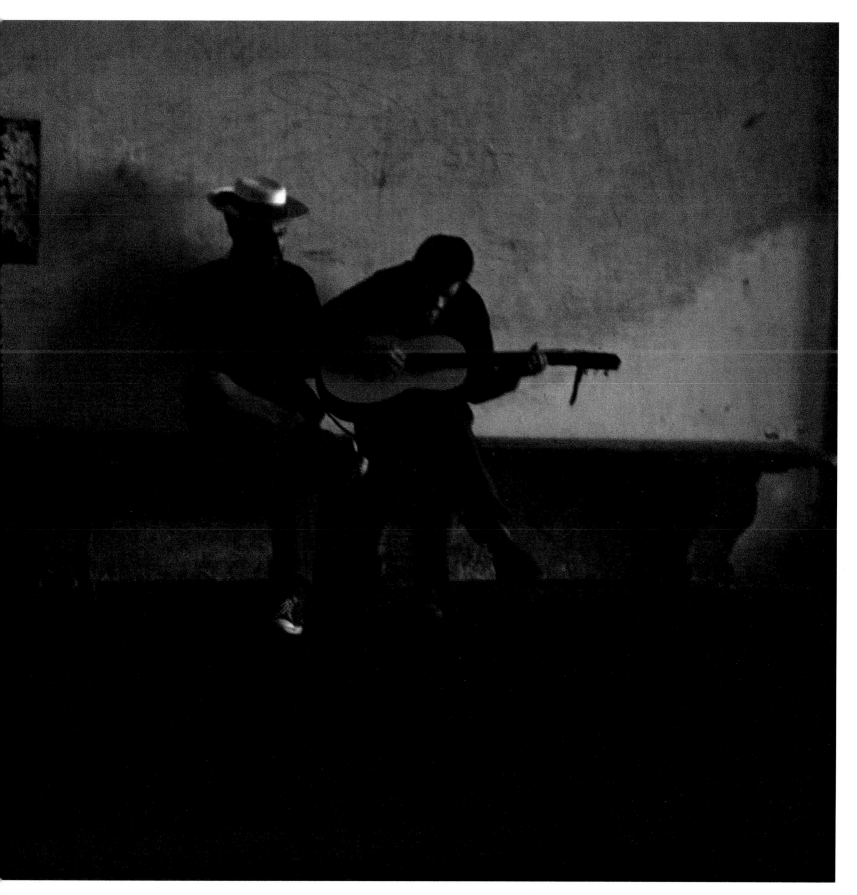

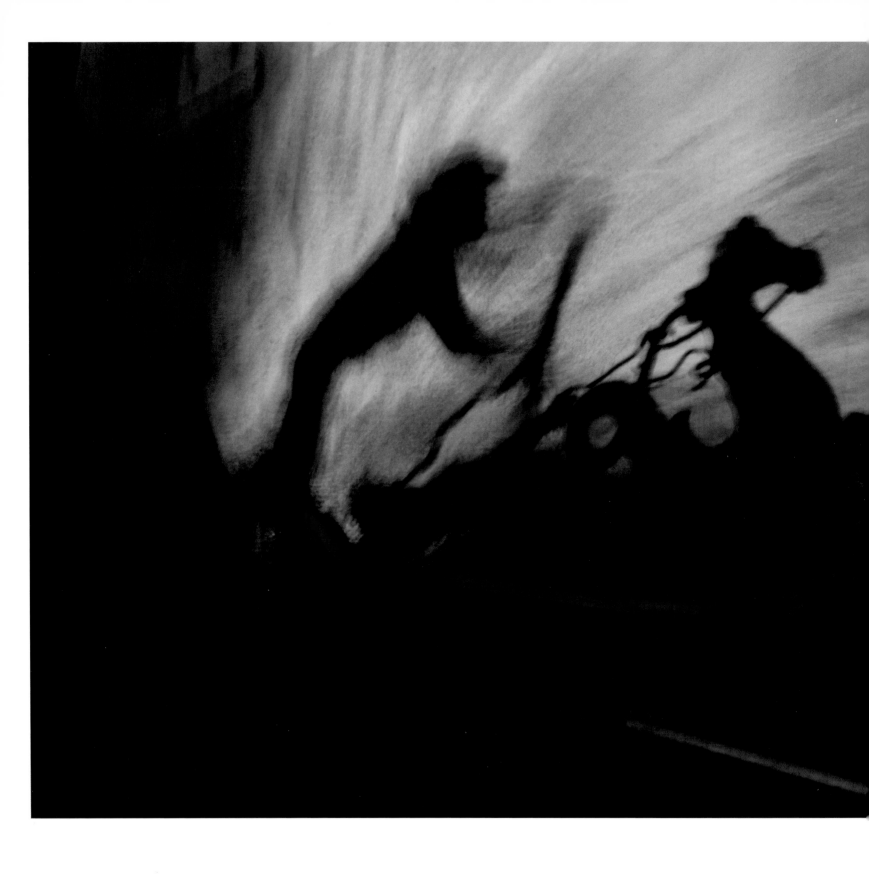

Ernst Haas Shadow of a Gondolier, 1955

Ernst Haas Gondolas, Doge's Palace, 1955

Ernst Haas Reflections I, 1955

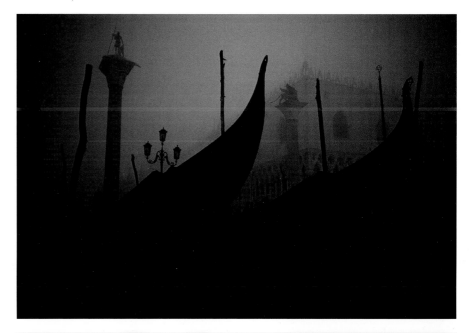

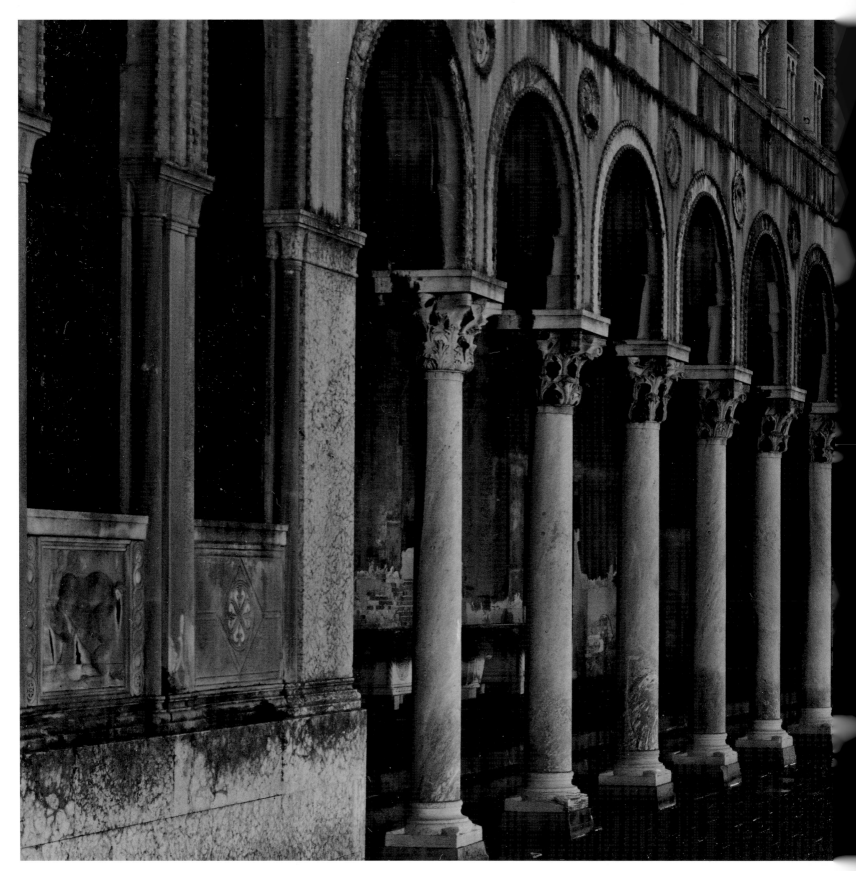

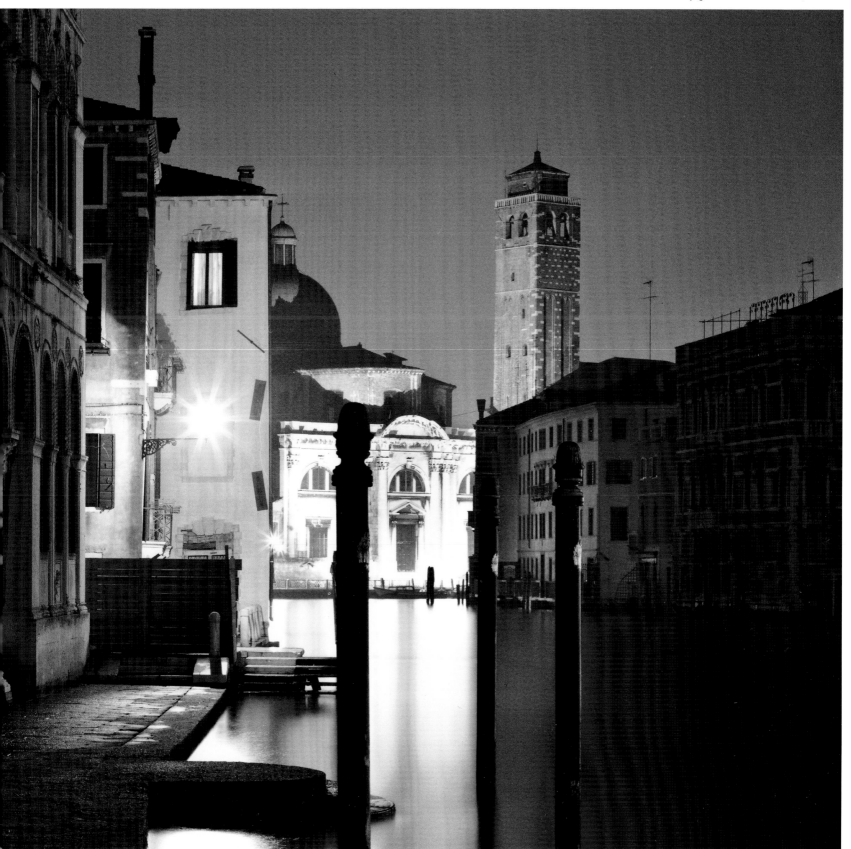

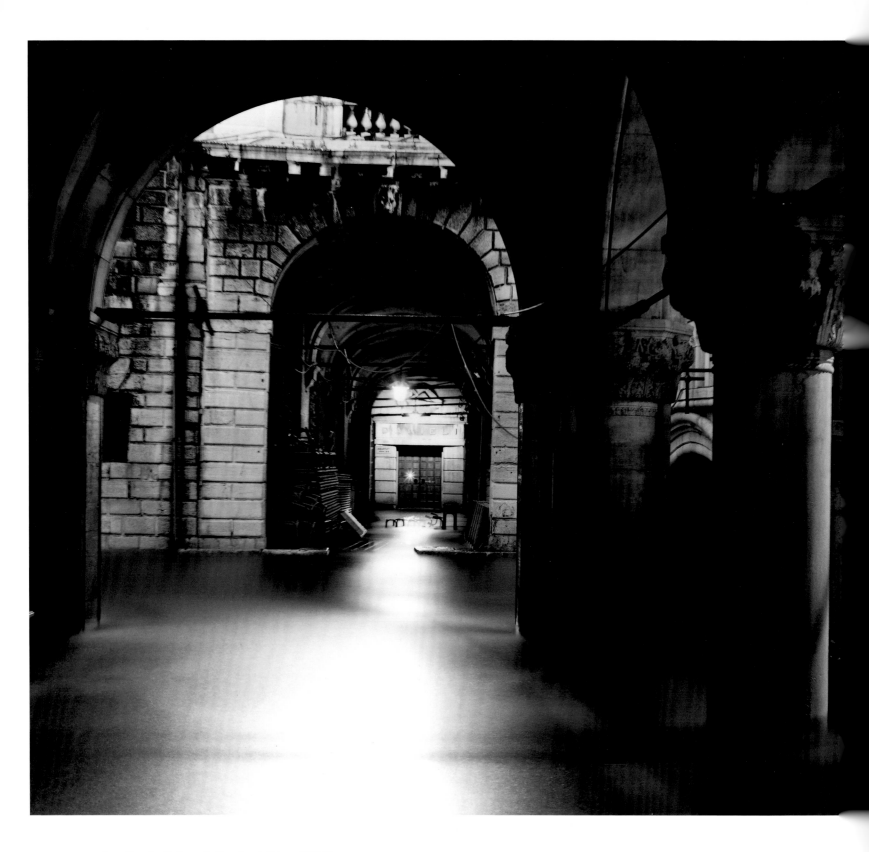

Luca Campigotto Inner Portico, Doge's Palace, 1992–94

Luca Campigotto Campo Santa Maria Formosa, 1992–94

« Whoever has the fortune to understand Venice, is not scared of its beauty. Because they have learnt – before and quite apart from photography – to face the rhetorical deceit of all extraordinary poetic expression.

(from 'Screenplays for History', in *Venetia obscura*, Rome, 1995)

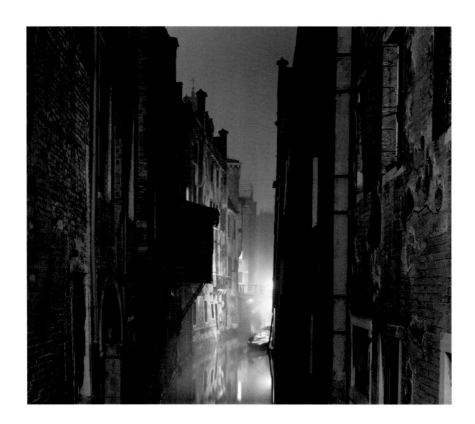

Luca Campigotto Rio di Santa Maria Zobenigo, 1992–94

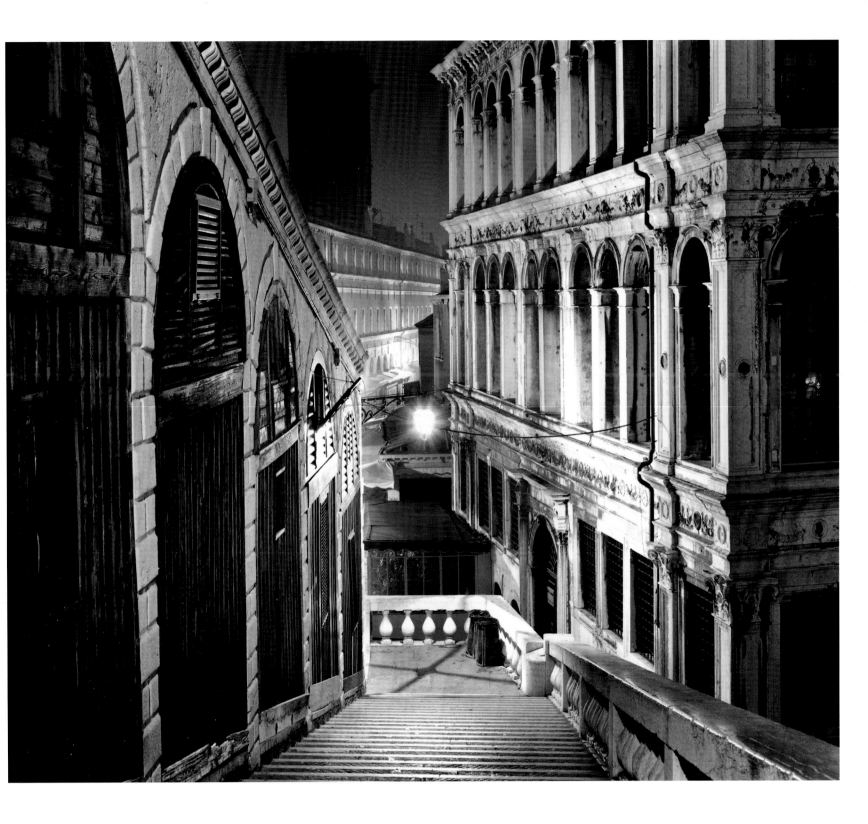

Luca Campigotto Ponte di Rialto, 1992–94

The Fascination of Myths

Herbert List belongs to that group of refined aesthetes, photographers, painters and writers, who visited Southern Europe between the wars, in search of the charm and emotion of the Mediterranean, and in search of a classical ideal of beauty and formalism. From the 1940s on, he consciously uncovered the attraction of Italy, visiting more and more frequently, and staying for longer. Except for *Rome*, in 1955, he never published his extensive work on Italy in book form, although after his death, his heir and curator of his archive, Max Scheler, would publish some of it in the 1995 book *Italy*. In List's photos, time is still, suspended. His photography is limpid, influenced by the aesthetics of the new objectivity, but tempered by a sensual and evocative light. Mimmo Jodice's background, meanwhile, owed much to the international avant-garde active in his home town of Naples in the 1970s. Jodice took the remains of Greco-Roman civilization as the subject of a sustained enquiry conducted in numerous museums and archaeological sites (published as the volume *Mediterraneo* in 1995). His journey is a search for the very roots of ancient civilization, for the origins of myths, which seem to be revealed in the vibrations of a strong, magical light. His photography, which in many of his earlier projects was a tribute to a consolidated documentary style, changed register: poetry takes the place of rigour, and his images are full of intimations, which breathe life into the air that seems to pulsate around columns, statues and buildings. Despite differences of experience and intent, both artists depict a kind of magical suspension of time. On the other hand, while the intoxicating remains of the past are for Herbert List places of enchantment and amazement, for Mimmo Jodice they are the subject of an investigation into the roots of his and our culture. In the linguistic complexity of his rereading, the faces of statues, the tapering of columns, the saturated skies, the sea and the pebbles are all charged with symbolic values which one is not obliged to decipher, adding mystery to their attraction. List's photography teaches one to see, purifying the formal composition to the point of creating an ideal world, or rather, to the point of concretizing an aesthetic dream. For Jodice, the myth of past civilizations is a universe in which it would be easy to lose oneself. It invites questions destined to go unanswered, but also, thanks to the profound lyricism of Jodice's interpretation, encourages a silent reflection on the contradictions of contemporaneity.

herbert list

mimmo jodice

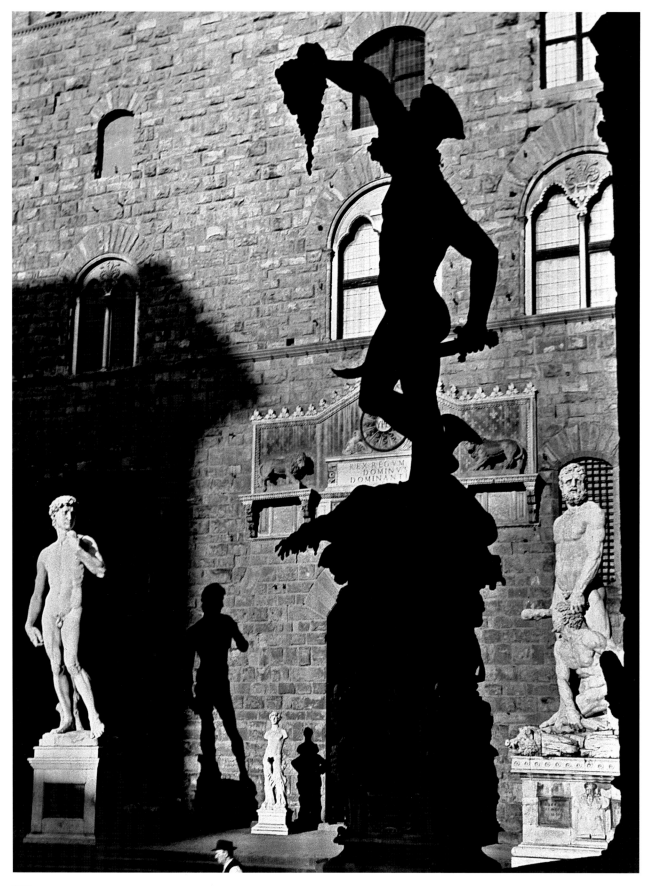

Herbert List Florence, 1939

 # The lens cannot be objective.

(quoted in *Italy*, preface by Luigi Malerba, London, 1995)

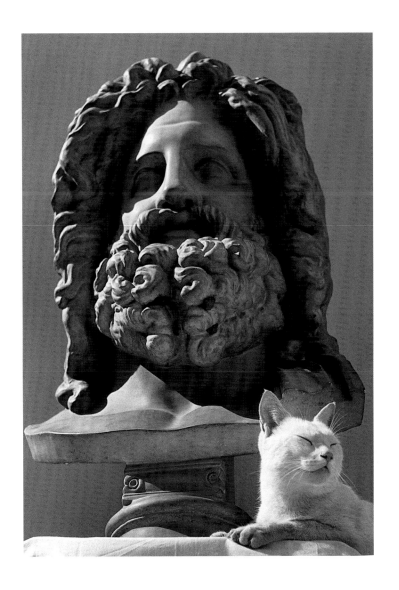

Herbert List Rome, 1949

Herbert List Bomarzo, 1952

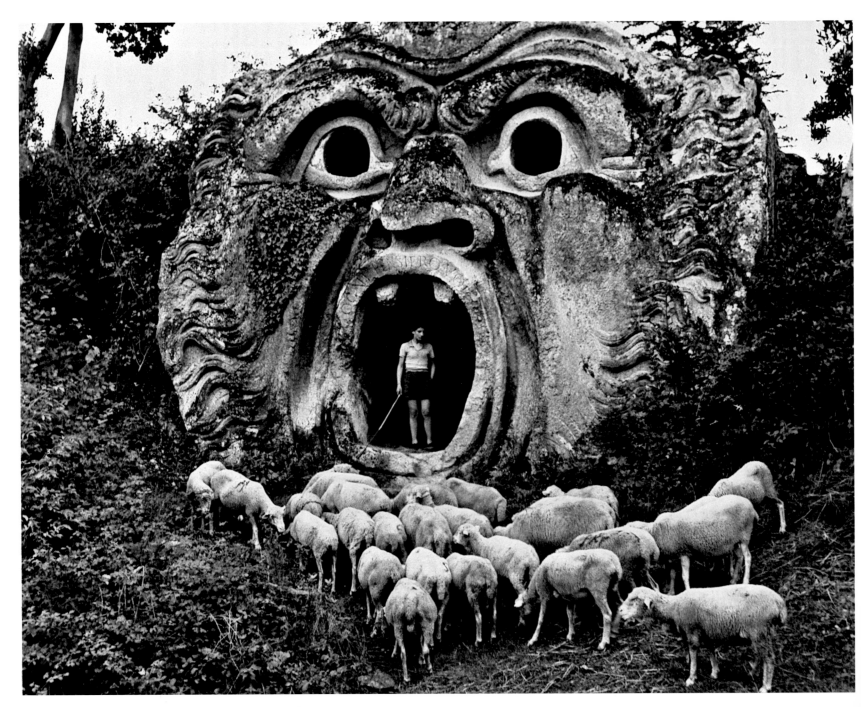

Herbert List Rome, 1949

Herbert List Rome, 1951

Herbert List Naples, 1958

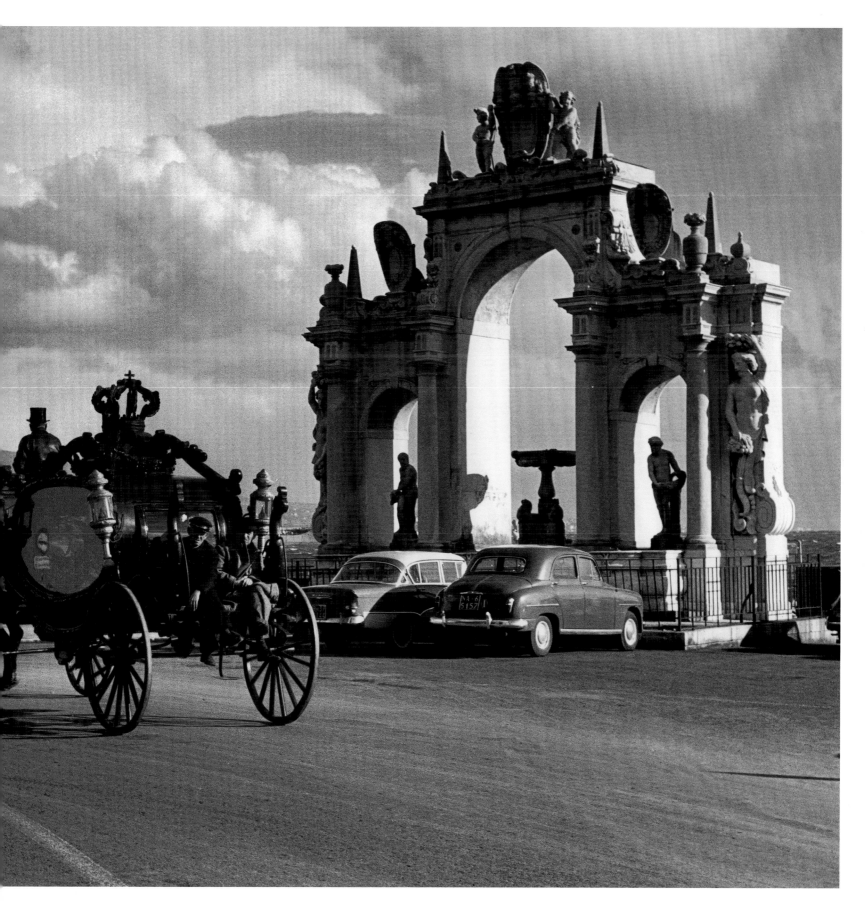

Mimmo Jodice The Sibyl's Cave, Cumae, 1993

Mimmo Jodice Athlete from the Villa of the Papyri in Herculaneum, Naples, 1986

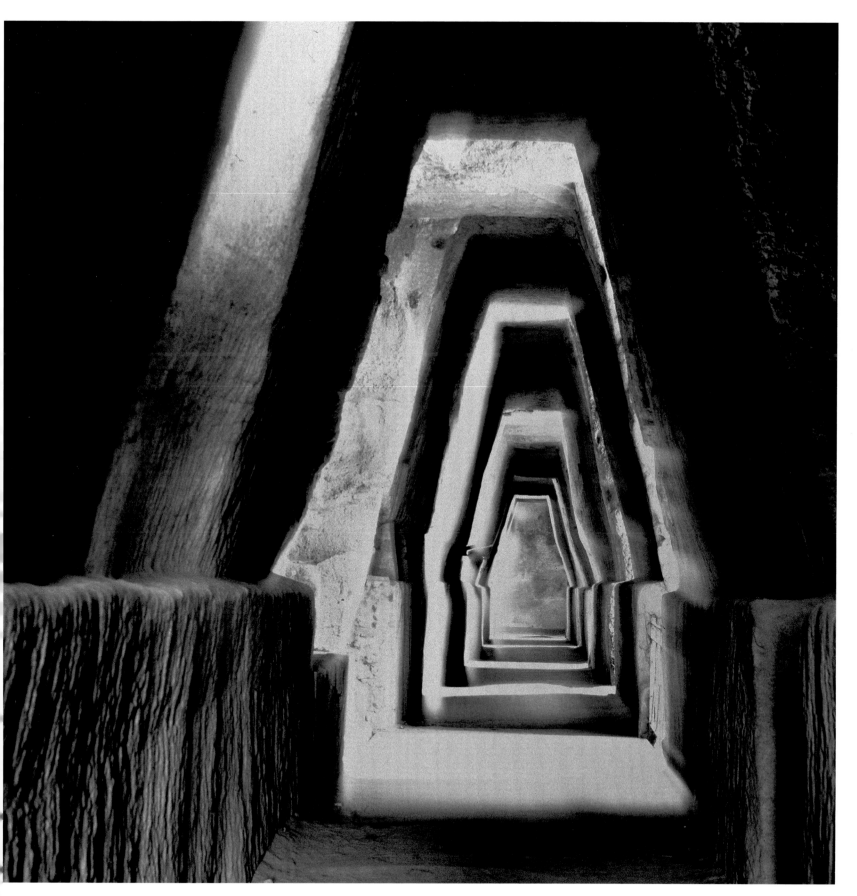

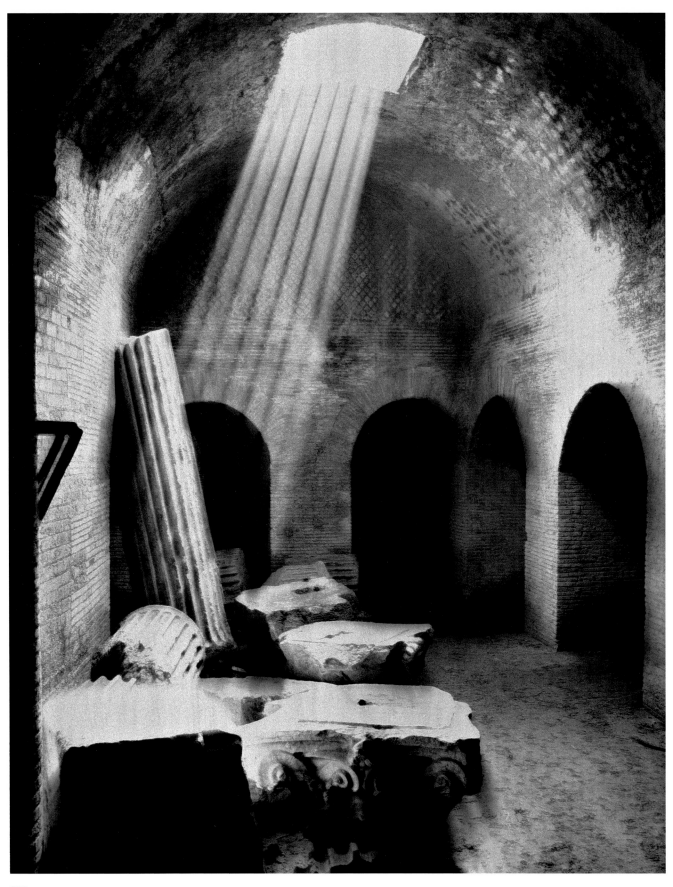

Mimmo Jodice The Temple of Neptune, Paestum, 1990

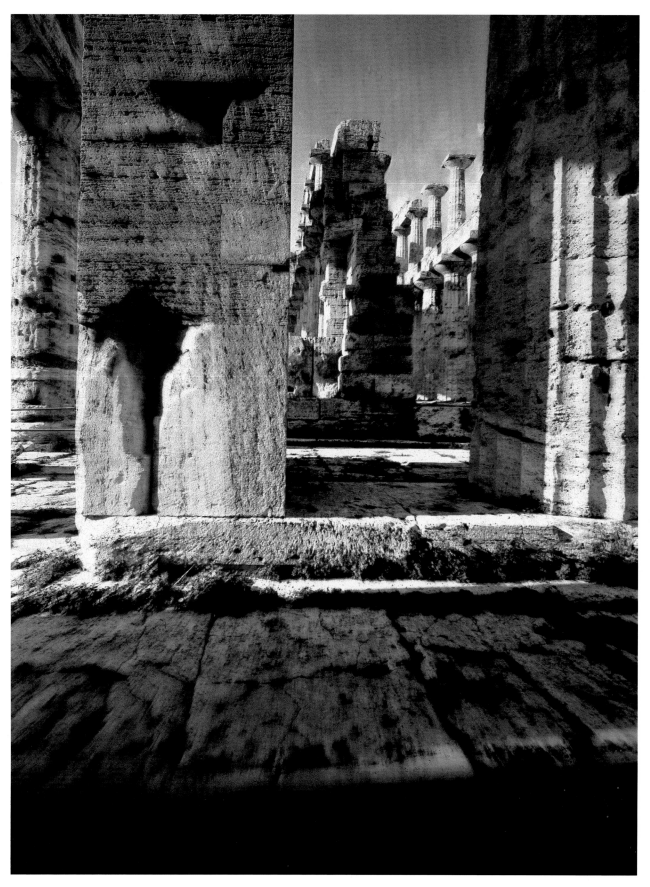

« To review the past means understanding the symbolic nature of emotions and values which we still share. The rich and contradictory mosaic of our modernity was created in the myth of the Mediterranean.

(from *On Myth*, unpublished, 2003)

Mimmo Jodice Athlete from the Villa of the Papyri in Herculaneum, Museo Archeologico, Naples, 1986

Mimmo Jodice Walls of the Greek City, Paestum, 1986

Tuna Fishing

Sebastião Salgado and Giorgia Fiorio are both artists involved in large-scale projects. And for both, the *tonnare* – the last bastions of fishing for tuna and swordfish in Italy – represent just one aspect of ongoing investigations. Salgado compiled his book, *Workers*, published in 1993, while in Trapani, in Sicily. It is an extraordinary volume, which sets out to tell the history of an epoch, and is almost a visual encyclopedia of all those who still, in this post-industrial era, work solely with their hands. The themes that run throughout the book are those of fatigue, desperation, the absence of hope for the future, and the awareness that their work has become anti-historical. 'At the end of the Second World War', writes Salgado, 'over thirty groups of Sicilian fishermen would have participated, in tune with the tides, in the ceremony of the *mattanza*, the great annual massacre of tuna. Today only two groups continue the tradition.' Salgado portrays the old patriarchs, the preparation of the nets, the agitated activity of the fishing and the desperate attempts at escape on the part of the tuna, like a sequence of apocalyptic visions which glorify and ennoble man's battle against the forces of nature, but also against history and the inevitable pressing of time. Giorgia Fiorio uses a more mediated, almost nostalgic approach. Her work forms part of a larger project on closed masculine communities. Other episodes have focused on boxers, the Italian army, the Foreign Legion, matadors and American firemen. *Men of the Sea/Hommes de la Mer*, of 2001, took her to Sicily and Sardinia. As is her way, she lived with the fishermen, setting sail with them, eating with them, dreaming that 'some merciful god will reward them with some fish'. Her images have a classical feel to them, but they are also both intense and poetic. They tell of exhaustion, silence, concentration, the relationship to the sea, but above all they recount the faces of these men. Young and old, caught in the framework of the composition, they are the unwilling and heroic protagonists in a battle for survival, which they have little chance of winning. This is the theme linking the very different visions of Sebastião Salgado and Giorgia Fiorio: the awareness that the work of the tuna fishermen is destined to disappear, obliterated by pollution, by better organized competition, and by history itself. Both of these artists, through the faces of their heroes, pay tribute to a memory which, while still present, already belongs to the past.

sebastião salgado

giorgia fiorio

Sebastião Salgado Trapani, 1991

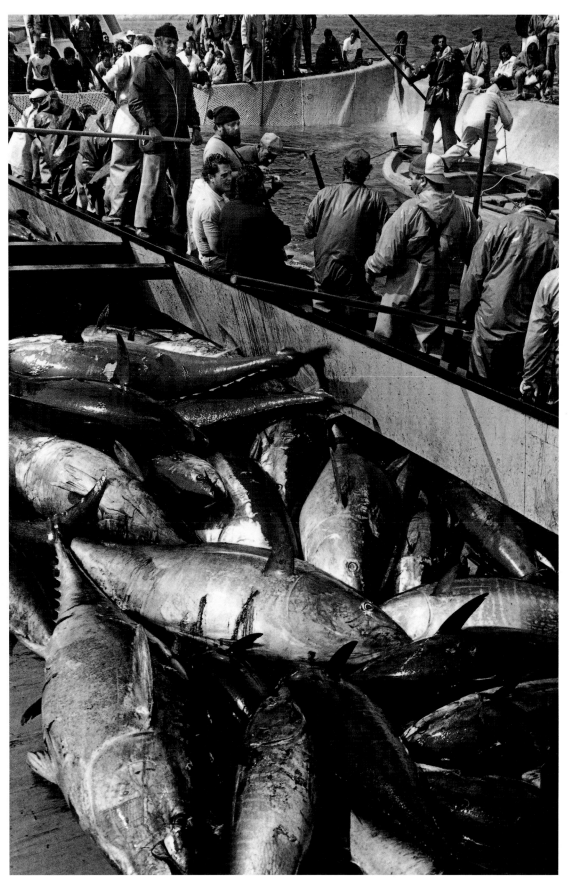

Sebastião Salgado Trapani, 1991

Sebastião Salgado Trapani, 1991

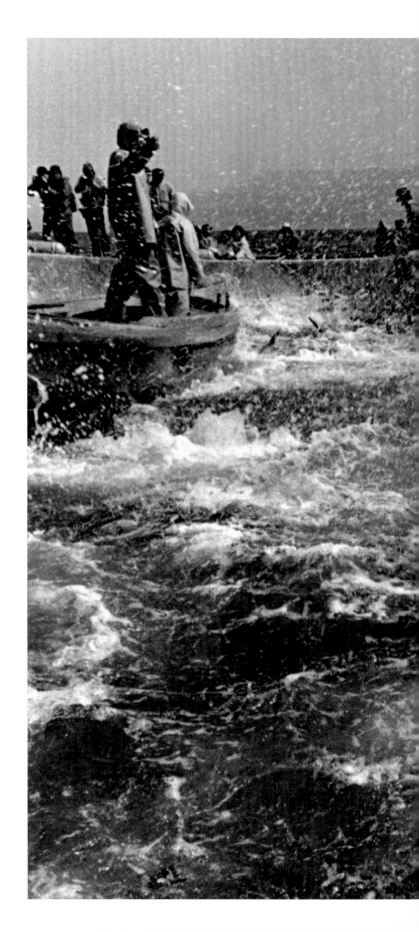

« *La Mattanza* is a traditional tuna-fishing method in the Mediterranean, shown by documents, drawings and paintings to have been in use during the Middle Ages. It is slowly vanishing.

(from *Workers*, London, 1993)

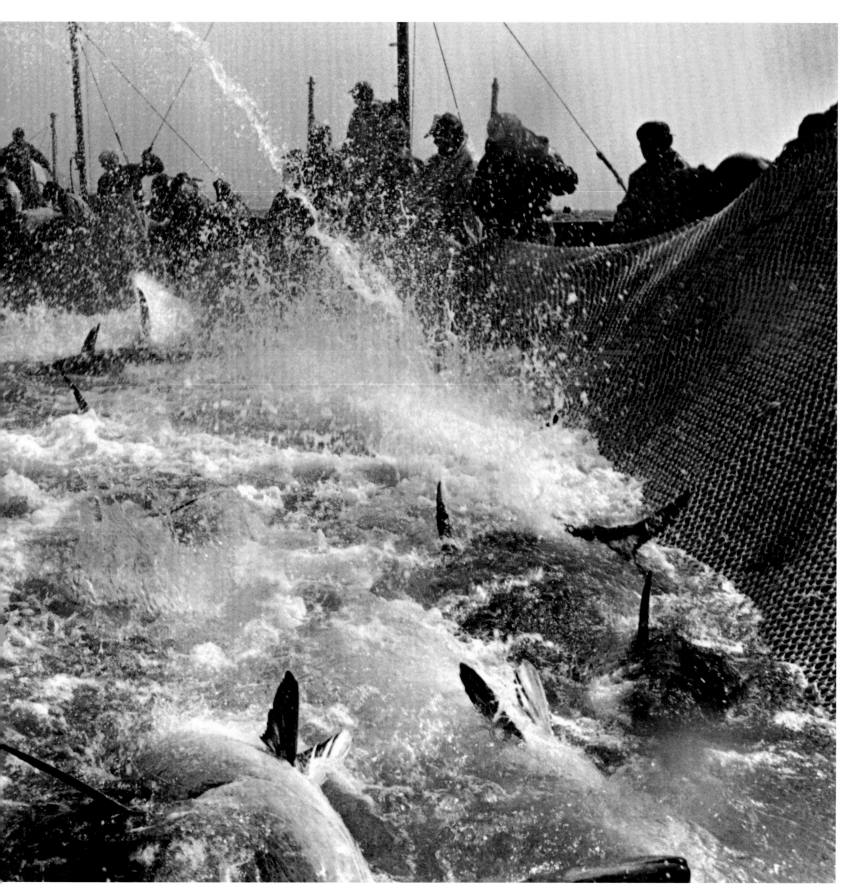

Giorgia Fiorio Carloforte, Island of San Pietro, Sardinia, 1999

« The weeks of the *tonnarotti* have no Saturdays or Sundays. By its very nature, work at sea is exhausting and interminable. It starts at night and ends at night.

(from *Hommes de la mer*, Paris, 2001)

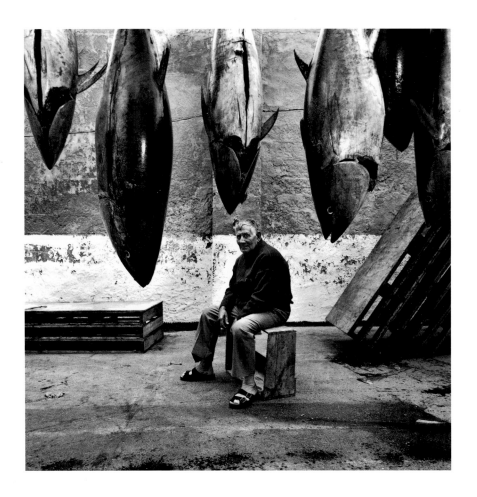

Giorgia Fiorio Carloforte, Island of San Pietro, Sardinia, 1999

Giorgia Fiorio Carloforte, Island of San Pietro, Sardinia, 1999

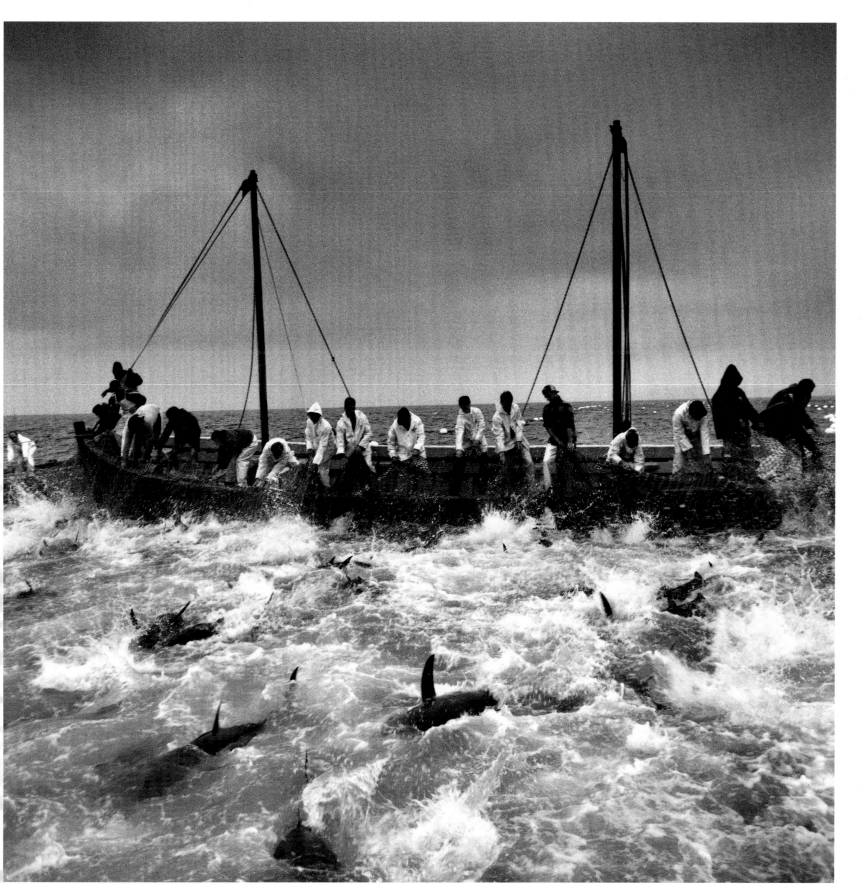

Volcanoes

Between 1987 and 1995, Roger Ressmeyer was working almost full-time for *National Geographic*. He carried out a series of important scientific and geographical features for the legendary American monthly, which called for a strong and spectacular communicative impact, informing as well as astounding the reader with the exceptional quality of the images. At the beginning of the 1990s, Ressmeyer embarked on a journey around the world to photograph the most important active volcanoes. He was not interested in questions of interpretation; his aim was to be as direct and truthful as possible, in keeping with the best traditions of photo-journalism. He did not shy away from the more photogenic situations; on the contrary, he sought them out, tackling eruptions, lava flows, ash and smoke, skies full of fire and infernal landscapes, to create photographs that have a great emotional impact. The finished project was published as an interactive CD-ROM in 1996, entitled *Volcanoes: Life on the Edge*, and is an extraordinary lesson in scientific and environmental photo-journalism. Antonio Biasiucci's approach to volcanoes is profoundly different. His interest came out of his collaboration with the Osservatorio Vesuviano (the observatory at Vesuvius). Begun in 1984, the project had the institutional objective of disseminating information about volcanoes. It might have been a professional undertaking, but Biasiucci, always inclined towards what he himself described as 'interior reporting', experienced Vesuvius as a place of extreme situations, as the theatre of uncontrollable and unforeseeable energies. Soon, volcanoes became the subject of a new project. After Vesuvius, he went to Etna, Stromboli, Solfatara and Vulcano. Biasiucci almost loses himself in this enchanted environment of continuous metamorphosis and strange contrasts. *Magma*, which he published in 1998, is the account of experiences of primordial forms and forces, and contact with the origins of the nature of man. Despite having dedicated nearly ten years to volcanoes, Biasiucci thinks that his work is still evolving. Indeed, he writes: 'If a project finishes when you have revealed its mystery, then volcanoes still represent an unfinished project.' His analysis cannot be categorized within the tradition of landscape photography because it strives to be an investigation of sensations and memory. He captures the sensuality of the matter and of the forms, entering into the details of boiling magma, and intentionally losing any notion of scale in the folds of pure substance. Biasiucci does not concern himself with the requirements of description or truthfulness; instead he is obsessed with confronting the questions thrown up by such an extreme reality.

roger
ressmeyer

antonio
biasiucci

« My life as a photo-journalist has been thrilling, both physically and intellectually. I've hung from helicopters over molten lava... and confronted some of the most powerful forces of nature.

[From *www.rogerressmeyer.com*, 2003]

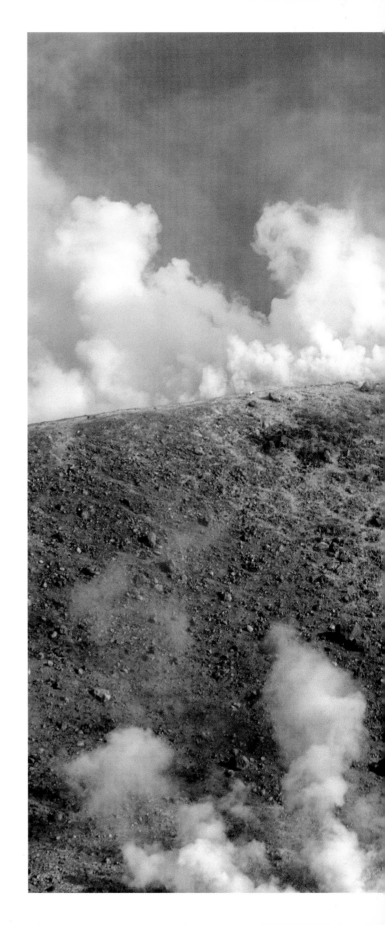

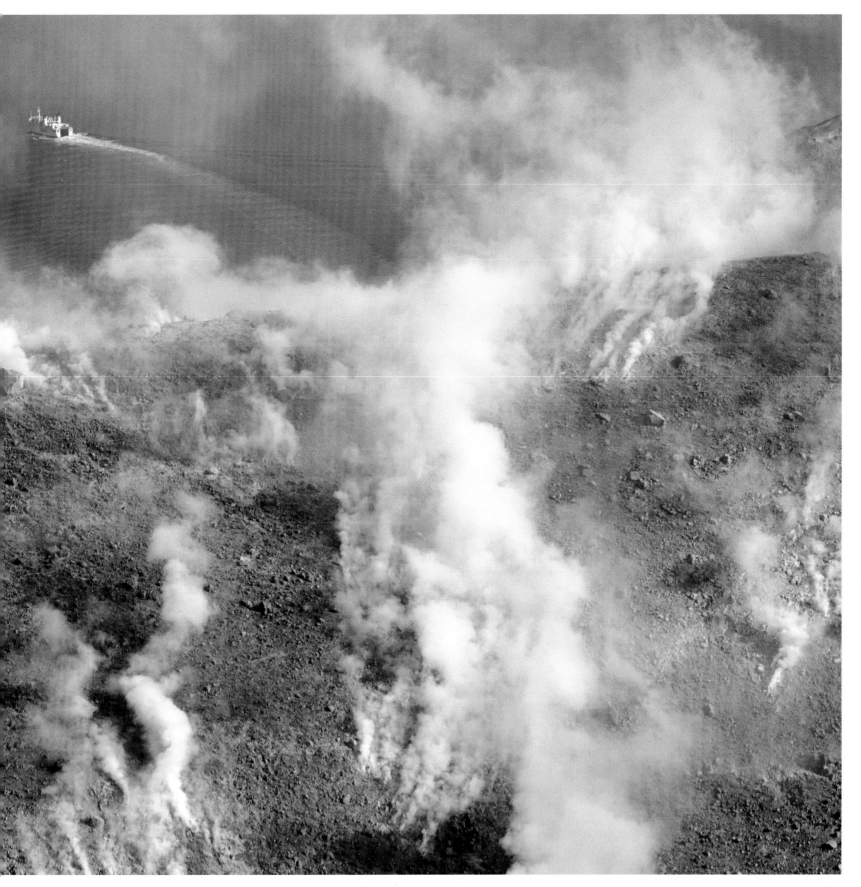

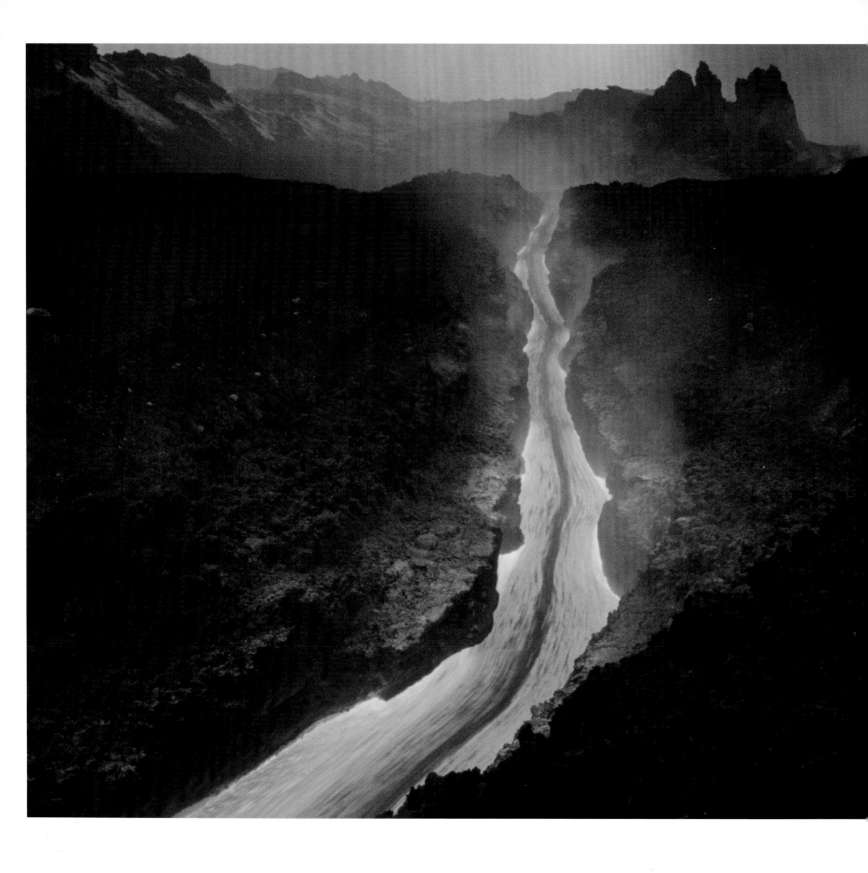

Roger Ressmeyer Etna, Catania, 1992

Roger Ressmeyer Vesuvius, Naples, 1991

Roger Ressmeyer Vulcano, Aeolian Islands, 1991

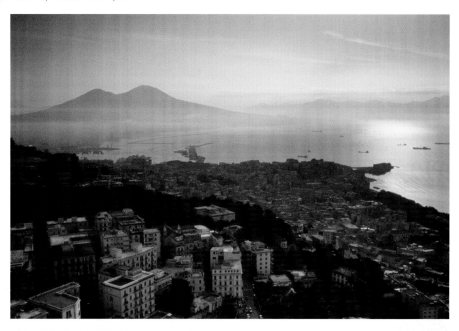

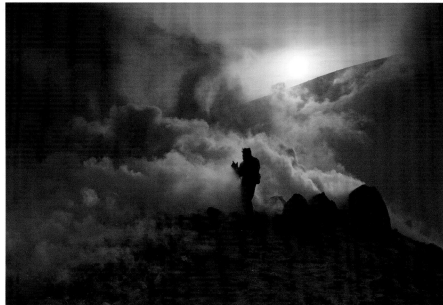

 «...every day I went to the area around the crater to watch the indescribable event of the eruption, without ever feeling the need to photograph it. The mystery and wonder of this phenomenon were just too overwhelming.

(from 'Journeys without Tracks: Dialogue with Antonio Biasiucci', in *Magma*, Milan, 1998)

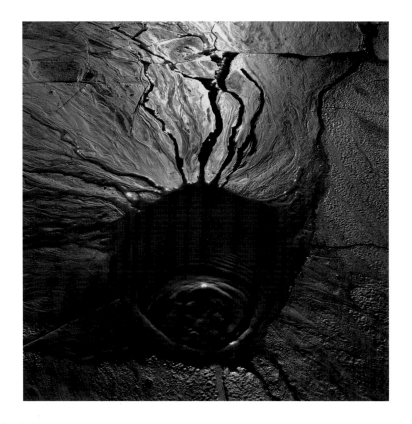

Antonio Biasiucci 1984–95

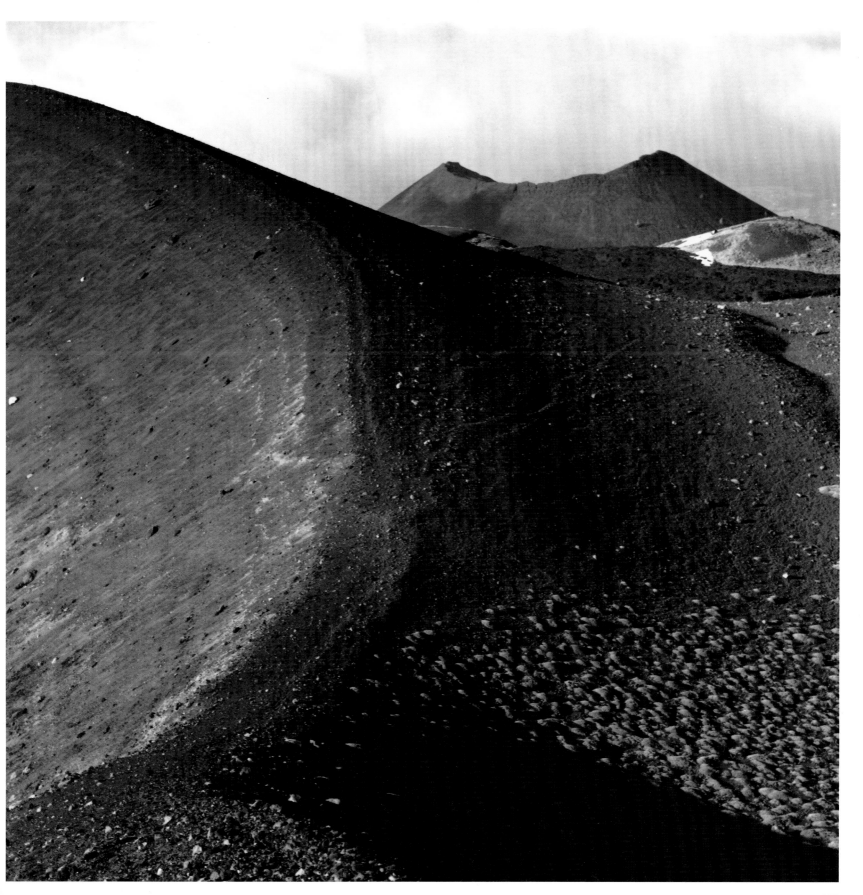

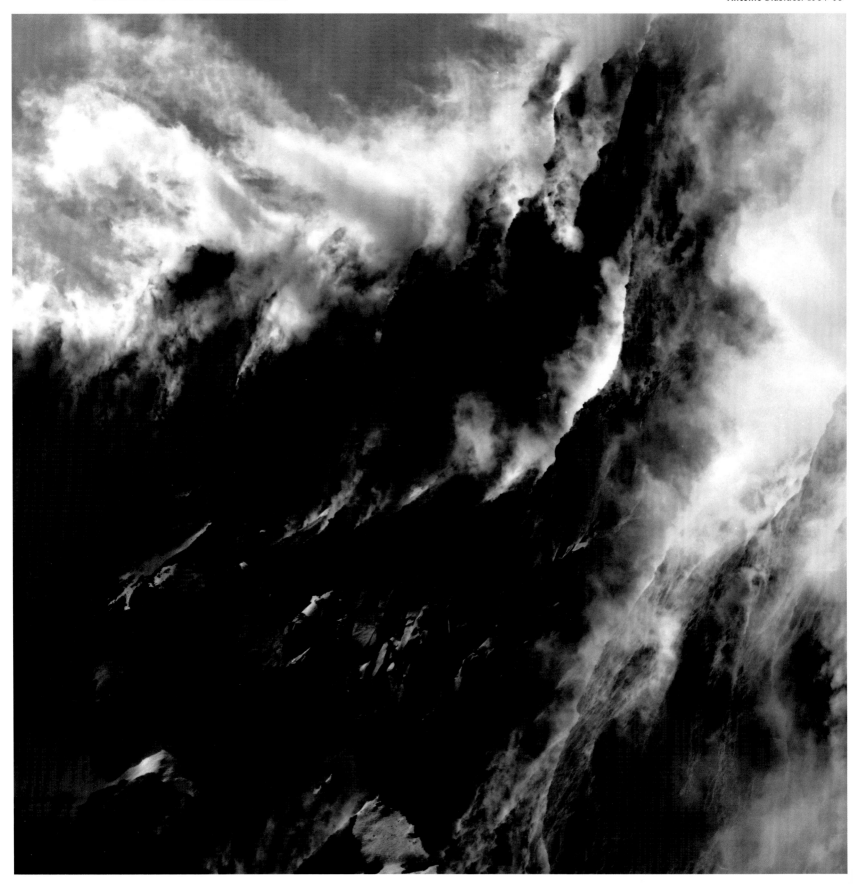

Roman Walks

Joel Sternfeld worked on the Roman countryside between 1989 and 1991. He had already published *American Prospects*, an impassioned and sceptical analysis of the United States that has been compared to the work of the *New Topographics* in its inclination towards objectivity and neutrality. Yet, his photographs, which generally focus on nature, always contain some disturbing detail, some event that transforms apparent serenity into drama. In *Campagna romana*, published in 1992, he approaches the countryside and remains of ancient Rome with his usual sensibility and creates a vision that is open to many possible interpretations. At first glance, it seems that Sternfeld has let himself be enchanted by the warm, soft light, the broad horizons, the imposing presence of the ruins and the aqueduct, but on closer inspection his images are disquieting. There are glimpses of the blight of unregulated buildings, and the narrative rhythm suddenly becomes more urgent. His measured gaze takes in the environmental destruction, the mountains of waste, the disfiguring graffiti and the monstrous tide of cement that seems merely to be waiting for the right moment to suffocate this extraordinary landscape. When people make an appearance, they seem incongruous, as if frozen in posed portraits or in gestures caught at a distance. Gabriele Basilico's work on Rome was of a rather different nature. He cooperated on the project 'I tempi di Roma', which was organized in the context of the Jubilee in 2000. Perfected during the course of numerous photographic campaigns throughout Italy and Europe, his vocabulary is rigorous, full of silences and strongly urban. Basilico constructs an itinerary derived from his usual working method: from the park of the aqueducts he moves closer to the centre of the city, searching for traces of the past in the present, for that contamination, that interdependence of styles which has always fascinated him. His images enter into a dialogue with the city, taking in the changes, the signs of transformation, the modifications to the urban fabric, from the periphery to the centre. The countryside is simply a point of departure for his journey into familiar territory: namely, the rereading of the complexities of constructed space, the cohabitation of ancient and modern, of monumental remains with the signs of modernity. Joel Sternfeld and Gabriele Basilico can both be classed as documentary landscape artists, and they would both acknowledge the influence of artists such as Walker Evans. And yet, their photographs represent a merging of a documentary style with an aesthetic and emotional attempt at restoring some visual order to the chaos of construction. In this respect, the human presences of Sternfeld are equivalent to the silences and voids of Basilico.

joel
sternfeld

gabriele
basilico

« It was Helen Levitt who taught me that barely perceptible changes in light and landscape may be of consquence.

(from *Walking the High Line*, Göttingen, 2001)

Joel Sternfeld Claudian Aqueduct, Rome, 1990

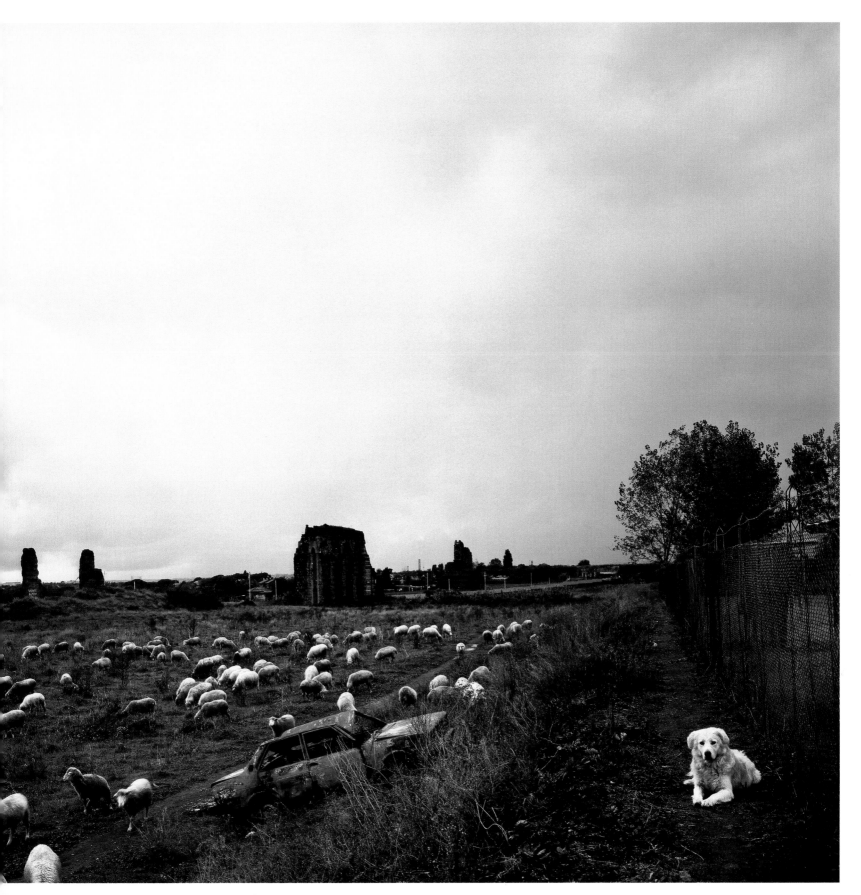

Joel Sternfeld Parco dei Gordiani, Rome, 1990

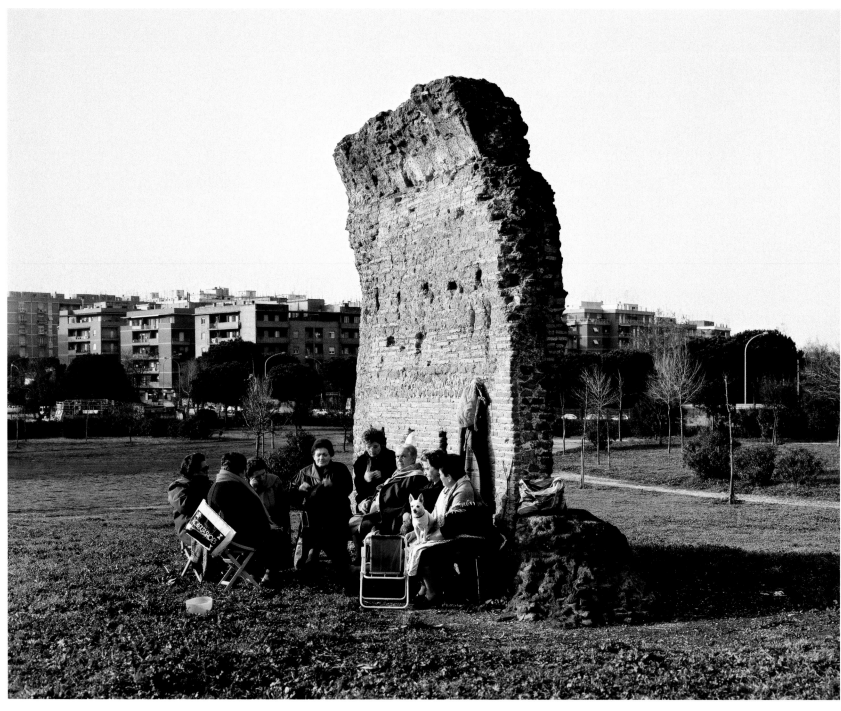

Joel Sternfeld Great Nymphaeum in the Parco dei Gordiani, Rome, 1990

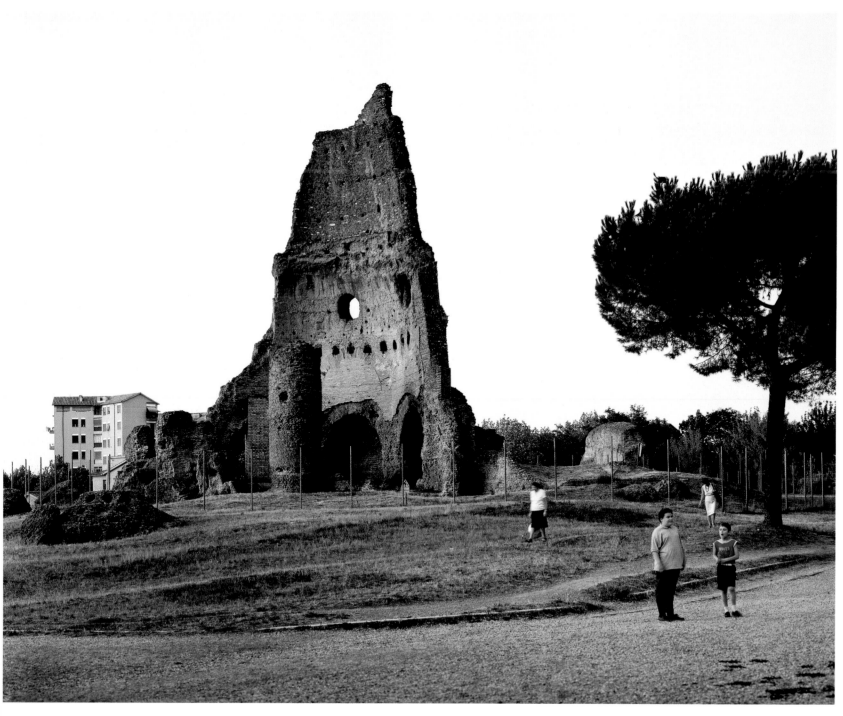

Joel Sternfeld Claudian Aqueduct, Rome, 1989

Joel Sternfeld Tor Pignattara, Via Casilina, Rome, 1990

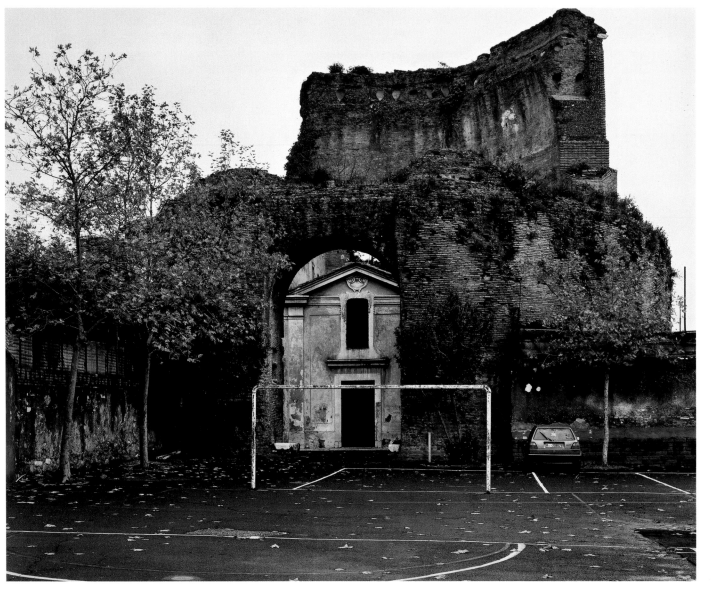

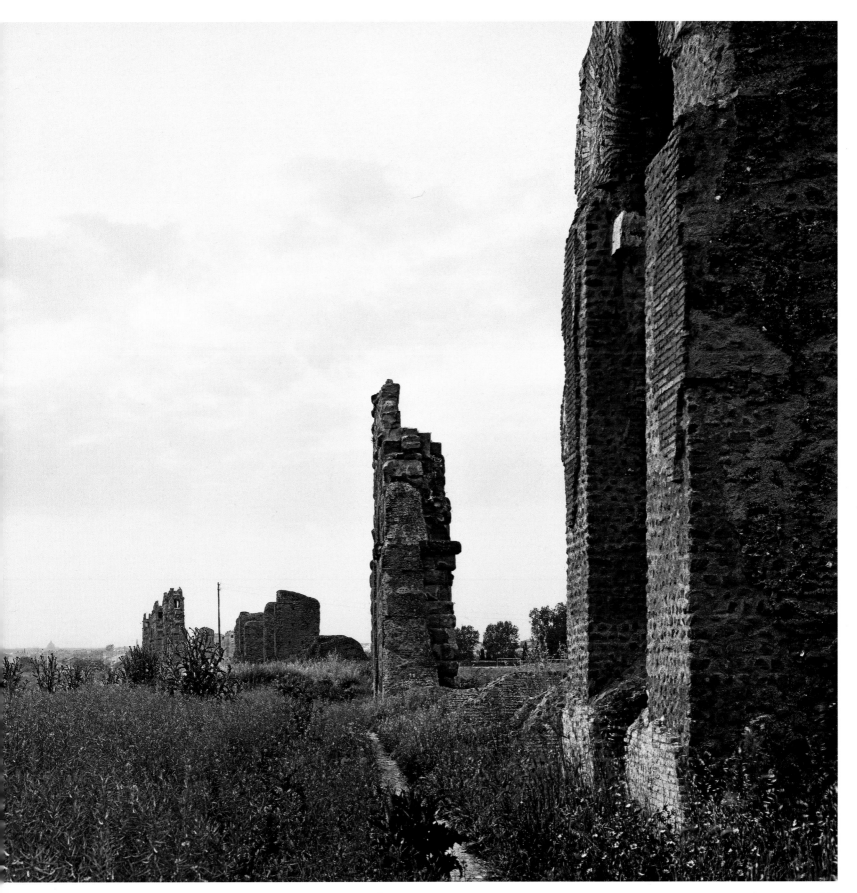

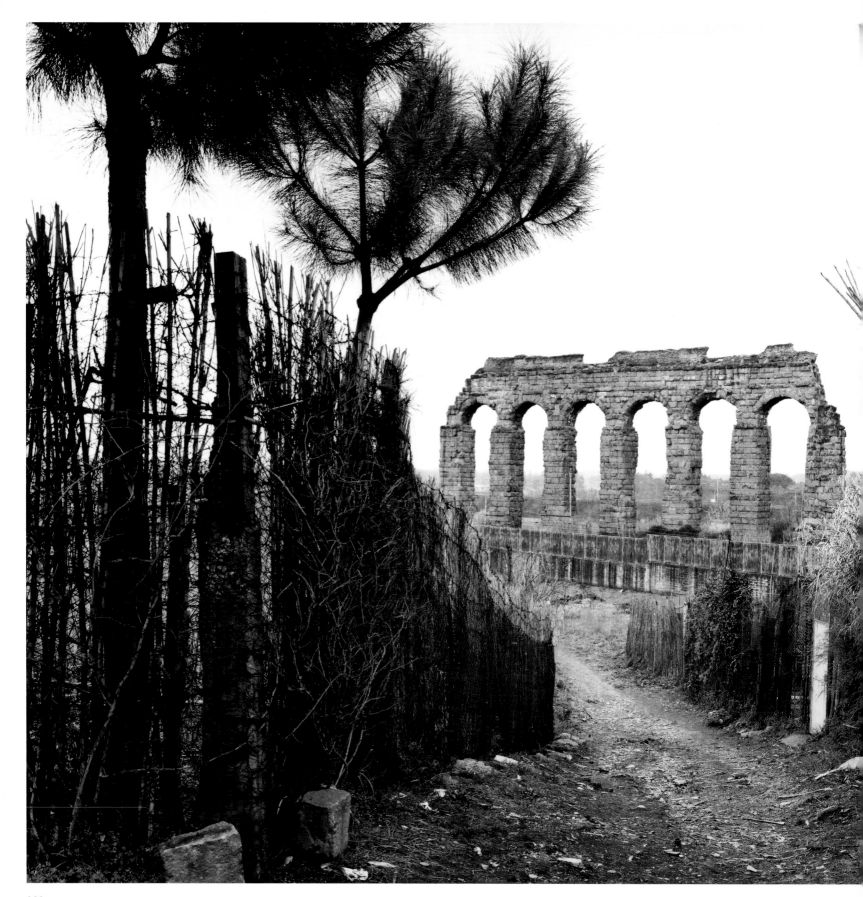

Gabriele Basilico Claudian Aqueduct, Rome, 2000

« In the description of the natural landscape and of architecture, significant markers such as roads or elements of urban disorder are transformed into something normal and help me to represent space.

(from 'Contemporary Landscape. Dialogues between Photography and Painting', in *Basilico/Salvo*, Bergamo, 2002)

Gabriele Basilico Via Giolitti, Rome, 2000

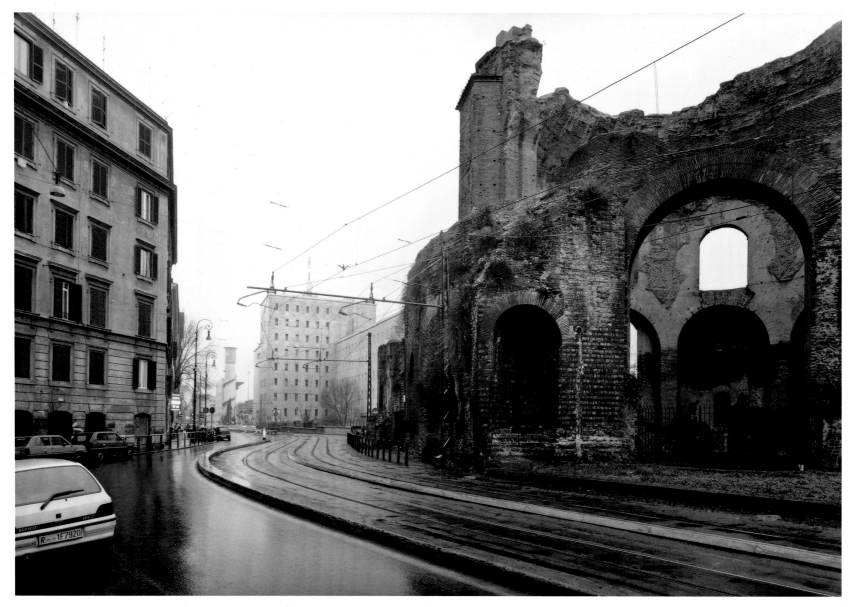

Gabriele Basilico Via Guglielmo Pepe, Rome, 2000

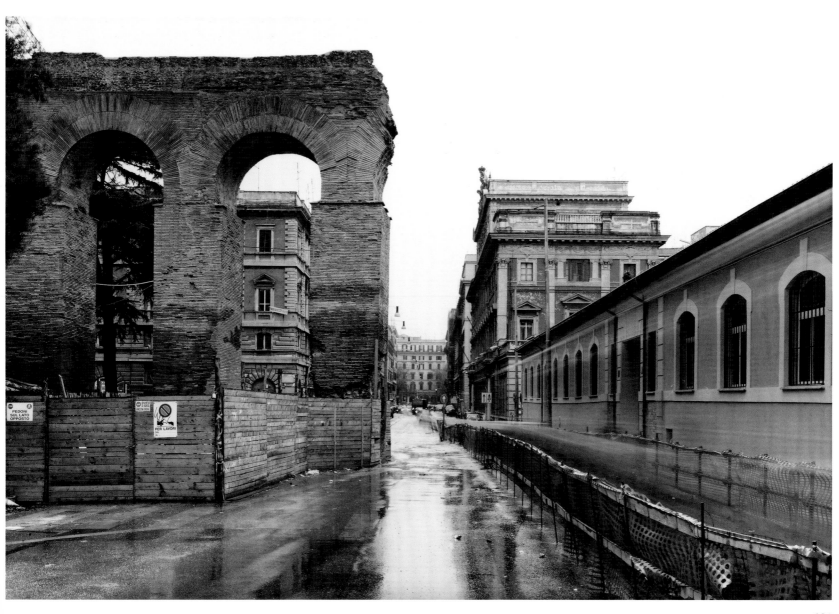

Gabriele Basilico Tiburtino District, Rome, 2000

Gabriele Basilico Piazza di Porta Maggiore, Rome, 2000

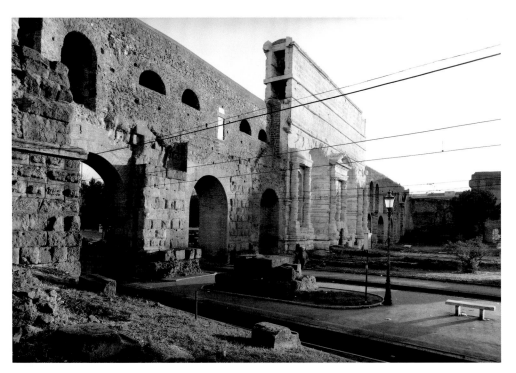

Beaches

Massimo Vitali has conducted a long and searching investigation into beaches, which began in 1994 and is still ongoing; while for Martin Parr they are just one of the many possible venues for his particular reading of reality. Putting his earlier experiences as a photo-journalist decisively to one side, Vitali dedicated himself to Italian beaches, choosing a working method based on time and waiting: he installs himself on a platform seven metres high, when the beach is still deserted, and waits for the bathers to arrive. He then observes how territory is occupied, looking at the creation of personalized micro-environments, and at colours and objects. From his watchtower, he keeps an eye on the constant movement of the people animating the landscape in front of him. The moment when the photograph is taken can come after many hours, when the beach has filled up, the rituals have been played out and the crowd of bathers has had time to accept and forget the presence of the photographer. His photographs contain an enlarged and 'objective' vision, which afford every observer the possibility of investigating, discovering mini-events, or imagining private stories and relationships. Martin Parr's work on beaches, on the other hand, was predominantly carried out in the context of the 1999 project 'Squardigardesani', on behalf of the council of the Riva di Garda. This gave him the opportunity to visit many beaches on Lake Garda. His disenchanted gaze never fails to notice the burnt skin, the bulging bodies and the small habits and gestures that characterize the holidaymaker. Using a language with which he has experimented in numerous books, he chooses moments of interaction, and situations which he can manipulate, so as to underline, with irony, the incongruities and weaknesses of those who dare to go to a beach under his watchful gaze. His eye tends to focus on details of bodies and highlight small paradoxes, giving a sense of oppressive heat and sun creams. He does not delegate the interpretation of events to the viewer, but guides them instead in the direction that he himself has laid down. Both artists, however, incorporate their method into their creative vision. The apparent impartiality of Massimo Vitali, his declared 'absence of judgment' on what is exhibited in front of his lens, is based on the search for beaches in which the throngs of bathers are crowded and convulsed, and the choice of where to position his camera, all of which already contain a declaration of intent and an implicit assumption of responsibility. Martin Parr, on the other hand, becomes almost merciful in his abrasive exercise of detachment, setting off a mechanism of self-identification, which makes us all protagonists and accomplices.

massimo vitali

martin parr

Massimo Vitali Rosignano Solvay, 1995

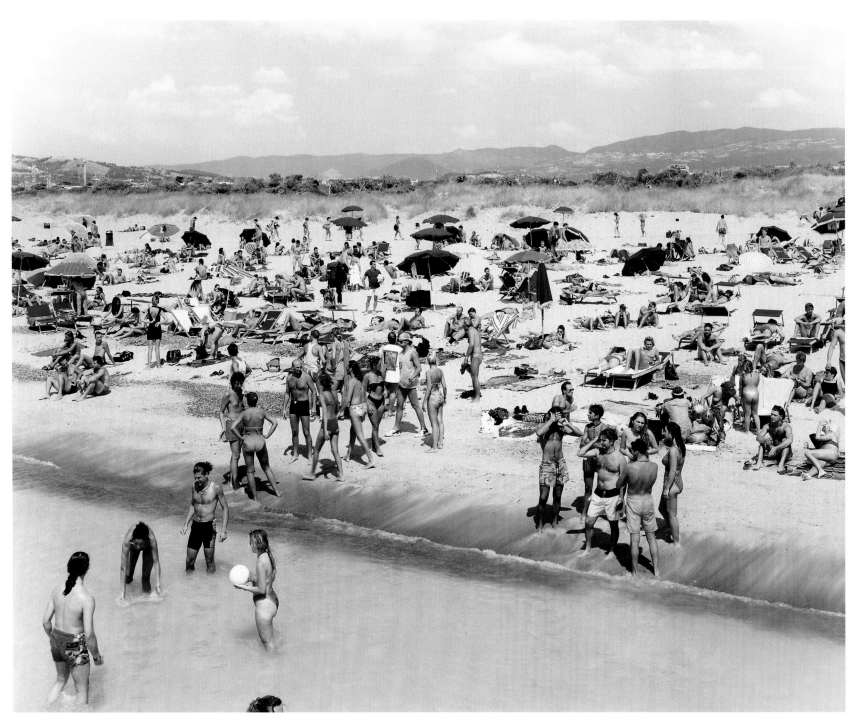

Massimo Vitali Rosignano Solvay, 1995

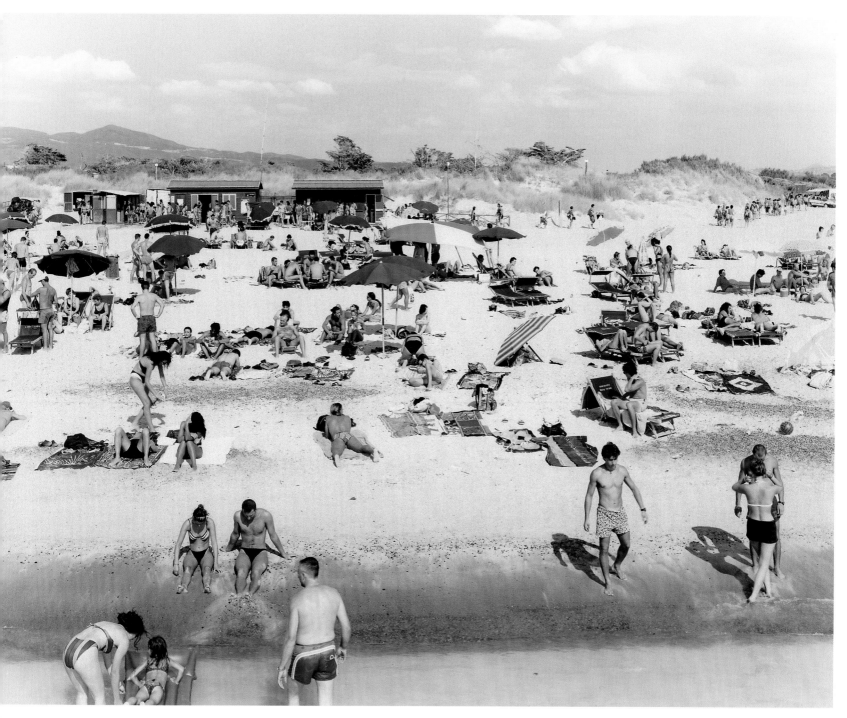

« From my vantage point, I cannot help but be generous with my subjects. I don't judge, I just tenderly watch over a human terrain sometimes entirely given up to itself.

(from a conversation with Massimo Vitali, September 2002)

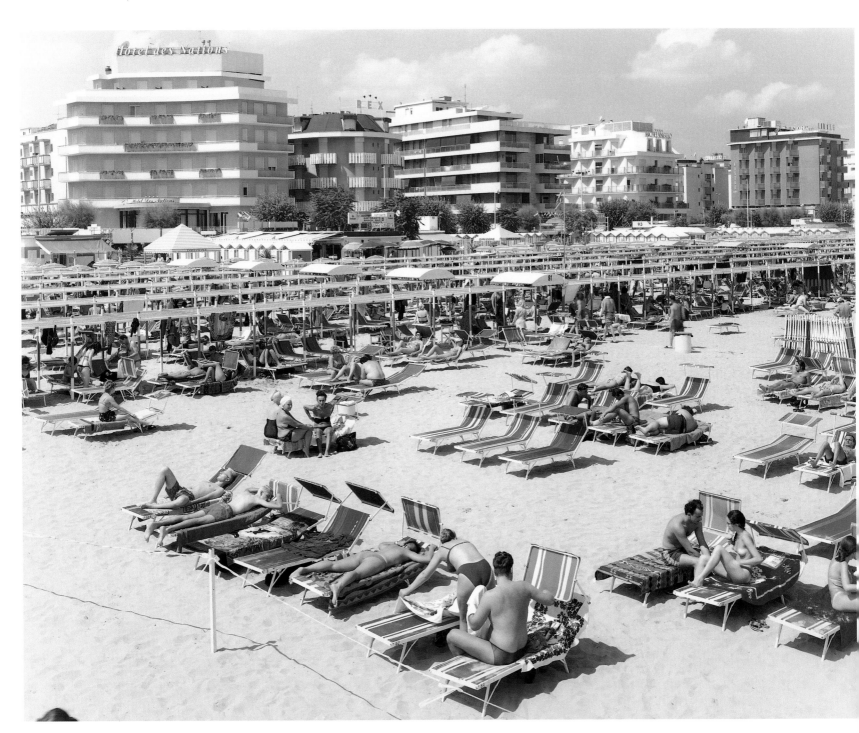

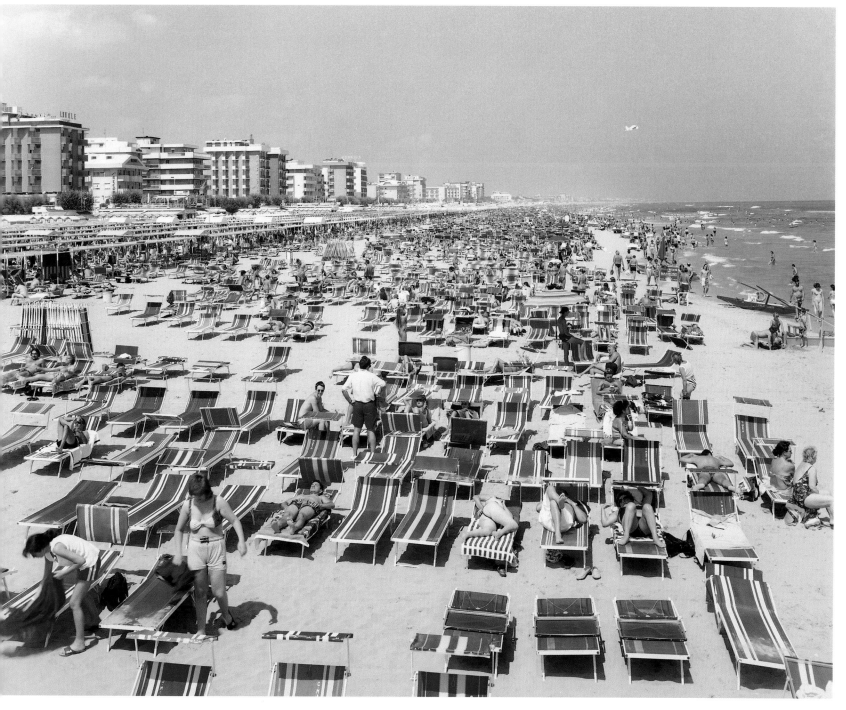

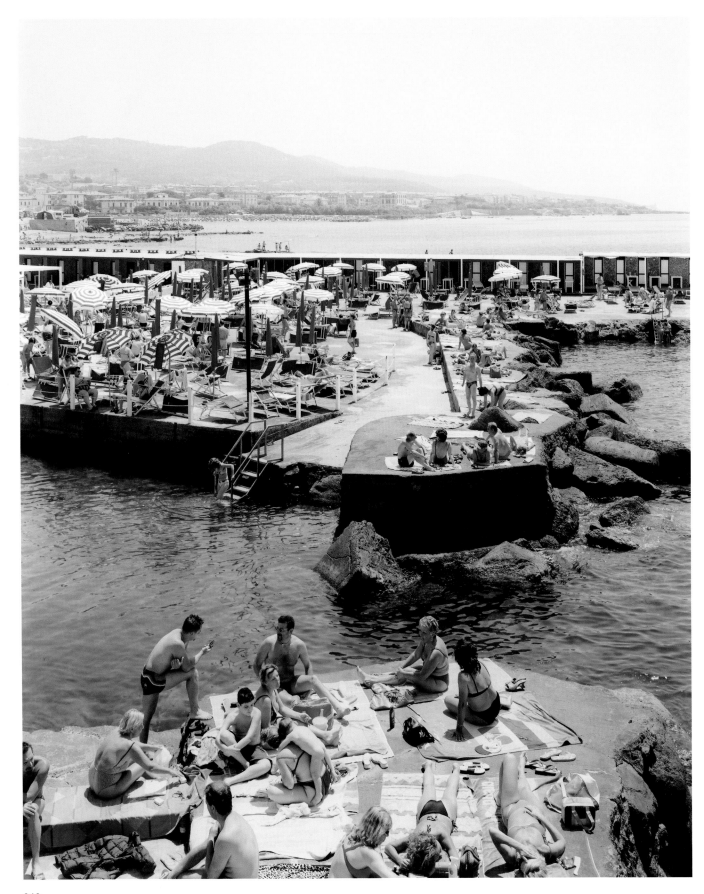

Massimo Vitali Bagni Lido V., Livorno, 2002

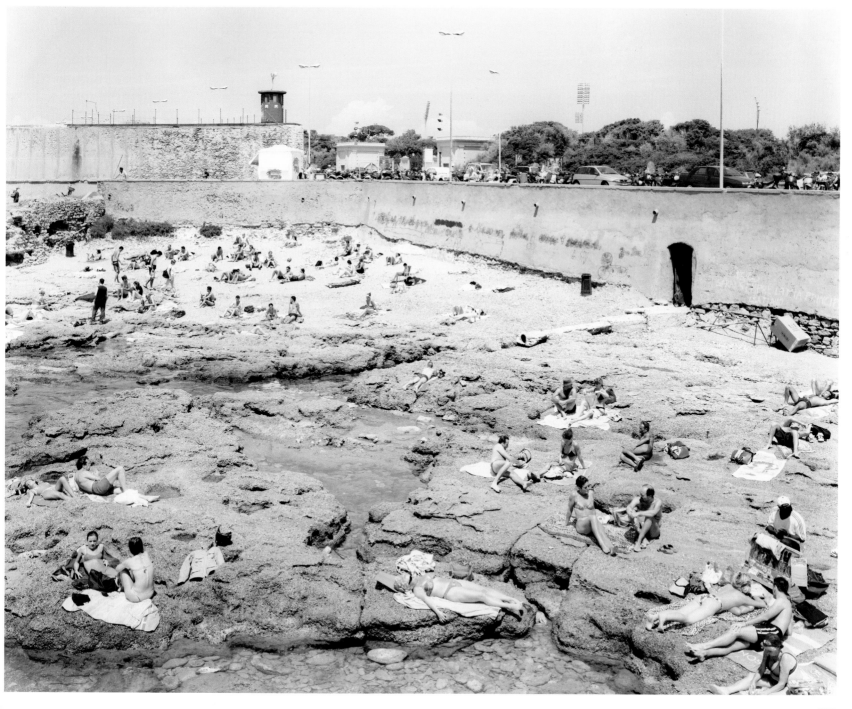

Martin Parr Sirmione, 1999

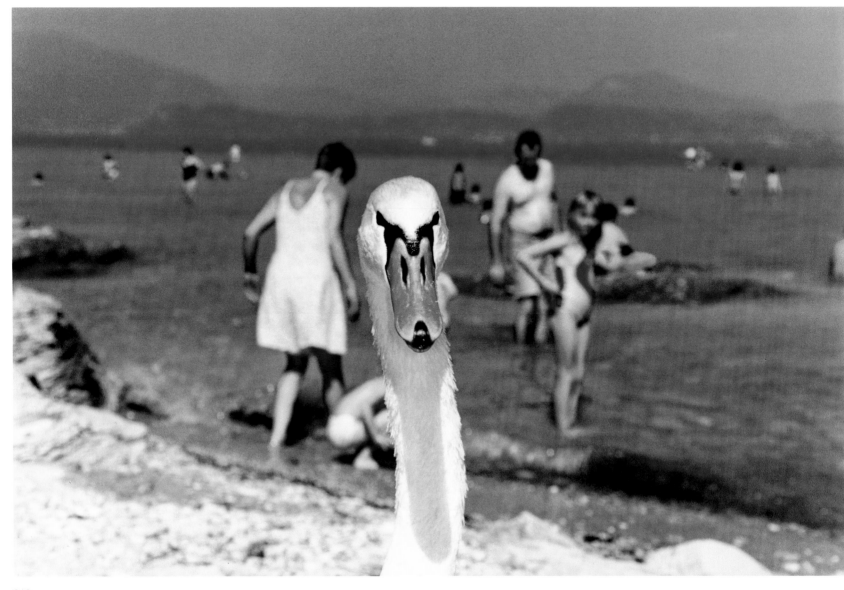

Martin Parr Sirmione, 1999

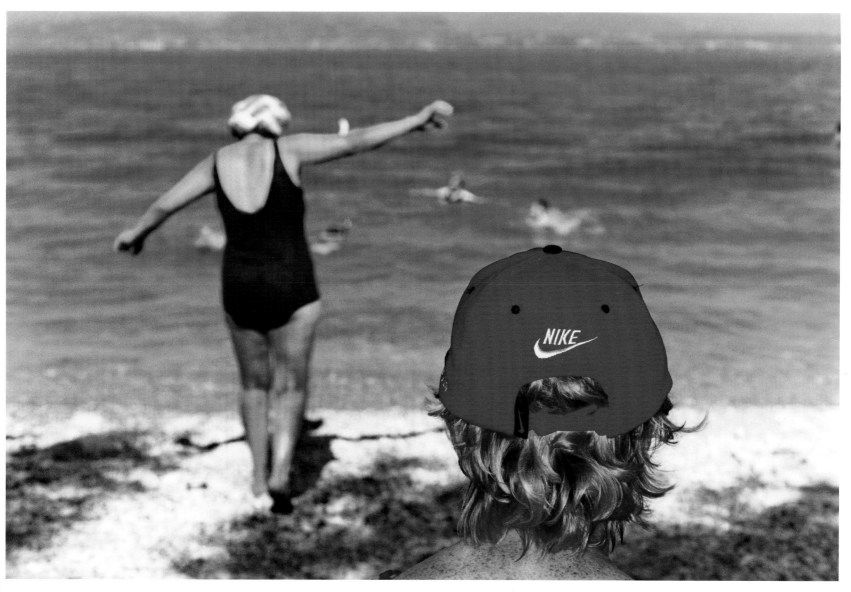

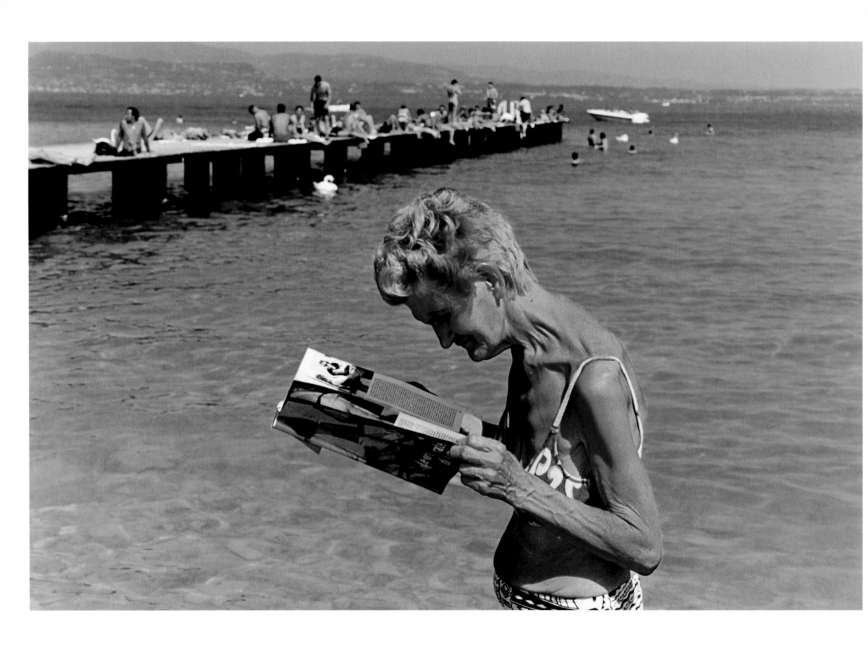

Martin Parr Sirmione, 1999

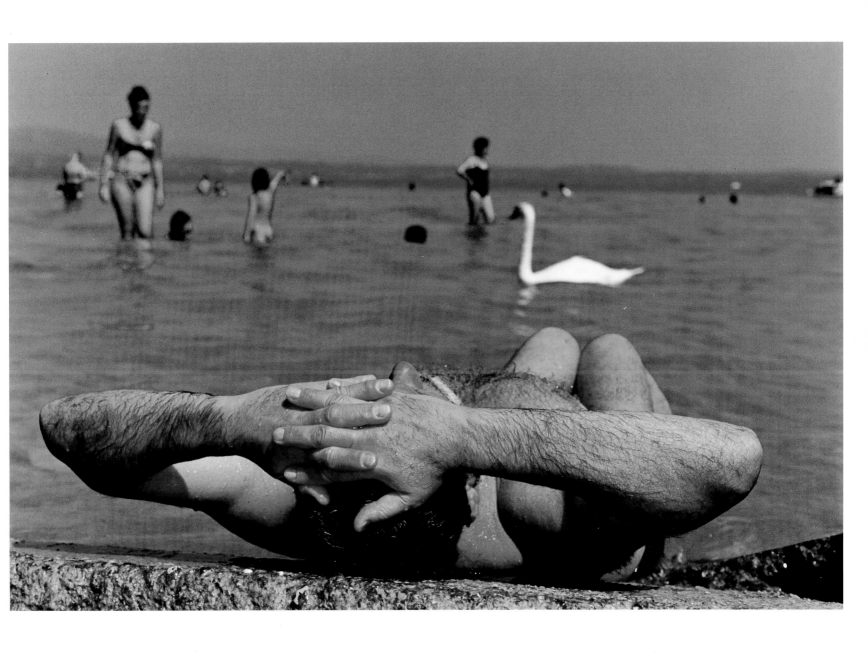

Martin Parr Sirmione, 1999

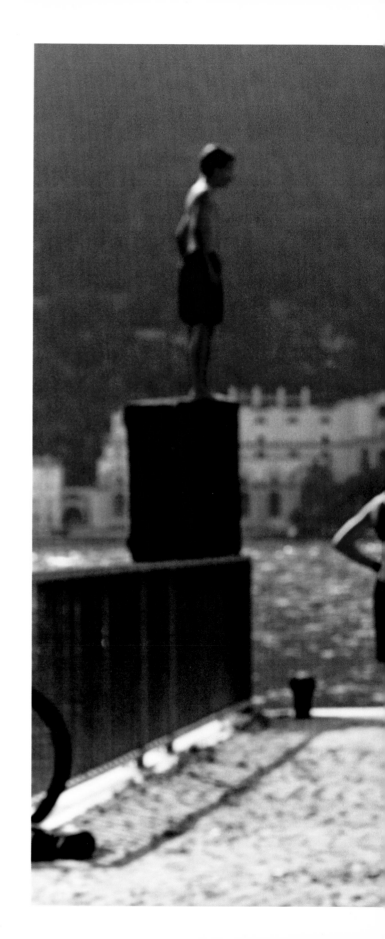

« It's because I'm a consumer that I can recognize the consumer element in other people and in society as a whole.

(from an interview after the publication of *The Cost of Living*, New York, 1992)

Index of Names

Page numbers in roman type refer to illustrations; page numbers in *italics* refer to text.

Picture Credits

Carlo Bertelli is a Professor of Art History at the Architectural Academy of the University of Italian Switzerland in Mendrisio; **Giovanna Calvenzi** is a photo-editor for *Sportweek/La Gazzetta dello Sport*, and a critic and historian of photography; **Christian Caujolle** is artistic director of Agence VU and of VU' la galerie, Paris; **Cesare Colombo** is a photographer, a scholar of visual imagery, a curator of exhibitions and an editor of photographic books; **Aldo Colonetti** is the director of the monthly magazine *Modo*, and scientific director of the Istituto Superiore di Design; **Paolo Pietroni** is a journalist and writer, and the creative director of Class Editori; **Roberta Valtorta** is a critic and historian of photography, as well as a lecturer at the C.F.P. Riccardo Bauer, Milan.

Thanks go to Roberto Koch, who conceived this project, to Francesco Camagna,

who designed it, and to Suleima Autore who made sure we didn't lose our way.

Thanks to all the photographers who have taught us to see Italy, and to Carlo Bavagnoli

and Letizia Battaglia who are not in this volume, but whom we wish could have been.

My thanks also go to, in alphabetic order: Cecilia Alemani from Galleria Monica De Cardenas,

Gabriele Basilico, Gabriel Bauret, Kitti Bolognesi, Giovanni Botticini/Centro Documentazione Mondadori,

Kim Broker from Pace McGill, Christian Caujolle, Elena Ceratti, Cesare Colombo, Simona Corvaia,

Giulio Editore, Simone Giacomelli, Domenica Ierardi from Laura Ronchi, Laura Incardona,

Gilou Le Gruiec, Walter Liva, Uliano Lucas, Anthony Montoya from Aperture,

Melina Mulas and the Mulas Archive, Grazia Neri, Giuseppe Pinna and the Pinna Archive, David Secchiaroli,

Chiara Spat, Monika Sprüth Galerie, the architect Tambresoni and Leslie Thomas of AP.

Giovanna Calvenzi

A book is always the result of teamwork. *Italia* is no exception to the rule.

Therefore I thank Alessandra Mauro, Denis Curti, Roberta de Fabritiis, Barbara Barattolo,

Suleima Autore (what would we have done without her?) and everyone at Contrasto.

Barbara Verduci and Renata Ferri for their contribution to the original selection process.

Yves Marchand, Thomas Neurath and Lothar Schirmer for having believed in the book from the beginning.

Grazia Neri, Carlo Bertelli, Christian Caujolle, Cesare Colombo, Aldo Colonetti, Guido Furbesco,

Paolo Pietroni and Roberta Valtorta for having been so enthusiastic and accessible.

All the photographers, many of whom have been friends of mine for a long time,

who kindly consented to having their work published in this volume.

The staff of EBS, who guaranteed the quality and special attention which a book such as

this requires. Francesco Camagna for his graphic design which has enriched this book,

and for his constant willingness to change, cut and perfect an ever-changing layout.

And of course Giovanna Calvenzi who edited this book with affection and a competence and

determination that are totally her own. This book was conceived, prepared and created over the course

of two years and exists above all thanks to her.

Roberto Koch

Printed in Italy by EBS, Verona, in July 2003